Portrait of the Art Dealer
as a Young Man

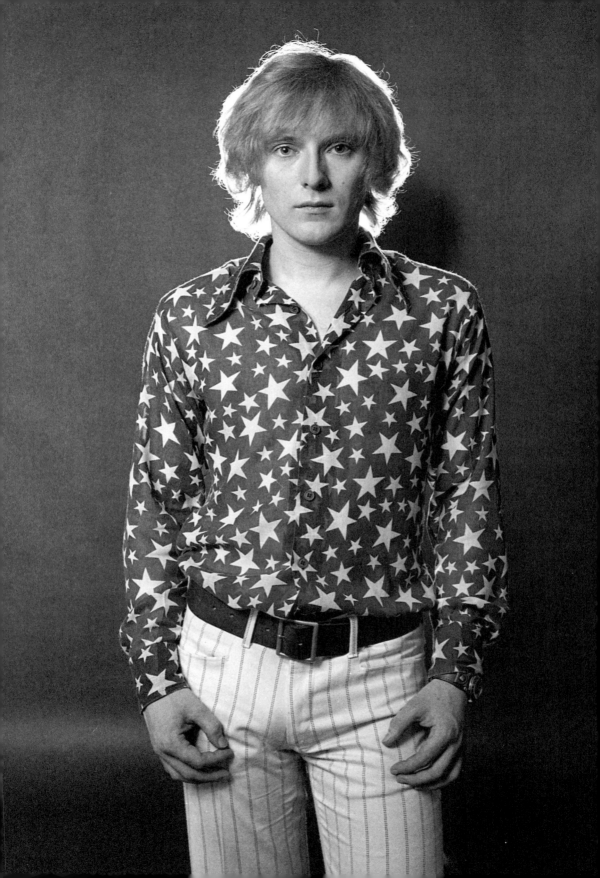

Portrait of the Art Dealer as a Young Man

New York in the Sixties

★

MICHAEL FINDLAY

Prestel

Munich · London · New York

© Prestel Verlag, Munich · London · New York, 2024

A member of Penguin Random House Verlagsgruppe GmbH · Neumarkter Strasse 28 · 81673 Munich

© for the text by Michael Findlay, 2024

Library of Congress Control Number is available; a CIP catalogue record
for this book is available from the British Library.

Editorial direction: Rochelle Roberts · Copyediting: John Son
Design and typesetting: Mark Melnick · Production management: Martina Effaga
Separations: Schnieber Graphik, München
Printing and binding: TBB, a.s., Banská Bystrica · Paper: Serixo

Penguin Random House Verlagsgruppe FSC® N001967

Printed in Slovakia

ISBN 978-3-7913-7726-1

www.prestel.com

Contents

For Victoria, my wife now and forever

Chapter One

*You were just
one for the road, son.*

FATHER

•

*I gave up when you
came along.*

MOTHER

The Convert

It is Saturday, July 26, 1952. I am seven years old in my wee kilt standing next to my comfortably stout grandmother in her Harris Tweed coat. We are looking at a giant painting of Jesus Christ on the cross. For her, a deeply pious Catholic, this is an occasion for silent prayer. For me, it is the beginning of my passion for modern art. We are gazing at a work installed just days before at the Kelvingrove Art Gallery and Museum in Glasgow, a vast Spanish Baroque red sandstone palace of wonders containing all manner of artifacts, from ancient bagpipes to French Impressionist masterpieces. Mrs. John H. Duffy, whom I call Opu, has organized my first visit to a museum to see a recently acquired work of art making a stir in the press.

We are among the first members of the public to lay eyes on Salvador Dalí's *Christ of St. John of the Cross*. I am so used to seeing Christ figures nailed and bleeding on crucifixes in churches as well as in every classroom in my Jesuit school that they barely register for me, but I am hypnotized by this painting. My first feeling is of vertigo from the aerial perspective, the cross floating high in the sky. My second feeling is of unease, the image at once so familiar yet so strange—where are the nails, the blood, the crown of thorns? I can't even see Christ's face!

Taking my silence as a sign of faith, and perhaps it was, but not the religious kind, Opu steers me to the museum shop where I spend sixpence for a color postcard of my first favorite work of art. This sixpence went in its entirety to the museum because the director, Tom Honeyman, purchased not only the painting but the copyright when he negotiated the price of the acquisition from £12,000 down to £8,200. He was heavily criticized at the time for not spending the money on exhibitions of local artists. Dalí's masterpiece continues to stoke controversy.

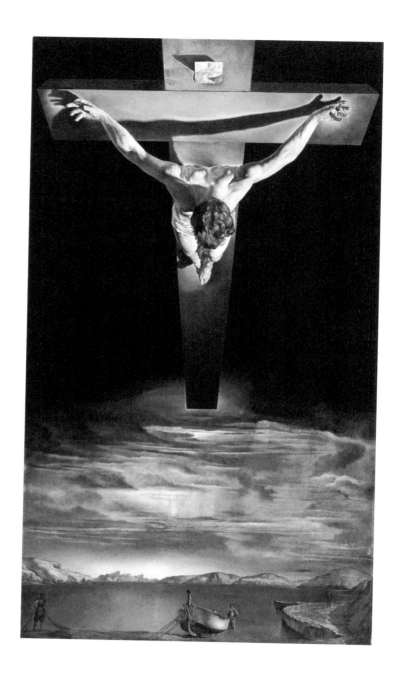

Salvador Dalí, *Christ of Saint John of the Cross*, 1951
Oil on canvas. 80.7 × 45.6 in. (205 × 116 cm). Kelvingrove Art Gallery, Glasgow

Over the years it has been attacked by art critics with words like *kitsch* and by the public with hurled stones, but in 2006 it was polled as Scotland's favorite painting.

A few days after my conversion, I was home in the Wimbledon suburb of London, my Dalí postcard pinned to the beaverboard wall of my narrow bedroom. It became the first thing I looked at in the morning and the last at night. I was a fully paid-up, fish-on-Fridays child of the Holy Roman Catholic Church, but my fascination for this work of art had very little do with the Son of God. With short, tousled hair as my only clue, I was convinced that this was no New Testament Jesus but some young fellow of my own times, this despite the fact that the fishermen far below the giant levitating cross were by the Sea of Galilee. How wonderfully strange. I had been hooked.

Family Portrait

I wriggled out of my mother's womb in Dunoon, a fishing village on the River Clyde an hour from Glasgow, just as the Second World War was ending. Evacuated from London to her native Scotland with my two older brothers, my mother kept the home fire burning with peat while her husband rose rapidly and unwounded through the ranks of the British Army, deployed first in Burma then in Italy. Officer's swagger stick under his arm, Major Robert Findlay stepped ashore in August 1945 after an exhausting two-week holiday at Shepherd's Hotel in Cairo. Of medium height and solidly stocky, he was sandy haired and handsome save for what my mother referred to as his "rat trap" mouth. Saluted by his nine- and ten-year-old sons in navy-blue Sea Scout uniforms but not by his unsmiling wife whose arms held a screaming three-month-old baby. "What the hell is that?" was my father's tender greeting as he peered down at me, his third son. He

eventually remembered being home on leave the year before—as he said to me sixteen years later, lunching at the Press Club in Fleet Street, "We wanted your brothers, but you were just one for the road."

Born of Irish Protestant stock in the Gorbals, the worst of Glasgow's slums, my father parted ways with formal education at fourteen and, as he was hauling himself up by his bootstraps, met my refined mother, also of Irish yet Catholic stock. Educated in France, she was the oldest of three daughters and three sons; their father, John H. Duffy, was the least successful of three patrician brothers. Petite and slim, my mother had dark-brown hair, was sharp featured and even sharper witted. She had modeled hats when she was nineteen and retained the trick of tilting her chin and presenting the left side of her face when in the presence of a camera. She was particularly proud of what she frequently referred to as her "bosom," to the extent that she never quite trusted flat-chested women, one of her many less than rational peeves. My father was besotted with her. And though ambitious, he was poor and Protestant. The Duffy matriarch, my great-grandmother Mary Teresa McMenemy, summoned him to her regal presence in order to say, "You will not be seeing my granddaughter again."

The young lovers eloped to London, my mother Higgins to his Doolittle. He became a journalist and, after conquering the Axis powers, sports editor of Britain's largest newspaper, *The Daily Express*. His own sport of choice, however, was to wager his generous salary on slow racehorses. As frugal with his family as he was profligate at the racetrack, my father installed us in a low-income council flat occupying what had been the servant's rooms on the top floor of what is now a highly desirable house on a leafy tree-lined road off Wimbledon Common. He spent most of his time "at work" in London, thirty minutes by Underground. When I was five years old, he was asked

to leave our household. The request came from my mother as she pummeled his chest and shouted words I had never heard before. This was the closest I ever saw them come to an embrace.

I could not have been happier. Peace, finally. My oldest brother, Robin, had already left to train for Holy Orders although they never came through. My other brother, John, was eyeing the door while completing his final school exams. More avuncular than paternal toward me, my father gave me some of his attention every other Friday. He usually took me to his job, which meant attending a sporting event from the comfort of the press box and getting swappable autographs from soccer and cricket stars like Stanley Matthews and Denis Compton. This in the heavily male atmosphere of pipe and cigar smoke, abundant whisky, and baffling allusions to coitus. Other times we went to see a film and he napped. And he gave me two shillings. It worked for me.

Our brief weekly encounters did not provide me with enough evidence to deduce the accuracy of my mother's daily recitation of his sins, including, but not limited to, adultery, gambling, and the demon drink. This was delivered at dinner time, as I raced through a plate of half-boiled beef and potatoes, and she marched up and down in a cloud of Craven "A" cigarette smoke. Maybe that is why I still eat too fast. Fortunately for me she did not require conversation, just an audience. Thus I learned the wisdom of diplomacy and the ability to appear to be listening.

I was nine when she was treated with electric shock therapy. Driven to visit her at a gloomy private nursing home in Hampshire, a dead ringer for Manderley in *Rebecca*, I was ushered into a dark bedroom. She lay inert, disheveled, disoriented, and with no idea who I was. She later claimed my father had her put away because she wouldn't give him a divorce. What she had done was stage a

high-volume rant at his Fleet Street office in front of his staff aimed specifically at Joan Morgan, my father's pert, doe-eyed young secretary—and mistress.

The Findlay Collection

Alone with mother, I needed to find a world beyond my claustrophobic home life. We had no television and going to the "flicks" was for special occasions. After a visit to Bertram Mills Circus at the age of four, I wanted to be a clown. At six I was transfixed by the magician Jasper Maskelyne sawing a lady in half and asked Father Christmas for a magic set. At seven, the age in which I had fallen under Dalí's spell, I saw young Richard Burton playing a bounding, high-energy Hamlet at the Old Vic and became determined to make a living treading the boards.

There were only two original paintings in our flat. Above the fireplace was a canvas of a single white snowdrop on a black background in a hideous scalloped frame. I would listen to *Journey into Space* on the radio and stare at that snowdrop until it became the astronaut Whitaker spinning into the void away from his rocket ship. The other painting was of my grandmother Opu, slim and elegant with Clara Bow lips, rakish wide hat, a fur stole, and muff. Her bachelor brother-in-law, my great-uncle, was the artist Daniel James Duffy, a member of the Royal Scottish Academy. His dear friend, Francis Wilson, also a member of the RSA, had painted Opu. The lack of definition in the background indicates this portrait was either progressively avant-garde, which is unlikely, or unfinished. Family lore has it that when my grandfather James found out that his fiancée, Kathleen McSherry, was modeling for an artist, albeit in outdoor wear, he ended the sittings in a fit of jealousy.

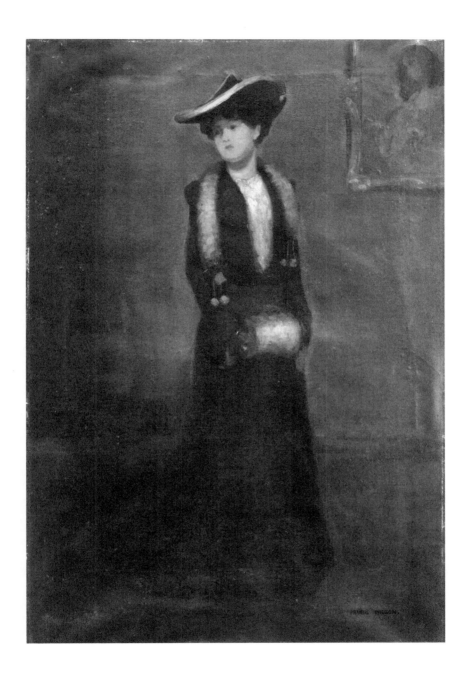

Francis Wilson, *Kathleen McSherry*, c. 1909
Oil on canvas. 30 × 20 in. (76.2 × 50.8 cm). Author's collection

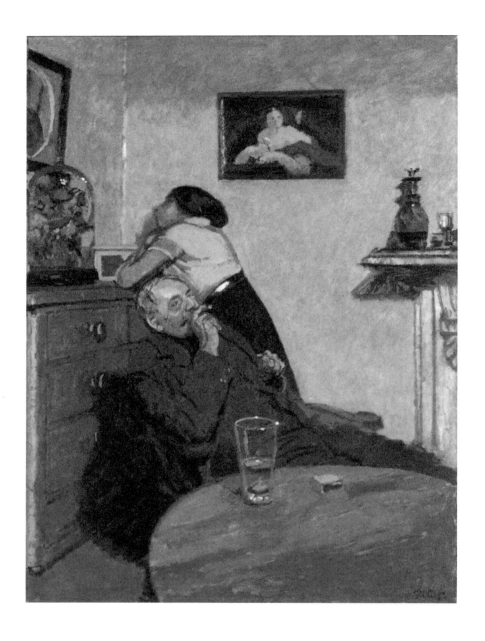

Walter Sickert, *Ennui*, c. 1914
Oil on canvas. 30 × 22 in. (76 × 56 cm). Tate Collection, London

Duffy and Wilson hewed closely to a restrained form of Post-Impressionism as did most of their *fin-de-siecle* peers at the RSA. Their work was more than competent but has failed to reach beyond the lowest tiers of art history. Auction results for their work peaked in the mid-1980s with Wilson's *Dinner at the Glasgow Arts Club* selling for £3,300, while the more accomplished *Campo di San Agnese, Venice* by Duffy sold for a mere £825.

The rest of the Findlay Family Collection in 1955 consisted of reproductions, one memorable to me because it sharply contrasted with what I had witnessed of married life. *Ennui*, by Walter Sickert, is a domestic scene of a husband and wife, backs to each other, staring into space. I would have titled it *Felicité*. Over the bookcase in our living room were three reproductions of beach scenes by Raoul Dufy, which were there to inspire my mother to wax eloquently and frequently about her French education and, by extension, her love of everything French, as in the stories of Guy de Maupassant, the songs of Edith Piaf, and, in emulation of Marcel Proust, the taste of absinthe, although Pernod was as close as she could get. Unfortunately for me, French cuisine was not on her school syllabus in 1925.

Dufy's deft and colorful renderings were the most modern images on our walls, but they held no interest for me until my brother John, a science student, took it upon himself to copy them, for his own amusement and with some skill. Unwilling to give him any credit, I dismissed Dufy as an artist "easy to do," a prejudice that stayed with me for far too long.

Sending Away for Art

It was not long before my Dalí postcard was joined by inexpensive reproductions of three well-known works. My bedroom was squeezed

between that of my mother and one that my two brothers occupied. The three rooms had once been one. Fifty years later I made a nostalgic return to this house and marveled that our entire flat had been renovated into a dormitory and recreation area for Mumford & Sons musician Ben Lovett and his brothers by their parents.

My upbringing was lenient compared to many British children of my generation. My mother's relationship with me was absent-minded, while my father was simply absent. By staying out of my mother's way and monitoring her mood swings, I got permission to paint my room canary yellow. When this was done, what little wall space I had looked even more bare. I sent away for a reproduction of Frans Hals's *Laughing Cavalier*, which I had not yet seen in the Wallace Collection. This was advertised for five shillings plus postage in the *Daily Express*. In those days boys my age sent away for anything seriously interesting like itching powder or a book to improve memory. I demonstrated a keen interest in what would become my adopted country by sending away for an autographed, glossy, black-and-white photograph of Roy Rogers on his horse Trigger. It took over a year to arrive, my joy tempered by the fact that I had no way to obtain the one United States dollar required to join his fan club.

My mirthful cavalier arrived more promptly, and I was delighted that, as advertised, it had been printed on heavy stock with a ridged surface to simulate brushstrokes on canvas. Brilliant! And it was the size of the original, almost three feet high. I installed it with push-pins onto the sloping eave above my bed and filched a length of lavender netting from my mother's closet which I draped around it. I can still see it in my mind's eye—if exhibited today the ensemble would nicely fit the postmodern category.

My first female pin-up joined Jesus and the cavalier when I was nine, after seeing the original on a primary school visit to the Tate Gallery. This was *Ophelia* by John Everett Millais. After my mother,

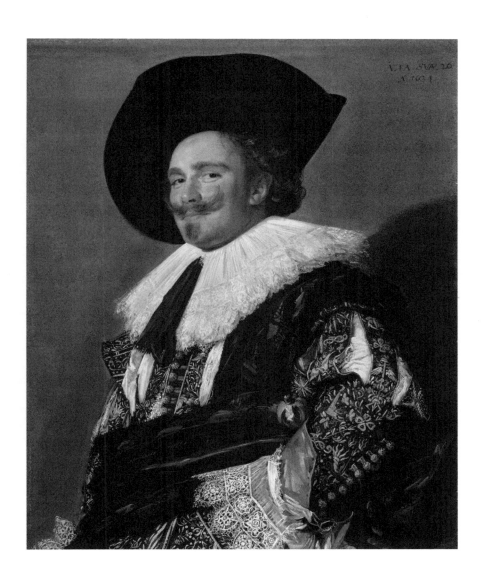

Frans Hals, *The Laughing Cavalier*, 1624
Oil on canvas. 33 × 26 in. (83 × 67 cm). The Wallace Collection, London

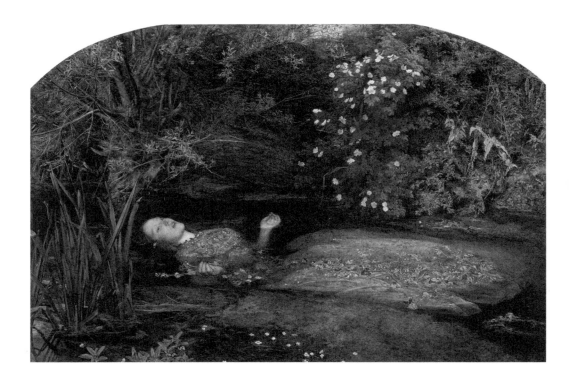

John Everett Millais, *Ophelia*, 1851–2
Oil on canvas. 30 × 44 in. (76 × 112 cm). Tate Collection, London

Ophelia was the second and far from the last unhinged woman in my life. I fell in love with Claire Bloom's Ophelia opposite Richard Burton's Hamlet, and I gazed at Millais's Ophelia as much as I stared at Dalí's Jesus, possibly for different reasons. I was told the actress Elizabeth Siddal, who modeled for Millais, had actually drowned in the bathtub while being painted, which added to my morbid fascination. The real story is that her father sued the artist when she caught a bad cold, my first lesson to pay less attention to tales about the painting than the painting itself.

On that same primary school museum trip the good Jesuit Fathers took us to the National Gallery where I was admonished for staring too long at *The Rokeby Venus* by Diego Velazquez, transfixed as I was by her rosy bum. Some things never change. I was encouraged to spend as long as I wanted when I stopped in front of *The Fighting Temeraire* by J.M.W. Turner. When I insisted on buying a reproduction in the museum shop, our Headmaster Father Egan S.J. suggested I give a talk about it to my classmates. This was the most agreeable thing he ever said to me. Our usual communication consisted of him applying a whalebone covered in leather to the palms of my hands, with some force, the punishment for "talking in class." Now he was asking me to do exactly that! Unable to find words for exactly why I liked the painting, I delivered a stirring account of the Battle of Trafalgar. I have returned to this painting many times and appropriate words still elude me.

Hals's *Laughing Cavalier* is quite another story. I lost interest in him quickly and permanently, feeling little for Old Master paintings until, now old myself, I am drawn back to seventeenth-century Holland by Rembrandt's haunting self-portraits. As for *Ophelia*, I didn't need a lesson in art history to become vocally scornful of the sentimental dramas of Millais and the flimsily clad, frolicking lassies and lads of Dante Gabriel Rossetti and Edward Burne-Jones. I did,

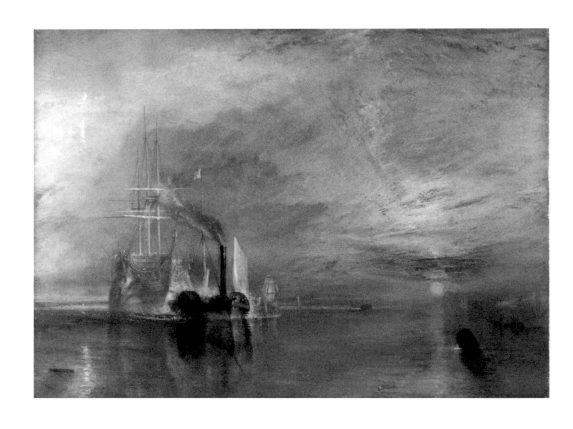

J.M.W. Turner, *The Fighting Temeraire*, 1838
Oil on canvas. 35.7 × 47.9 in. (90.7 × 121.6 cm). National Gallery, London

however, nurture secretly a soupçon of fascination that still lingers. As I saw and learned more, I began to see Millais as old-fashioned and Turner as a very modern artist.

La Vie Bohème

From the ages of six to eight I worked for sweet coupons. After the Second World War all food was rationed in Britain. Everyone had a book of coupons which had to be handed over when paying for food. I was only interested in sweets (candy), limited to twelve ounces a person per month. Older people rarely used their sweet coupons. At Easter, my mother took me to visit Mrs. Yeoman, who was almost a hundred. As a young barmaid at the Rose & Crown pub on Wimbledon High Street, she had served the notorious Victorian poet Algernon Charles Swinburne. I held her withered hand and sat by her bed gazing at the pale-yellow wrinkled skin of her face and her wispy white hair. She feasted her eyes on my blond curls and rosy cheeks, rewarding me with enough coupons to score a big chocolate Easter egg.

The first artist I saw at work was our downstairs neighbor, freckle-scalped old Mr. Hardy, who lived with his wife and their fat tortoiseshell cat, Toby, in the first-floor garden flat. The Hardys gave me their sweet coupons as wages for my daily job boiling cod dinners for their wretched feline. The smell disgusts me to this day. After feeding Toby, I was allowed to perch next to Mr. Hardy's easel and watch him design greeting cards. He was a meticulous watercolorist. I was almost as interested in his obsessively well-ordered cakes of color and rows of brushes as I was with his painstakingly rendered cavalcades of merry, colorful people (actually all white) celebrating whatever season might lie six months in the future. He

concentrated hard, spoke softly, and was very neat. Later I was surprised to learn artists had a reputation for unruly behavior, even hedonism.

Bohemianism entered my life so early that I took it for granted a man might paint his toenails and a woman bend iron bars. One of my mother's brothers, tall Black Irish Arthur Duffy, with a devilish widow's peak, was one-legged from the age of seven, the result of a minor cut, sepsis, and an incompetent physician. Arthur lived on quaint Jubilee Place off King's Road in London's Chelsea. His friends included Reginald Reynolds, who was an ardent Quaker and a conscientious objector during the war; the self-declared "fairy" Quentin Crisp; and assorted lady friends, including blonde Joan Rhodes, a professional wrestler and strongwoman, and brunette Delia Dudgeon, known as the "wheelchair photographer." In the late 1950s Crisp celebrated his birthday (and Christ's) with Uncle Arthur and his assorted bohemian friends in our modest Wimbledon flat. It is just as well my father had left our unstately home when he did; to him, Reynolds, a close friend of Mahatma Ghandi, was a despicable "conchie" (conscientious objector), and Crisp, with his long marcelled hair, quite beyond the pale. To dissuade me from going on the stage he told me that the distinguished actor Alec Guinness was, voice dropped to a whisper, "a *known* homosexual."

My brother John carried Delia on his back the three flights of narrow stairs to our flat while Arthur swung his crutches to take the stairs two at a time. "I tried a false leg once," he told me. "It fell out of my trousers when I ran for the bus and a woman fainted." My mother's other brother Desmond inevitably brought new technology for our amusement such as a portable tape recorder, and once, a new electric record player with a "single" from America—Elvis Presley singing "Love Me Tender."

My Early Debut as an Art Dealer

The first time I saw money being paid for art was outside the National Gallery. My mother told me she was taking me to Trafalgar Square to feed the pigeons. She amused herself by making me assume a crucifixion pose before sprinkling birdseed on my head and outstretched arms. This was in order to take a photograph. Abusive and unsanitary. Afterward, I pushed my way to the front of the crowd of Londoners and tourists ogling the curbside masterpieces being made by pavement artists. Admiring as I was of the gigantic Mona Lisas and Marilyn Monroes rendered in colored chalk, I was every bit as impressed with the copper and silver coins accumulating in the strategically placed upturned hats.

Easy money! I enlisted the help of the boy next door, a cockney lad named Edward Sears who never saw the need to go to school and made up for this later by going to jail. With an intuitive grasp of "art brut" and every good artist's ability to improvise, we took crayons to large sheets of brown wrapping paper and rapidly covered them with imaginative interpretations of our suburban neighborhood. We spread these out on the sidewalk in front of our adjacent houses with a strategically placed old felt hat.

Shabby but genteel, Wimbledon Village was known as the place where everyone had a maiden aunt. The famous tennis courts were a mile away and might as well have been on another planet. Our street was quiet, very few cars. The horse-drawn milk cart rumbled by once a day. In the morning an elderly housekeeper might pull her wheeled basket on her way to the High Street butcher. After lunch a man might walk his dog. No tourists. Hardly Trafalgar Square. My mother happened into the front garden just as a window was thrown open in the house opposite and an elderly man with a handlebar mustache and very red face bellowed at us.

"ARE YOU LITTLE BOYS BEGGING?"

For once in her life at a loss for a pithy rejoinder, my mother hustled me inside. Thus ended my first attempt at becoming an art dealer.

I Learn How Professionals Do It

My own maiden aunt, Gabrielle Duffy, lived not in Wimbledon but in Notting Hill Gate, a far more exciting neighborhood. In 1958 there were race riots instigated by too-lazy-to-work "Teddy Boys" provoked by an influx of hardworking immigrants from the Caribbean islands. I never saw trouble, but to an eleven-year-old, the scent of danger added to the fun I always had on my Saturday visits with my favorite relative. Like my mother, she was a small-boned brunette but sturdier and, although comely, less vain, able to admit she needed glasses.

My mother was happy to have me get out of her hair and spend time with my aunt, even though she and her sister were on permanent non-speaks. My aunt had been in uniform during the war and turned up for a brief stay with my mother in the company of a female comrade from her auxiliary service unit. My mother was inconsistent in her attitudes toward sexual preferences. She begrudged her sister a girlfriend but once casually said to me, apropos a particularly well-cut jacket in her wardrobe, "that was from my lesbian period." When she noticed that I had started to bring girls home she told me, "It's a pity you're not a queer, it would just kill your father."

I took the District Line Underground train ten stops from Wimbledon to Notting Hill Gate and walked to Aunt Gabrielle's flat in Ladbroke Gardens. While she made lunch I browsed her bookshelves

for unusual reading material, including *Health and Efficiency*, a nudist magazine, and the luridly covered novels produced by her employer, a one-man publishing enterprise. There was rarely anything within the pages to justify the buxom beauties on the dust jackets.

After lunch we would "do" the Portobello Road from top to bottom, trekking slowly down one side and back up the other. This was my first real introduction to the business of selling *objects d'art*, although most of it was good old British flea-market junk. Now billed as "the world's largest antiques market," Portobello Road then had only what might very loosely be called antiques at the posh top end. My aunt and I meandered from the big stalls on the hill that sold fancy household silverware and tea sets to well-dressed American tourists down past pokey, ill-lit shops with abundant paintings of po-faced ancestors and highland cattle, not always distinguishable. We kept going to the very end under the A40 where stalls were replaced with rusting baby carriages filled with everything from lost and stolen umbrellas to second-hand plumbing fixtures.

For me this was pure entertainment. It never crossed my mind to buy anything, and I don't recall my aunt ever doing so. I was just as fascinated by the sellers as their goods. The women were generally congenial ("Go on love, pick it up and have a decko, it won't bite yer."), while the men were often surly or bullying in their salesmanship, as if it was beneath them to be polite. I did notice that the most effective ones were cheerful and had something flattering to say ("Nice school blazer young man, these books over here are for an educated type like you."). They were not upset if you kept going but should you stop and look at a pea-green silk lampshade or an ugly Toby Jug they had something interesting to say ("Belonged to Queen Victoria's butler, that did!"). Valuable lessons for an art-dealer-to-be.

Behind the Counter

Sweet rationing ended in 1953, so I could buy as many Cadbury Fruit & Nut chocolate bars as I wanted so long as I had the cash. I supplemented my two shillings a week in pocket money by earning an additional four shillings working at a small philately shop after school on Wednesdays. I started to collect postage stamps when I was eleven and took it very seriously. I only wanted stamps from current or former British colonies, of which, alas, there were many. It took some skill to remove stamps from envelopes and enter them on delicate gummed hinges into my bound albums, country by country.

Long distance telephone calls were prohibitively expensive and had to be booked in advance, so most communication with overseas friends and relatives was by mail. People with jobs in countries like Bechuanaland (now Botswana), Ceylon (now Sri Lanka), Rhodesia (now Zambia), and Nyasaland (now Malawi) sent letters home in envelopes bearing exotic, colorful stamps which were saved for collectors like me. Used rare stamps could also be bought, hence my employment. Expertise was required but not salesmanship; the stamp collectors know exactly what they want. My conversations across the glass counter were usually in hushed tones, involved a magnifying glass and much looking up in the Stanley Gibbons catalog, the bible of stamp collecting. I also learned the golden rule of retail business, one that stood me in good stead later in life: *it is generally best to sell an object for an amount in excess of what one paid for it.*

Art Out of the Classroom

My first encounter with a grown-up art lesson was at St. George's College, a private (in Britain confusingly called "public") boarding

school for boys run by priests of the Josephite Order, not as intellectually rigorous as the Jesuits but also firm believers in corporal punishment. By the time I reached eleven I had provided more than enough Freudian therapy to my mother, and I desperately wanted to get out of the house. Decades later, when Dr. Howard Zucker helped me sort myself out, he heard all and said little and I paid him well for the silent treatment, whereas my mother couldn't even cook me a decent dinner in exchange for listening to her endless tirades. And God forbid I nod off, which Dr. Zucker had a habit of doing on late Friday afternoons.

After reading *Tom Brown's School Days*, a classic mid-nineteenth century tale of brutal bullying and tender friendships at Rugby School, I instigated a campaign to be sent to such a bed-and-board seat of learning. There were still many around, as little had changed in educational practices in England between 1850 and 1950.

I had passed the "eleven-plus" state examination that all children took when ten years old to determine eligibility for either academic or technical training, which meant at that tender age you were directed toward either the front office or the factory floor. The rich, naturally, sent their children to private schools which were now required to take a few state-sponsored pupils. I was found a place at St. George's College, my tuition paid by government scholarship and my living expenses by my father. Whenever his contributions to lame horses caused him to be late with my school fees, the sports-keen headmaster was placated with sought-after tickets to major sporting events.

So I left for boarding school at the age of eleven, keen for the midnight feasts, perhaps less so for the beatings. Dry-eyed, my mother took the opportunity to rent my modest bedroom to an attractive student at the Wimbledon School of Ballet named Constance. I was thrilled vicariously at the prospect of a real girl sleeping in my

bed—I had glimpsed her briefly and she had possessed the prominent ears then requisite for engaging my attention. She failed to join the Royal Ballet but did, according to my fabulist mother, become one of the famous Bluebell Girls, a troupe of scantily clad dancers at the Paris Lido.

Most of my boarding school teachers were Roman Catholic priests who wore collars and ankle-length black cassocks. Required to address them as "Father," we gave them nicknames like "Dungcart" and "Kipper" and "Chimpie." St. George's was well regarded but barely a hundred years old and ranked below Stonyhurst and Downside, founded in 1593 and 1617 respectively. The pupils at those schools bore the same family names from generation to generation, whereas St. George's attracted a more diverse student body, including boys of color both British-born and from overseas. American Catholics in the military or State Department based in the UK sent their sons to St. George's; one or two ended up in every classroom. Living day and night with an international assortment of peers undoubtedly broadened my mind.

Qualified or not, the priests tried to teach most of the core subjects while culture was farmed out to lay teachers who were all male. Johnny "Jazz" Finch taught music appreciation, making it clear he appreciated Coltrane as much as Bach. For art we had Mr. Anthony Kerr—the fact that he was the only teacher with no nickname indicated the esteem in which we held him. Kerr was solid and wide with a generous but well-trimmed beard and wore three-piece twill suits. In his mid-thirties he nevertheless had a Victorian air about him, and to us pimpled thirteen-year-olds he was a towering figure of authority. While he did not reference his own work, rumor had it he was a "real artist." In fact, he spent his free time painting the length of the river Thames, from one bridge to another. Somewhat reminiscent of his countryman Alfred Sisley, his accomplished gen-

English landscapes can be found selling online today in the range of £100.

That first day he set us all the same task. "Take your pencil in one hand and place the other where you can see it," he boomed. "Now draw your hand." Thirty minutes later he glanced at the gathered results and quickly divided the fifteen of us into groups of nine and six. "You will learn to make art," he said to the nine. "And you will learn to look at art," he said to the rest, of which I was one, as well as my ginger-haired best friend Mike O'Ferrall. He and I were keen members of the school's winning track team as well as devotees of Thelonious Monk and Charlie Parker. Clandestine followers of the Campaign for Nuclear Disarmament, we were also members of the Anti-Apartheid Movement.

Kerr's art lessons for us lookers-rather-than-doers was to insist we saw real art before we wrote or even spoke about it. When he mandated monthly visits to London's museums we cheered loudly. The city was a forty-minute train ride away and any trip there involved salty hot, vinegary, newspaper-wrapped fish and chips at Waterloo Station. After a six-year hiatus since being stunned by the Dalí in Glasgow, my romance with modern art now continued.

Kerr did not accompany us to stand in front of a well-known painting and declare what the artist was trying to say. Doing so is still, horrifyingly, a common practice. Recklessly, to some, he sent us to wander on our own through the Tate Gallery and the National Gallery. His sole instruction was for us to find one work we liked and to look at it for at least ten minutes and *not* take notes. The next classroom period was spent describing and discussing what had been seen. He did not care if we recalled the name of the artist or the title of the work. If I rambled on about a scrap of information I remembered from the wall text, Kerr would growl, "All very well, but what did you *see*, Findlay?" He did not impose his own taste on us nor did

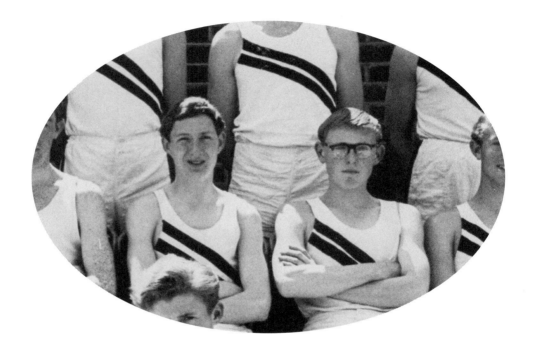

St. George's College Track Team, 1959
Michael O'Ferrall (left) and the author (right)

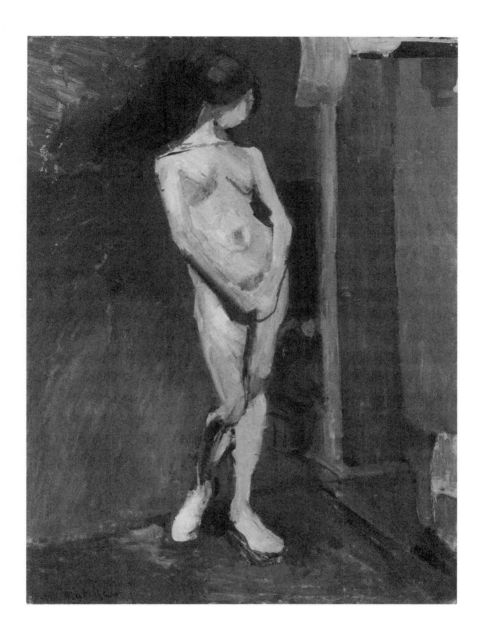

Henri Matisse, *Nude Study in Blue*, c. 1899
Oil on canvas. 28.7 × 21.2 in. (73 × 54 cm). Tate Collection, London

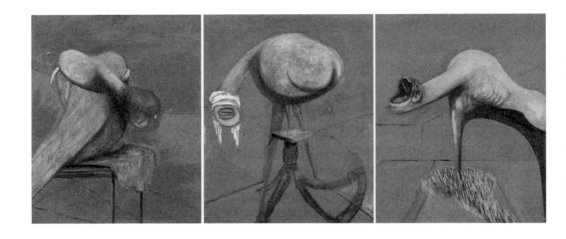

Francis Bacon, *Three Studies for Figures at the Base of a Crucifixion*, 1944
Oil on canvas. 37 × 29 in. (94 × 74 cm), each. Tate Collection, London

he talk about good art and bad art. We were graded according to the degree to which we were able to articulate our response.

As I describe in *Seeing Slowly: Looking at Modern Art* (2017), I was "strangely transfixed" by *Nude Study in Blue* on my first visit to the Tate Gallery. Why? An ungainly figure with club-like hands and feet, standing faceless and downcast in the corner of a messy studio, her bare flesh bruised with a strange palette of blue and green and yellow. Looking at her now, the only identification I can imagine my teenage self might have made was with the cartoon character Olive Oyl, who I still find oddly appealing. Kerr also insisted we devote one visit to finding a work we did *not* like and explain why. Though I was fascinated by Francis Bacon's *Three Studies for Figures at the Base of a Crucifixion*, I chose it as my "disliked" work probably because it terrified me. Now I like it for the same reason.

Young Man Goes West

I intended to spend two years in the sixth form, the equivalent of twelfth grade, accumulating enough good exam results to get into a decent university. This was standard for boys who did not have jobs waiting for them in their father's bank or insurance company. My brother John was the first in our family to be educated beyond high school, getting his doctorate in chemistry at the University of New Brunswick in Canada with some study at Oxford University. I had not begun to think about where I might apply and there was no such thing as college counseling. My long-distance romance with America was unabated. I expressed this once too often to my mother and in her inimitably tender manner she wrote to me at school: "Why don't you bloody well go to Harvard?"

I applied. The next thing I knew I was in a roomful of young Americans at the embassy in Grosvenor Square taking the SAT exam. I was accepted. The only hitch was the cost of tuition, living, and travel. My father would have needed a winning season of fifty-to-one favorites. Instead, he was looking forward to me being off the family payroll. His firstborn, Robin, who had left his religious training to join the British Army, was doing his national service stationed in Singapore, while second-born John's higher education was full scholarship. I was the only offspring left with a call on his wallet.

One day an item pinned to the upper school notice board caught my eye. An Anglo-Australian conglomerate called Rio Tinto Mining Company was offering to pay travel, tuition, and living expenses for a British student to study for a bachelor's degree at a new, small, progressive liberal arts college called York University affiliated with the University of Toronto. I had the basic exam passes that were required yet none in science which I assumed a mining company would want. I applied nonetheless and was selected for an interview at the Rio Tinto offices in London.

I reckoned my chances slim to none, but this was a day off school for me to visit the Tate and the National Gallery, grab a hamburger at a Wimpy Bar, and perhaps even squeeze in a film. The Rio Tinto head office was in fashionable St. James, home of gentlemen's clubs and expensive restaurants. I joined two other boys seated on a bench in a corridor. I had expected there to be many more candidates, but for the average Brit North America was a life-changing emigration terminus, not a destination for a holiday or even a college degree.

I went last. Nervous, I sat in a straight-backed chair opposite a long desk behind which were three elderly pin-striped members of the Rio Tinto board, none of whom seemed any more at ease than me. With their Dover sole and port waiting for them at White's, this was obviously a chore outside their usual somnolent, late-morning

duties. After much throat clearing, the one in the middle asked me why I wanted to go to Toronto. All of them took notice when I told them my brother was making a success of his scholarship opportunities in New Brunswick. No mention was made about mining, nor did they ask about my exam results. I wrote the whole thing off as soon as I was out of the building and headed first for the Tate and then Wimpy's. I didn't have time for a film.

Later that month, Mike O'Ferrall and I scandalized the priestly body and puzzled most of our fellow students by replacing the expected Shakespeare production with *Waiting for Godot* as the school play. This just five years after it premiered on the London stage and was derided as "twaddle." I finished the summer term in early June, fully expecting to return for my second sixth form year the following September. Instead, a letter arrived informing me that I was now a Rio Tinto scholar and that arrangements would be made for me to fly to Toronto on September 5.

Why was a giant mining company sponsoring an undergraduate degree for a British student to a small, newly founded Canadian liberal arts university? I got part of the answer on arrival. York University started in 1959 with two hundred students and added another two hundred in its second year. Star faculty were hired from the United Kingdom and the United States as well as Canada to participate in what they were told would become a crucible of progressive liberal education with an emphasis on philosophy, psychology, sociology, and the arts. Small seminars, no lectures, and a three-to-one student-faculty ratio. Needless to say, the founding students were adventurous idealists who had excelled in high school

Then starting its third year of existence, York still lacked an ingredient essential to being able to advertise itself as both progressive and cosmopolitan—foreign students. Rio Tinto to the rescue. Within a few days of my arrival I found myself featured on the front

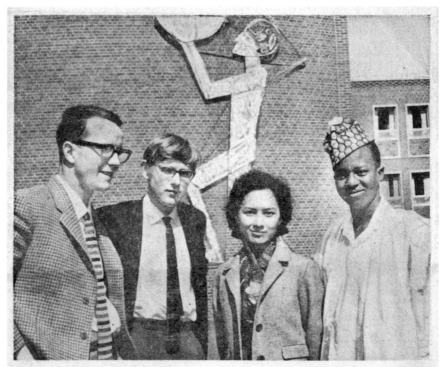

QUARTET OF SCHOLARSHIP WINNERS TOGETHER AT YORK UNIVERSITY
From left: Gary Caldwell, Toronto; Michael Findlay, England; Annie Woo, Hong Kong; Sani Dauda, Nigeria

Toronto Daily Star, September 1962

page of the *Toronto Daily Star* next to Annie Woo from Hong Kong and Sani Dauda, wearing a fila hat, from Nigeria. Had I known, I would have worn my kilt.

Bought and paid for, I was required to maintain a high degree of visibility and encouraged to sing for my suppers by joining all the student clubs. I was eagerly accepted by most, including the Hillel Society, although I didn't last more than a couple of meetings at any of them. During the winter break, I scoured Toronto for culture and discovered an avant-garde theater group called Toronto Workshop Productions, the brainchild of George Luscombe, a pioneering, left-wing director and devotee of my theatrical god, the Russian actor and director Konstantin Stanislavski. When I informed Luscombe I had read *An Actor Prepares* and played Estragon in *Waiting for Godot*, he let me join his troupe. The theater, wet and cold, was near the waterfront. The play that season was Georg Büchner's *Woyzeck*. We rehearsed endlessly, improvising, and finding our inner voices. I loved it.

Art Touches Me and I Touch Art

At the start of the second semester I was roped into a scheme to borrow works of art from local collectors to brighten the halls and corridors of the mansion on Bayview Avenue that was York University's first home. This led me to the doorstep of Sam and Ayala Zacks, Toronto's leading collectors. They collected works by modern masters such as Wassily Kandinsky and Marc Chagall, as well as contemporary Canadian artists. When they invited me to see their collection it was the first time I set foot in an art-filled private home and my first close encounter with works by young artists. The Zacks introduced me to the casual, intimate relationship that serious collectors

have with their works of art. It dawned on me that art had an existence outside museums.

Ayala epitomized the best that a collector can be. Emotionally and intellectually engaged with art and artists, elegant and articulate, she was an extraordinarily generous benefactor to the museums on whose boards she served (the Art Gallery of Ontario, the Tel Aviv Museum of Art, and the Israel Museum). When I recognized similarities between works by artists in her collection and favorites from my visits to the Tate Gallery, she gave me the house tour, even going so far as to encourage me to feel the bronze contours of her favorite sculpture, *Decorative Figure* by Henri Matisse. This brought *Nude Study in Blue* at the Tate back to me. It was as if the same awkwardly angular model had felt wobbly after posing for the painting and had rested her right buttock on a pedestal. These were my first glimmerings of an understanding and appreciation for form.

Ayala and Sam generously allowed me to borrow a *Walking Woman* painting by the young Toronto artist Michael Snow and a colorful abstract work by the better-known Jack Bush. I did not have a very high opinion of either work based in part on having bought into the prevailing complex of cultural inferiority then rife in Canada. The highest encomium Canadian critics allowed their art, literature, and theater was to say that it was almost as good as in London or New York.

I later changed my mind about Snow, who by 1962 had moved to New York and was expanding his repertoire beyond painting. I remained cool to Bush. I had been introduced to postwar abstract art when Mike O'Ferrall and I saw *The New American Painting* exhibit in 1959 at the Tate Gallery. I fell completely under the spell of works by Jackson Pollock, Mark Rothko, Franz Kline, Philip Guston, and the whole pantheon of "action painters" championed by Alfred Barr, the director of the Museum of Modern Art in New York and the high

priest of modernism who organized the exhibition. The exhibition also made an impression on Mike. After leaving school we stayed in touch by mail for a few years as I went west to the Americas and he east to Asia; we eventually lost touch with each other until serendipity brought us together over forty years later and I visited him and his family in Perth, where he had become the distinguished curator of aboriginal art at the Art Gallery of Western Australia.

While not hostile to modern art, Mr. Kerr had restricted our outings to the Tate and the National Gallery, or else I might have visited the Institute of Contemporary Art (ICA) which exhibited the newly formed collection of E.J. "Ted" Power in 1958. This included works by many of the artists in Barr's show the following year at the Tate, as well as European moderns like Jean Dubuffet and Antoni Tàpies. The landmark ICA exhibition was curated by an energetic young critic and curator, Lawrence Alloway, who was later credited with coining the term "Pop art." He and his wife, the painter Sylvia Sleigh, arrived in New York a year ahead of me.

I Don't Want No Education

With the penchant for reckless personal choices that I was yet to fully refine, I did not date young ladies from my freshman year as was expected of me but allowed myself to be beguiled by a senior, Shari, a leading light of the founding class of York University's existence. The daughter of a well-known author, she had impeccable left-of-center credentials and a dangerous smile. I was welcomed into her charmed circle of progressively minded seniors.

Halfway through the winter semester news reached the campus that a cozy deal was in the works between York's President Murray G. Ross and the local government to expand York into the country's

third largest university with over 50,000 students, which indeed it is today. This bombshell shocked the faculty and the graduating senior class. Shari and her gang were joined by the faculty at the barricades, and I was willingly co-opted. While Ms. Woo and Mr. Dauda kept sensibly out of the fray, I volunteered to be the token foreign student on the protest committee. My anti-establishment credentials were strong, including Aldermaston anti-nuclear weapons marches under the banner of the Chertsey Young Liberals League, and one arrest, with the mandatory police beating, at an anti-apartheid sit-in outside the South African Embassy.

As a gesture of solidarity I renounced my scholarship, sacrificing my remaining two years of free higher education. The seniors were sacrificing nothing since the faculty supported them sitting in protest rather than sitting finals and they graduated honorably with black armbands and white corsages. I sent a rude letter to President Ross which was answered by an appointment with the bursar, who said, "Apparently there has been a mistake with the terms of your scholarship, Michael." I assumed I was going to be expelled rather than allowed to resign. "We underestimated your cost of living. Going forward this will be increased by fifty dollars a month." A bribe. Rio Tinto must have had money to burn. Instead of negotiating for seventy-five dollars, I kept my feet planted firmly on high moral ground and abandoned my chances for a degree.

I have never regretted the decision. Arriving in New York when I did, in 1964, allowed me to be present at a cultural inflexion point that is still evident in the arts today. Plus, the curriculum at York bored me. My strongest subject was English literature, which I had started at the age of twelve and so was well acquainted with everything on York's three-year syllabus, from Beowulf to T.S. Eliot. Because President Ross was a sociologist, this discipline was emphasized at York and, ignorant as I was, I couldn't see the difference

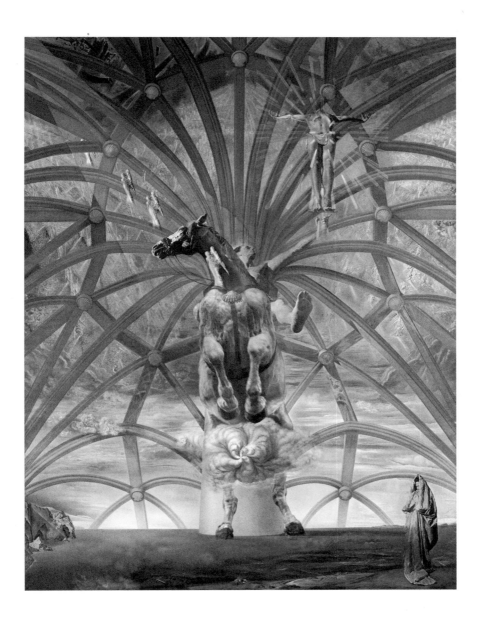

Salvador Dalí, *Saint James the Great*, 1957
Oil on canvas. 160.5 × 120 in. (407.7 × 304.8 cm)
Beaverbrook Art Gallery, Fredericton, New Brunswick, Canada

between sociology and what used to be called general knowledge. I was sorry to leave Luscombe's experimental theater company, but he was not about to pay me to stay. My other avocation, poetry, had found no foothold at York. If there was a poetry scene in Toronto, I had failed to find it, even if it had been sympathetic to my adolescent mash-up of Gerard Manley Hopkins and Ezra Pound. I had one poem included in the college magazine, but like Groucho I scorned the company for accepting me.

Coincidental with me joining her cause, Shari dumped me in favor of Gary Caldwell, the dashing all-Canadian president of the senior class seen welcoming me to Canada in Section 2 of the *Toronto Star*. They made a lovely couple at graduation. During an argument with my roommate Jeremy over his habit of storing dirty laundry in our oven, he chose to tell me that Shari's relationship with her graduation partner started when they were sophomores and I had merely been an intermission. Jeremy was happy to add that there had been other Garys before Gary. It had dawned on me then that what I had been led to believe was a mutual premiere was in fact my debut alone. Silly me. With my mother's flair for the dramatic, I swallowed a fistful of sedatives which resulted in a refreshing night's sleep. Treating this as a lesson I needed to learn, I stayed on good terms with Shari, who had dinner with me on a visit to New York a couple of years later.

Maritime Life and Art

I kept my open ticket back to England and was in no hurry to leave North America. My brother John was a train ride away. By then a full professor and sensibly married to his freshman sweetheart, Frankie, he generously invited me to stay with them, hoping to per-

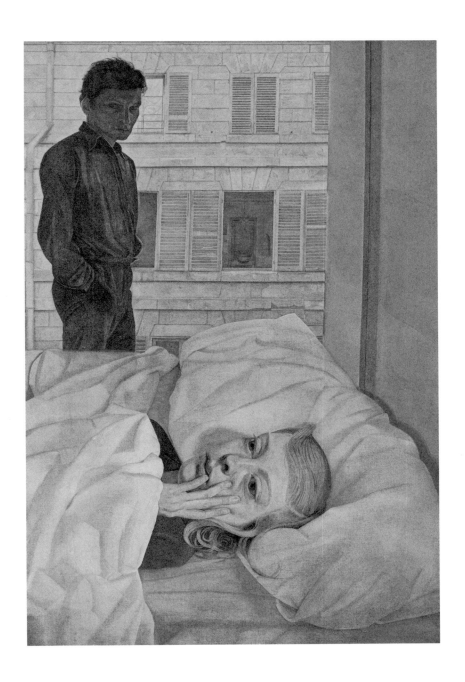

Lucian Freud, *Hotel Bedroom*, 1954
Oil on canvas. 39.6 × 29.9 in. (100.5 × 76 cm)
Beaverbrook Art Gallery, Fredericton, New Brunswick, Canada

suade me to enroll at their alma mater, the University of New Bruns-
wick. They had a spacious house fifteen minutes by foot from the
campus. My plan was to take a year off school, stay with them in
Fredericton a month or two, then head back to the UK, where I
would get a job and apply to colleges for the following fall. I plotted
my route home via Idlewild airport so I could spend a few days in
my cultural mecca, New York City.

For many teenagers of my generation, the arts and letters (and
music and film) of postwar austerity Britain held little attraction.
My existential inspiration came from across the English Channel in
the form of Alain Resnais's *Last Year at Marienbad* and Jean Gen-
et's *The Maids*. At the same time, Jack Kerouac's *On The Road* was
my new catechism and I was listening to the Modern Jazz Quartet,
Ornette Coleman, and Miles Davis. I devoured Alistair Cooke's *Let-
ter from America* in my father's newspaper, *The Daily Express*, in
which he covered everything from Senator McCarthy's witch hunts
to Pentecostal snake handling. I wanted to experience as much as
I could firsthand. I calculated the need for three hundred dollars to
follow my rent-free stay in Canada with up to two weeks in New
York and a tiny bit left for when I got back to London.

No one would have ever given me a job selling art if they had
witnessed my abject failure peddling the *Encyclopedia Britannica*
door-to-door, my first effort to raise cash. I trained with an ill-kempt,
diminutive, fifty-ish gentleman who looked like he might have done
hard time. His strategy was to target a working-class neighborhood
where housewives would be home with children, preferably between
the ages of five and ten. Without mentioning the total cost of all fif-
teen volumes, he persuaded mothers ambitious for their children's
future that a modest monthly payment of $10 guaranteed that lit-
tle Tom and Sarah would have a place at Harvard or McGill in a few
short years. He admitted to me it was bunkum and most people de-

faulted, but he got his commission upfront. He scored in seven out of ten visits, and I made no sales at all.

I turned to my painfully truth-telling college roommate Jeremy for help. His father invented a flameless heater for Bunsen burners and had a small factory in a desolate industrial park on the outskirts of Toronto. From June through August of 1963, I sat on a bench making dented cubes of fabric out of glass fiber and sewing the tops with electrical filament. The high point of the day was the noon arrival of the Jiffy truck bearing tea, coffee, and prepackaged sandwiches. All day tiny fragments of glass fiber attached themselves to my skin and I spent every evening soaking in the tub trying to remove them. By the end of the summer I had my three hundred dollars, and I took the Canadian Pacific from Union Station in Toronto through Ontario and Quebec, then into and out of New England to New Brunswick.

Fredericton was and still is a small, friendly town with a lot of snow. Most of my stay was spent in the university's large, quiet, wood-paneled library, writing the great Canadian novel in longhand. Just before eleven o'clock on Friday, November 22, 1963, a distraught female professor ran in and shouted, "He's been shot! Kennedy was shot!" My brother John, his seven-month pregnant wife, and I were glued to the flickering black-and-white television for the next four days, watching in horror when Jack Ruby shot Lee Harvey Oswald the following Sunday, and in overpowering sadness at the funeral procession that Monday. Although I eventually completed my novel, it was mercifully lost, uncopied, and unlamented. I doubt it contained even one very small pillar of wisdom.

In 1917, the Canadian press magnate Max Aitken was elevated to the peerage by his drinking buddy Winston Churchill and became Lord Beaverbrook. The scholarship won by my brother bore this name since "The Beaver," as he was known to his journalist em-

ployees, claimed Fredericton as his birthplace. Beaverbrook was an accomplished art collector. His taste was wide, but he had a decent eye and good advisors, including a curator of the Boston Museum of Fine Arts. When I wasn't scribbling in the library or shoveling snow, I could be found in his recently opened eponymous museum, The Beaverbrook Art Gallery, a five-minute walk from my brother's house.

There I renewed my acquaintance with works by the British Masters, Turner, John Constable, Sir Joshua Reynolds, and Thomas Gainsborough, as well as another new work by my then favorite modern master, Salvador Dalí. Twice the size of Kelvingrove's Christ, *Saint James the Great* is worth a visit to Fredericton, even in winter. Bursting with white-and-gold sunlight, Saint James the Great brandishes a huge crucifix while barely keeping his seat on a rearing white steed. Reversing the perspective of Glasgow's painting, Christ is now seen from below rather than from above. One other contemporary painting that grabbed my attention was *Hotel Bedroom*, in which the dark figure of a clothed man gazes down on the troubled face of a blonde woman in bed. It is in fact a self-portrait of the thirty-two-year-old artist Lucian Freud with his mistress, Lady Caroline Blackwood. I was not at all sure that I liked it, but it was disturbing enough to stay with me. Beaverbrook had bought it when it won second prize in the *Daily Express* 1955 Young Artists competition.

Young Man Goes South

Canadians enjoy telling new arrivals that the first winter feels mild, but because one's blood gets thinner the second hurts. In my case they were right. By the end of January 1964, Frankie had given birth to my niece Claire, and I had had enough of the frozen North. Thanks to my brother's hospitality I still had most of my three hundred dol-

lars, although that would shrink when changed into US currency. My brother drove me to the Maritime Bus Terminal in St. John and bid me a fond farewell as I bought a ticket for the twenty-hour drive to New York City, where I was determined to get my money's worth of jazz, poetry readings, and hopefully the top of the Empire State Building. Then back to London. In the words of my father's favorite poet Robert Burns:

The best laid schemes o' Mice an' Men
Gang aft agley (go often askew)

I stepped on the Trailways bus a skinny eighteen-year-old college dropout and wannabe actor who scribbled poems and had more than a passing interest in fine art. I had no idea that an intended nibble of the Big Apple would become the rest of my life.

Chapter Two

There are roughly three New Yorks. There is, first, the New York of the man or woman who was born here, who takes the city for granted and accepts its size and turbulence as natural and inevitable. Second there is the New York of the commuter—the city that is devoured by locusts each day and spat out each night. Third, there is the New York of the person who was born somewhere else and came to New York in quest of something. Of these three trembling cities the greatest is the last—the city of final destination, the city that is a goal. It is this third city that accounts for New York's high-strung disposition, its poetical deportment, its dedication to the arts, and its incomparable achievements. Commuters give the city its tidal restlessness; natives give it solidity; but the settlers give it passion.

— E.B. WHITE, *HERE IS NEW YORK*, 1949

Choosing

The following May, I elbowed my way into the Grotta Azzurra restaurant on Pearl Street on the border of Little Italy and Chinatown in New York City. I sat down at a round table crowded with twenty artists and their friends after the opening of an exhibition called *The Artists Collect* at the Richard Feigen Gallery on 24 East Eighty-First Street, where I was employed. Like all uptown openings it was on a Tuesday evening with a wet bar dispensing Ricard, the anise-flavored aperitif that the company supplied free to art galleries for these occasions. I had called the restaurant at about 7:30 p.m. when it appeared guests at the opening wanted to keep the party going downtown.

These *ad hoc* artists dinners were self-funded with cash thrown into a growing pile as the check passed from hand to hand. Most took place at inexpensive Chinese, Greek, or Italian restaurants with the capacity to seat anywhere from fifteen to thirty at short notice. For the exhibition I had helped to borrow works of art owned by contemporary artists, many acquired from each other by swap or purchase. These included Jasper Johns, Roy Lichtenstein, Arman, Robert Rauschenberg, James Rosenquist, George Segal, Bob Indiana, Tom Wesselmann, and Christo. Many of them were at the table. A thirty-something man with a crooked smile wearing what looked suspiciously like a silver-gray wig came up beside me.

"Can I sit next to you? I'm Andy, what's your name?"

History caricatures Warhol as a faux-naïf given to oracular pronouncements. The man I knew for twenty-three years was a talkative, opinionated, curious, energetic workaholic, characteristics shared by many artists.

"Of course, sit down," I said, and introduced myself. "I'm a friend

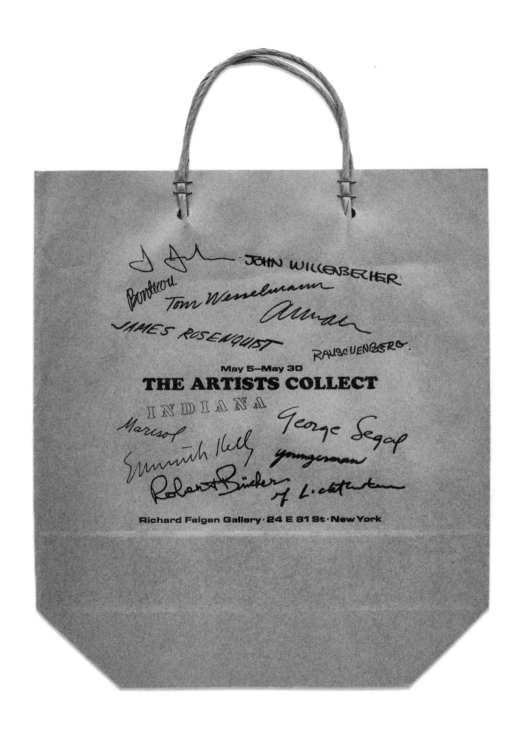

Shopping bag mailer for *The Artists Collect* exhibition,
Richard Feigen Gallery, 1964. Author's collection

of Gerard's. He and I read poetry together." Gerard Malanga was Andy's assistant.

"Oh, gee, you know Gerard?"

I told him Gerard and I had swapped poems at a reading because he wanted to hear his with a British accent and of course I wanted to hear mine in his distinctive New York voice. I told him I had seen his recent exhibition of Campbell's Soup boxes and asked him what he was working on, but he wasn't interested in talking about art.

"Oh, I've stopped painting," he said quietly, looking around. "I got a new camera and from now on I'm just gonna make movies." He paused. "Hollywood movies." Or perhaps he said, "Holly Wood-lawn movies."

I had heard about his infamous experimental movies like *Blow Job* (1964), but he made it clear he was embarking on a career making narrative films. He wanted to know what kind of a story I thought would make a good movie, and somehow it surfaced that we had both been raised Catholic.

"Perhaps a scene in a confessional?" I suggested.

"Oh yeah, like the Pope hearing Baby Jane's confession, or Edie's."

Intrigued as I was by Andy, I did not neglect the young lady named Loretta seated on my left. I had met her at the opening and boldly invited her to be my dinner date. Dark-haired, pretty, and engagingly gap-toothed with a wide-brimmed purple hat, she was more enigmatic than Warhol and would not tell me much about herself, but she smiled a lot, so I fancied my chances. I juggled the two of them until it was time to leave. And choose.

"Come back with me, I'm having some friends over," Andy said quietly in one ear.

"Shall we go somewhere else for a drink?" Loretta said, less quietly, in the other.

Long story short, Loretta lived with me for a year then swapped

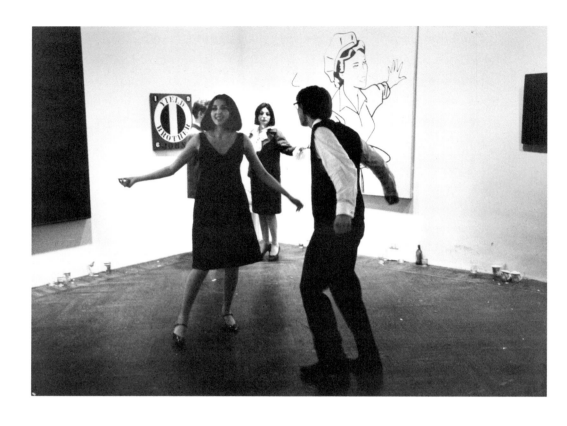

Opening party for *The Artists Collect* exhibition,
showing the author dancing with Sylvia Castro-Cid

me for a man who took her to Ibiza. Andy and I were friends until he died.

Across the table and next to the dashing poet Frank O'Hara was the gruffly sardonic Kynaston McShine, the up-and-coming Trinidadian curator at the Jewish Museum. Next to him was the Nefertiti-like Venezuelan sculptor Marisol in earnest conversation with two of the artists represented by the Feigen Gallery, the Chilean kinetic art pioneer Enrique Castro-Cid and rising young sculptor John Willenbecher. Enrique was boisterous and boyish but also a keen follower of mathematical philosopher Norbert Wiener. John, formerly an art historian before turning to make beautifully enigmatic box-like constructions, retained a studious air. Others at the table included Fluxus and Pop pioneer Al Hansen, whose collages of Hershey wrappers were in high demand, and Castro-Cid's striking wife, Sylvia, who had just appeared on the cover of *Harper's Bazaar*, photographed by Richard Avedon.

All belonged to the small community of artists and their friends who made up the New York City art world in 1964, a far cry from the monetized, high-stakes glamor swamp it would morph into in the twenty-first century. Back then, the goal for an artist was an exhibition at Sidney Janis or Marlborough or Betty Parsons on Fifty-Seventh Street, or Leo Castelli, Jill Kornblee, Robert Elkon, or Richard Feigen, all on Upper Madison Avenue. If you survived the barbs of *New York Times* reviewer John Canaday and your dealer sold three or four works, you could pay the rent; if you had two or three good shows in a row, you could buy your own loft. That was success.

How did I find myself working in a smart Upper East Side gallery for the fantastic salary of fifty dollars a week? Cash. My rent was only ten dollars. Rags to riches in barely three months!

Arrival and Arrest

I was apprehended a little over an hour after I got off the Trailways bus from Canada. I had plotted my arrival carefully, consulting street and subway maps of New York City. I disembarked at Port Authority Bus Terminal on Forty-Second Street and Eighth Avenue, purchased a fifteen-cent subway token, and took the IND subway one station downtown to Thirty-Fourth Street. I checked into the Sloane House YMCA and walked back up to Times Square.

"I'm home," I said to myself, taking in the bustle and noise and looking up at the glowing neon signs and giant billboards that reminded me of Piccadilly Circus and which Toronto had so sadly lacked. I saw something in a dusty bookstore window that I had to have. When I left the store, two men grabbed me and shoved me into the dark entrance alley of the Times Square Bowling Lanes beneath the smoke-billowing billboard for Camel cigarettes.

"Where are the pictures, son," growled a lean man with a crewcut. "Let's see the pictures." His shorter and beefier companion signaled to the driver of a car idling at the curb.

A badge was flashed. Bewildered, I was bundled into the back of the car. As we drove off one of the policemen grabbed my first purchase in America, a paper bound copy of *Finnegans Wake*. Rifling through the pages he asked me again for pictures. "You got photos?"

The unmarked police car had no destination. We drove around Times Square. Frustrated that James Joyce's novel was not illustrated, the thinner cop let slip the words "dirty pictures," and it finally dawned on me why the sleepy clerk at the counter of the sparsely stocked bookstore had seemed puzzled that I had wanted to actually buy a book in the window. Behind him there had been a curtain which presumably led to an inner sanctum of "adult" literature.

I never found out how old one had to be to buy smut in 1964, but

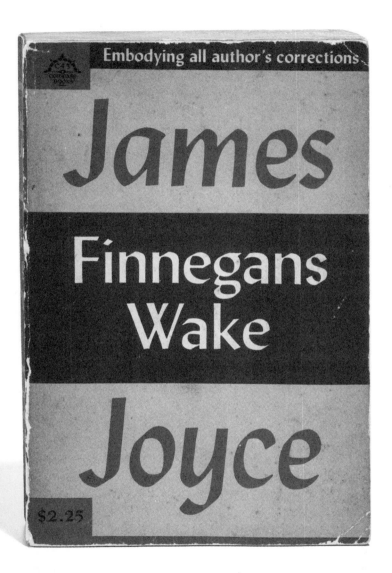

The author's copy of *Finnegans Wake* by James Joyce,
purchased February 1964

I looked young to these policemen. When it became apparent that I was eighteen, had no photos, and was in fact a very recently arrived tourist, my captors became friendly and solicitous.

"Where are you staying, kid?" the beefy one asked.

"The Y on West Thirty-Fourth Street."

"You can't stay there!" He looked horrified.

"Why not?"

"It's full of homos."

This fact was not unknown to me, and indeed, I had taken the precaution of barricading my door with the dresser before I unpacked my few belongings. Same-sex boarding schools are excellent places to learn about same-sex relationships, and I was not surprised when more than one young Christian man signaled his interest in showing me a good time.

Rather than debate the practice, at the time illegal, I muttered to my new undercover friends that I was only booked for two nights. By now they had returned to the spot where I'd been picked up, and as they let me out of the car, they became positively avuncular.

"Enjoy New York, son, but be careful," said the tall cop.

"Word of advice," said the short one. "So long as you're here, never go below Forty-Second Street."

"Absolutely!" I replied, relieved that I was free to go. However, I had but one address in my pocket and that was on Second Street near First Avenue, well below Forty-Second Street. I had promised my mother to visit her new husband's daughter.

Finding a Pad

After I left for Canada, my mother married Sam Collins, a mild-mannered London tailor whose only daughter was living in New York

City with a New York University graduate student and their one-year-old child. In due course my mother would discover that Sam, at first described to me glowingly as totally unlike my father, shared with him one fatal flaw—he was a man. But these were the halcyon days of their marriage. When I wrote to my mother that I would be in New York, she urged me to visit Paula Collins.

That first full day I spent in the city, I walked from the Y on Thirty-Fourth Street to Paula's address on Second Street. I routed myself through Greenwich Village, about which I had read so much. On Bleecker Street two teenage girls giggled, pointed at me and one shouted, "Beetle!" which left me utterly baffled. While in Canada, I was unaware that a Fab Four from Liverpool had become a cultural phenomenon and that my standard British school boy–length hair mimicked their instantly famous and recognizable mop tops.

Manhattan more than fulfilled my expectations, particularly when I reached the Lower East Side with its Ukrainian churches, synagogues, and Polish butcher shops. There were no traces of the young white dopers and dropouts that were about to stake a claim. Except perhaps for Paula's husband Rick, who had interrupted his studies at NYU to work as a campus messenger. They lived four flights up a narrow staircase in a three-room, cold-water railroad apartment. A countertop in the kitchen concealed the bathtub. Paula greeted me warmly, mewling babe in her arms.

Saddled with a morose husband, colicky baby, squalid home, and student debt, she could well have been the inspiration for Eric Idle's immortal ode "Always Look on the Bright Side of Life." She took to me like a long-lost sibling and set about helping me find a place to stay.

"And what about a job?" she said.

"I'm only here for two weeks," I replied.

"That's what *I* said. Now look at me!"

When the Trailways bus had stopped briefly at the border between Canada and the United States, a uniformed agent had swung quickly through the aisle asking, "Where do you live?" I had been coached that I should say truthfully but misleadingly "Fredericton" with as much of a Canadian accent as I could muster. Passports were not requested.

"Don't I need a visa or some kind of papers to get a job?"

"You just need a green card," said Paula. "Easy to get if you're from England. I have one. It means you are a legal permanent resident. You can get a job, pay taxes, do anything except vote."

I had been in the city a little over twenty-four hours and was already making plans to stay. After a cup of strong English tea, the baby deposited in a decrepit playpen, and Rick off to work, Paula and I placed an ad in the *New York Times* classifieds using as few words as my meager budget would allow: "British Boy Will Do Anything For Work" with Paula's telephone number. It ran the following Friday. Neither of us thought the statement suggestive. The respondents were all male and many hung up when they heard Paula's voice. She was discreet enough not to detail exactly what kind of work was offered.

I had better luck finding a place to bunk. A visitor from upstairs dropped in while we were having tea. Barbara was graceful and tall with very long, dark hair. She told me her sister Sarah lived in a student residence on West 88th Street and Amsterdam, and there were often cheap rooms available.

I set off again, walking to the Upper West Side. While my mother had urged me to visit Paula, my father wrote that I should stay at the Friar's Club because they had a reciprocal agreement with his own Press Club in London. "Just mention my name." With nothing to lose I made a detour to East Fifty-Fifth Street. Before I could even

utter his name, I was treated to a bum's rush almost enjoyable for its level of theatrical hauteur.

I moved in with Sarah. The bed took up most of her small room. Somehow, we managed. Eighteen, she had a job as a secretary while taking evening classes at Hunter College. Her passions at the time were Zionism and British rock bands. My longish hair ticked the latter box, I couldn't help with the former. The so-called student residence was a cross between a college dorm and a flophouse. Unaffiliated with any seat of learning, the rent of ten dollars per room per week was collected in cash on Fridays by a stocky, short-necked gentleman in a black suit who drove a Cadillac. There were five floors, each with eight rooms, two communal bathrooms, and a kitchen. Within a week the room opposite Sarah's became available and I took it. The smell of eight layers of lead paint baked by a hissing radiator is both unforgettable and not entirely unpleasant. Sarah and I became a couple, possibly a triple, for a few months. At times she appeared forgetful about mutually experienced recent events. I later discovered that she had an identical twin sister.

It was easy to make friends in that building. Nobody appeared to be a full-time student or even meaningfully employed, most were just scraping by. All of us twenty-something except for Sam, a smooth-faced young man who I thought was about sixteen but who turned out to be thirty-four and not a man. The major domo of this motley resident body was a dour, close-cropped fellow in a tattered check jacket who was charged by the shady landlord with keeping order, an impossible task. The most popular tenant was Charlie, monosyllabic and pasty-faced, whose room resembled a chemistry laboratory and who charged modestly for the hallucinogenic results of his constant experimentation.

Gift from a School Friend

The stoop was our common living room, and I adapted very quickly to stoop culture, where friendships flourished, nickel bags changed hands, and romances faded as quickly as they bloomed. For a few months I had a stoop-only dalliance with a young lady who was Patty Duke's stand-in on *The Patty Duke Show*, which meant little to me at the time since I didn't have a television. She lived with her actor dad in a brownstone in the low nineties between Broadway and West End, and we would alternate between her stoop and mine.

One day I came home to find three building buddies out on the stoop grinning broadly with faraway looks in their eyes.

"What's up?" I asked.

"You have a visitor," said Sam. "He's in your room. He brought you some stuff and he's been distributing it . . ."

"It's dynamite," chimed in Charlie, the man of few words.

Mystified, I made my way upstairs, noting the interestingly pungent odor permeating the corridor that got stronger as I approached my room. Sitting on my bed was a thin, young man with limpid brown eyes and shoulder-length black hair wearing what appeared to be white linen pajamas. He had a beatific smile.

"My name is Juan," he said. "I just arrived from India. Mike gave me your address. Mike O'Ferrall." Indeed, the most recent letter from Mike had been postmarked Delhi.

"What's that smell?"

"Ganja," said Juan. "Very good, from Mike." He proceeded to hand me a thick sausage of sticky, dark-brown hashish wrapped in tinfoil.

Juan had been repatriated by US authorities in India and deposited at Kennedy Airport. He was making his way home to Belen, New Mexico. He had no money and no luggage.

"How did you get this through customs?" I asked. Juan pointed down to where I hoped his billowy pants had pockets.

By then I had ditched the Catholic dogma of my childhood, but the combination of a Jesus-like youth appearing in my room on his way home to Belen (Spanish for Bethlehem), doing a loaves-and-fishes act on my friends and neighbors with a stick of hash was a boat-rocking spiritual manifestation. This when Liberace was the man in America with the longest hair and four years before the Beatles journeyed to India. With half the tenants in the building stoned, we were happy to pitch in and spot Juan for the Greyhound bus to Albuquerque.

Reading Out Loud

My gods actually walked the earth, and I could afford to meet them. For a fifty-cent bottle of beer I heard Charles Mingus play two sets at the Five Spot on St. Mark's Place, marveling at the audience of stoned, white college boys oblivious to his muttered insults. And for a dollar fifty I squeezed into a second-floor room on West Fourth Street, sitting, literally, at the sandaled and not entirely clean feet of Allen Ginsberg, Peter Orlovsky, and LeRoi Jones. I fell into conversation with a lanky, bespectacled poet named Joel Oppenheimer, who told me where I could go to read my own poetry.

A couple of days later, I waited my turn at the Judson Memorial Church open readings and met young poets Anne Waldman, Diane di Prima, John Giorno, and Gerard Malanga. Soon I was regular at the Judson and at the boisterous gatherings on Gansevoort Pier, where men and women of all ages read their own or other people's poems. It was there I met Barbara Holland, then in her late thirties, who recited her own intense declamatory work from memory and

NEW YORK 1965

```
exitpush exitpush exitpush exitpush exitpush exitpush exitpush
exitpush exitpush exitpush exitpush exitpush exitpush exitpush
exitpush exitpush exitpush exitpush exitpush exitpush exitpush
exitpush exitpush exitpush exitpush exitpush exitpush exitpush
ExitPush ExitPush ExitPush ExitPush ExitPush ExitPush ExitPush
ExitPush ExitPush ExitPush ExitPush ExitPush ExitPush ExitPush
ExitPush ExitPush ExitPush ExitPush ExitPush ExitPush ExitPush
EXITPUSH EXITPUSH EXITPUSH EXITPUSH EXITPUSH EXITPUSH EXITPUSH
EXITPUSH EXITPUSH EXITPUSH EXITPUSH EXITPUSH EXITPUSH EXITPUSH
EXITPUSH EXITPUSH EXITPUSH EXITPUSH EXITPUSH EXITPUSH EXITPUSH
EXITPUSH EXITPUSH EXITPUSH EXITPUSH EXITPUSH eatkill EXITPUSH
No Loiterig.
```

Michael Findlay

POEM

```
Medicated shave with each thrust.
Her hands held high in prayer.
Hauled.             the couch.
Now every day the waves rise higher each tilt presumes to hael.
Bloss.              rare world achieving receptical of sexon.
Listen              buddy boy                        soaps.
Frequently spurning dead on the wold and forever sold breasts on.
Rock on George one time for me.
I feel fine.                honey don't                    sunday
dumdumdumdumdumdumdumdumdumdumdumdumdumdumdumdumdumdumdumdumdoo
twentyoriginalflashbackhitsinonegroovyalbum
postage and              handling                          baby
                                                          babey
baibee
how many if one were to erupt    leaving you sir standing dumb
hot sox
ofra often for getting funtast  K    K     K     K
                            K    K    K
                                      Krazy........christ
in other foosnackers up
sister and brother and mother came came as soon as the news was a.
```

Michael Findlay

36

was kind enough to read and comment on my work. Almost every Sunday I read at the West End Bar on Broadway and 114th Street. Jazz was the main attraction, but during the breaks anyone could sign up for ten or fifteen minutes. I enjoyed the music more than the sound of my own voice. I can claim that I shared the bill with great experimental jazz musicians like Sun Ra and his Arkestra and saxophonist Jimmy Giuffre.

My work became less digressive and allusive and much simpler. I formed blocks of the same repeated word which I learned was called concrete poetry. Much later I saw Carl Andre's poetry from 1964 and mine was very similar. Something in the air? Surrealism addict, art dealer, and publisher Timothy Baum included two of my poems in the second issue of his magazine *Nadada*.

On Broadway, Almost

I stopped worrying about getting a job. Instead, I cashed my ticket home for two hundred dollars, and I still had over a hundred from the previous summer's work. I was flush. Soon I had New York down pat. The streets went up and down and across and everything cost fifteen cents. Manhattan was my oyster. Quite literally, because my first favorite hangout was Grant's on Forty-Second Street and Sixth Avenue. Vast and open to the street it boasted two long counters facing each other, dotted with barstools. On the right, liquor and all brands of beer at fifteen cents a glass, on the left, hot dogs and hamburgers also fifteen cents, two for a quarter. In the rear a bearded giant in a leather apron stood behind a huge barrel of oysters, shucking them with breezy nonchalance as he chatted with customers. Grant's was the epitome of economic and racial diversity. Before Times Square sadly fell to its lewd low in the 1970s, then rose again,

just as sadly, to become family-friendly, it was the nexus of the have-a-lots and the homeless. High-spirited sports fans ejected from Jack Dempsey's bar mingled at Grant's with late-night refugees from the exclusive university clubs in the forties; together they eyed appealing women, some with social standing and others of the street, as well as gender-fluid flotsam and jetsam from worlds literary and artistic. There was always a spare barstool for a not-quite penniless poet or actor-to-be to perch on and soak up the high-toned squalor.

Still convinced I was born to tread the boards, I recklessly invested most of my savings in a semester of evening classes with Mr. Traficante at the American Academy of Dramatic Arts on Madison and Thirtieth Street, where it still stands today. The attribute I expected to sweep me to success, my smart British accent, failed me. It failed me miserably and execrably. I had a vastly inflated estimate of the value of my diction, based almost entirely on American girls giggling when I said the word "chocolate."

My springboard to fame, or so I thought, was *Orpheus Descending* by Tennessee Williams. I played the Orphean hero Val, a roaming singer in a snakeskin jacket. Cliff Robertson did a credible job in the original production. My final exam performance scene was with the wild and brazen town exhibitionist, Carol Cutrere, who was played by a French-Greek student named Giselle. Giselle lived with her sister, Maria, a model and former Miss Greece, in a smart apartment on West Seventy-Ninth Street, and it seemed only appropriate to rehearse in the comfort of her home, and, for the sake of realism, often in her bedroom. Older and wiser than me, Giselle was an excellent pianist and cook who happened to mention, once things were well under way, that the Panamanian ambassador to the United Nations at the time was also her estranged husband. Sister Maria, who amused herself and entertained others by walk-

ing around the apartment in her underwear, had divorced a Jaguar car dealer from California and was looking forward to marrying an Irishman who bred racehorses, or so she said. In hindsight, it is possible that they were self-employed in the home-and-away entertainment business, and not even sisters.

Giselle and I were spectacularly miscast. Why did our coach Mr. Traficante want to torpedo my career? Was he jealous of me? In Noël Coward's *Private Lives*, we would have had five curtain calls. No matter how much we rehearsed, in or out of the bedroom, neither of us was remotely capable of achieving anything close to the pitch and cadence of Southern speech essential to the genius of Tennessee Williams's dialogue. At our graduating performance, the glare of the footlights spared us from the sight of teachers and fellow students choking with laughter, some even stuffing their mouths with handkerchiefs. So ended my theatrical career as well as my homework with Giselle.

I Land a Job

Funds were getting low. Persisting with the illusion that I had a salable speaking voice, I tried getting work recording books at the Lighthouse for the Blind, but strangely they only wanted American-accented readers. My goal was to find work that was not too taxing but would keep me in modest circumstances until I published my first slim volume of verse. I felt sure I would make an excellent bookstore clerk and popped my head into Brentano's, Scribner's, and Doubleday but none were hiring.

I was broke and homesick for overcooked meat and undercooked potatoes, so I readily accepted Paula's invitation for dinner and again

ran into her neighbor Barbara, who bore me no malice for dallying with one (or perhaps both) of her twin sisters. Instead, she set my compass for the rest of my life:

"Michael don't worry, you can get a job in an art gallery. You just sit at a desk by the door and smile at people when they come in."

Perfect. Why didn't I think of that? To my shame I had been in New York for two months and had yet to visit a museum. I had filled days and evenings with music and theater and elbowed my way into poetry circles, but I had neglected art. No matter, right away I saw myself at a Marcel Breuer desk angled toward the large, glass street door of a grand emporium, discreetly fine-tuning yet another prize poem on my Olivetti Lettera 22 when the doorbell tinkles and I rise to open the door for an Audrey Hepburn lookalike who greets me with a shy smile as I guide her into the gallery. Fade.

Putting this plan in motion meant navigating through Central Park from my Upper West Side haven of friendly bodegas to the uncharted and possibly less friendly Upper East Side. On my departure from England some eighteen months earlier, my father had taken me to the head cutter at Daks Menswear where I was measured for a dark-gray three-piece suit ("Since you are going to Canada, would you prefer a North American cut, sir?"). Now well-worn, the trousers badly needed pressing but none of my fellow tenants possessed an iron. I smartly marched from Amsterdam Avenue to Central Park West, then two blocks south to Eighty-Sixth Street. I made my way through the park just north of the transverse, getting a first glimpse of what would become my private tutor, the Metropolitan Museum of Art. When I crossed Fifth Avenue fate determined I enter Eighty-First Street. On the south side, close to the corner of Madison Avenue, stood an elegant five-story limestone mansion. Next to the iron-grilled front door, at the top of five wide stone steps,

was a sign: Richard Feigen Gallery. This was the first art gallery I ever set foot in and the one in which I would learn the profession that has kept three fairly hot meals a day on my table and many different roofs over my head for, so far, sixty years.

The gallery was on the second floor, reached by a wide staircase winding up from the marbled lobby. The gallery door was open, and I walked into a narrow corridor. I could see into an office. The large room to my right was filled with dark-bronze vertical objects that appeared to be made from, or were simulating, plumbing fixtures. A small sign told me they were sculptures by Anthony Padovano.

"Can I help you?" A bright-eyed young woman appeared, smiling. She was trimly dressed in a fancy white blouse and short black skirt, her dark-brown hair tied back in a black velvet bow.

"I'm looking for a job." I explained that I had just arrived from Canada and lived nearby. We chatted briefly and she mentioned someone had just left their employment, "but Mr. Feigen is not here today. Can you give me a call tomorrow? He may want to see you."

She told me her name, Sandra Leonard, and gave me a business card. I left elated, not at the possibility of working in that gallery but at how easy it had been to get my foot in the door. I was sure to be employed by lunchtime.

My ignoble exit from the Friar's Club was nothing compared to the disdain that greeted my attempts to enter, let alone penetrate, the many galleries that flanked Madison Avenue between Seventy-Ninth and Fifty-Seventh Street. It slowly dawned on me that the job I wanted at the desk by the door was held by the person at the desk by the door who didn't want to let me in to apply for their job.

The next day I called Miss Leonard from the telephone booth on Broadway and Eighty-Sixth Street; half an hour later I was sitting in the private rear space of the Richard Feigen Gallery opposite the

owner, a tall, earnest young man dressed in a gray suit very much like my own except clean and pressed. He was enthusiastically telling me all about himself as he absently stroked his chin.

"I sold my seat on the stock exchange and started a gallery in Chicago in 1957 and I have another one with a partner in Los Angeles. I started this one two years ago with David Herbert who was running it but things didn't work out and so he's just left and I've moved here full time."

He spoke fast and I was trying to imagine what a stock exchange chair actually looked like when I noticed the room was stacked with black-and-white paintings of the same moon-faced man. As Mr. Feigen was talking, a short, dark-haired young man in a blazer came in to get one of the paintings. As he carried it out, I glimpsed the letters "KRAA" on the back.

"I'm keeping some of the artists that David Herbert showed but the next exhibition is by an artist I found." He gestured toward the many moon men and paused.

"Are these by Kraa?" I asked, a wild guess.

"Do you know her work?" he asked eagerly. Taking my mumbled reply for assent he gave me a lengthy spiel about the young woman who was until recently a student at Rutgers University in New Jersey. One of her teachers was Roy Lichtenstein, who showed with Feigen's friend and gallery neighbor Leo Castelli. Lichtenstein had suggested Feigen look at his former student's work, and Feigen believed Roy would draw a lot of attention to Kraa's exhibition.

My improvised deception aside, what clinched my employment was when I mentioned my brief flirtation with higher education in Toronto. Feigen asked me if I knew any Canadian art collectors.

"Only Ayala and Sam Zacks," I said, explaining that I had visited them at home and borrowed works for the walls of my college. These

proved to be the magic words. I was hired on the spot and started the next day.

Richard Feigen was the boss, Sandy Leonard, with an undergraduate degree from Sarah Lawrence and a master's in art history from Harvard, was the manager and academic brains of the operation. The fellow in a blazer who had unwittingly helped me was Jaime Andrade, the gallery art handler and former close friend of former partner David Herbert.

Feigen gave solo and group exhibitions to what we now call emerging artists but were then simply called young artists. The artists in his gallery included a group of talented British painters and sculptors: Allen Jones, Phillip King, Gerald Laing, Bridget Riley, Richard Smith, and William Tucker, as well as Americans Charles Hinman, John Willenbecher, and Chilean Enrique Castro-Cid. All had studios in Manhattan except King and Riley, who visited from England when their work was shown. It was standard practice for artists to have two-year contracts assuring them of a monthly stipend against sales.

The gallery artists were supported by a backroom business buying and selling works of art either by artists no longer living or, if living, pre-owned works that had been long out of their studios. The term "secondary market" had not been coined. Anyone in the art world using the word "market" would have been directed to Gristede's grocery store on Lexington Avenue. The first time I looked through the gallery racks I saw paintings by Claude Monet, Camille Pissarro, Max Beckmann, Yves Tanguy, René Magritte, and Jean Dubuffet, as well as drawings by Arshile Gorky and bronzes by Max Ernst.

Since there was no front desk, I left my Olivetti at home. My first duties were clerical and managerial. I answered the phone, wrote letters, kept track of the sales and stipends. I became a go-to per-

son for the artists. I organized the shipping and photography and enjoyed helping Jaime install and light the exhibitions. I was very proud of my idea to replace the ugly steel hanging rods with transparent 60-pound fishing gut from Abercrombie and Fitch.

The handful of collectors on the search for emerging artists liked to steal a march on each other and see our exhibitions before their Tuesday openings. Richard Feigen worked hard to get them in early and sell one or two works before the opening. This meant I was out and about in the galleries finishing the installation when these buyers came in; like the local gallery owners, they were happy to talk to me and I was smart enough to mostly listen. And learn.

My on-the-job education included frequent visits to the nearby contemporary galleries showing work by artists I quickly got to know because they attended their friends' openings at the Feigen Gallery. In the spring of 1964, Upper Madison Avenue was the vortex of Pop art. Professional wrestler and playwright Rosalyn Drexler was showing her painted-over movie stills at Kornblee Gallery. John Chamberlain's delicately balanced automobile sculptures were on display at Castelli, while at Cordier & Ekstrom I was awed by Richard Lindner's fierce female giants and amused by Andy Warhol's neat rows of Campbell's Soup and Heinz Ketchup boxes stacked as if in a supermarket storeroom. Some art lovers on their way home from midtown offices, tripped over these at the crowded opening. I was more impressed by the exhibition that followed at the Stable, Robert Indiana's brightly colored emblematic commands to "Eat" and "Die" ("Love" was yet to come).

Feigen's private sale business often involved purchases and consignments between dealers; I was equally involved with this, which took me to the gallery of the passionately knowledgeable Stephen Hahn, who was happy to chat and show me a new treasure he had

acquired by Miró or Matisse, or to take me to visit Eleanore Saidenberg, Picasso's American dealer, where one might hear an impromptu cello concerto by her husband Danny.

Collecting Art BC

Before Consultants (BC) major collectors wore out their own shoe leather regardless of rank and wealth. Key among those frequently coming in to chat and often to buy were the indefatigable art book publisher Harry Abrams, who might be persuaded to publish a monograph on a particular artist in exchange for a major work; Harry's friend and fellow publisher, John Powers, with his smart and beautiful young wife, Kimiko; brash Bob Scull and his well-coiffed, rail-thin, socially ambitious wife, Ethel; the erudite and elegant Janklows, Mort and Linda; the quiet Yale alumnus, Richard Brown Baker, Pop art collector *par excellence*; and the man with the biggest appetite, Joseph Herman Hirshhorn, who made up in bombast and energy what he lacked in height. If Joe liked an artist's work, two were never enough.

When it came to collector couples, the husband did not always lead the charge. Hunting for new artists, the stylish Holly Solomon was always, in every sense of the word, ahead of Horace, which was equally true of the amusing but no less discerning Elaine Dannheisser, who bravely adopted silver hot pants relatively late in life. Her bill-paying husband, Werner, would sit as patiently when she went shopping for art as he did when she went to Bergdorf's. Armand and Celeste Bartos were always quick out of the gate to see an artist's first exhibition, as was Freddie Eberstadt and his bride, Isabel. A frequent drop-in was Feigen's Harvard Business School class-

mate, John L. Loeb Jr., whose father was a Museum of Modern Art trustee.

If these were the hardy annuals, there were many equally colorful collectors who visited regularly like the affable Vera List, poet and architect Hanford Yang, and the very well-informed decorator Renny Saltzman. Shy but perceptive Norman Joondeph only bought black-and-white works. Courtly Count Giuseppe Panza di Biumo was one of the first major European patrons of postwar American art and a frequent visitor.

Not only did I benefit from being able to talk to clients when they visited, there was really only one office shared by Richard, Sandy, and me, and "tele-Feigen," as he was known to many, conducted most business by phone, loudly. I was privy to the hyperbolic wheeling and dealing at which he excelled. Nothing sacred, nothing private. Deals with collectors, deals with artists, and deals with dealers, promises made and unmade, payments made and payments deferred, I saw and heard it all.

What did art cost then? Richard Feigen sold Monets to GEICO Chairman David Lloyd Kreeger and his wife, Carmen, in the range of $100,000, while works by gallery artists in the front room exhibitions were priced from $800 to $10,000. Paintings by more established artists like Jasper Johns at Leo Castelli could be up to $20,000. A very good Jackson Pollock was $50,000. This was serious money. Proud as he was of his Harvard Business School degree, I never heard Richard Feigen sell a work of art with a promise of investment. The postwar generation of collectors active in New York in the 1960s and 1970s were paying what they could afford to buy, what they wanted to own and keep. This applied equally to those with traditional tastes and collected Pissarro and Cézanne, as it did to those who collected Pop art.

Compared to today's cutthroat competitiveness, there was a high

degree of collegiality and friendship between art dealers back then. They shared clients and honored each other's relationships with artists. Expensive works of art were bought and sold and co-owned on the basis of a handshake, with an invoice that might take a week to get typed and a month to get paid. No contracts. No lawyers. No lawsuits.

Flushing, Queens

Feigen, now "Dick" to me, acquired for himself and sold to his clients the work of reclusive and eccentric assemblagist Joseph Cornell, who would occasionally arrive at the gallery unannounced with one of his glass-paned shadow boxes under his arm. Containing dime-store items that he organized into magical worlds, these were sought after by a small coterie of American collectors like Feigen's fellow Chicagoans, Edwin and Lindy Bergman. There were always one or two in the gallery that Richard had either purchased from Cornell or had on consignment. One of these was called *Cassiopeia*, containing a sun face, rods, a ball, and a wine glass which had become dislodged. As soon as he noticed this, Richard called Cornell and then said to me after he hung up, "I just got off the phone with Joseph and I want you to take this to him tomorrow morning at ten. He'll fix it while you wait."

I took the subway, the box in a shopping bag perched on my knees. Cornell lived in Flushing, Queens, with his mother and brother, Robert, who had cerebral palsy. At the time, John Willenbecher was preparing to have an exhibition at Feigen of his own but equally intriguing boxes. He knew Cornell and warned me that I should expect the visit to be a strange one.

"How so?"

"You'll see," he had said knowingly. "I can't wait to hear all about it."

Cornell greeted me at the door of a modest house on Utopia Parkway where he had spent his entire life. Stooped with white hair and the seamed features of an old sailor, he looked closer to eighty than sixty. Taking his box from me, we sat in silence opposite each other in his front room while he delicately removed the screws from the top. I had seen the Unisphere of the recently opened World's Fair from the subway train and attempted to make conversation about it. "I know," he said, without looking up. Then casually added, "I was at the last one." He made 1939 sound like the week before. In the Dutch Pavilion at that earlier World's Fair, Cornell had acquired the white clay pipes of which one was in the box in his hands. He deftly re-secured the wineglass, and, while replacing the box's lid, he seemed to take me in for the first time.

"Would you like to meet my mother and my brother, Robert?"

His mother was bustling and matronly. If Cornell looked older than his age, she looked young enough that they might have been mistaken for husband and wife. His (younger) brother smiled at me in a sunny room surrounded by an elaborate model railroad. He and Joseph were impressed that I recognized them as being manufactured by the English firm Hornby Dublo.

As I was leaving, Cornell showed me a faded photograph of a tow-haired boy I guessed to be about twelve.

"That's me," he said, enigmatically.

Cornell enjoyed the attention of pretty, young women, and in 1966 two bob-haired, short-skirted brunettes—my fiancée, Alex Malasko, and her friend, Galina Golikova—knocked on his door. He hired them on the spot as assistants. To his mother's dismay, he was in the habit of taking in young ladies like stray cats. Galina was the girlfriend and later the wife of the British artist Gerald Laing, whose

first show of skydivers and drag racers at the Feigen Gallery in 1964 had put him on the map. He and I had become firm friends by the time our respective partners went in secret to assist Cornell. We were amused when their brief internships abruptly ended as he developed an intense but platonic relationship with the Japanese artist Yayoi Kusama.

Some four years later, Richard received a call about me from Cornell.

"Well, what did he say?" I asked.

"He'd heard you and Alex were divorced and wanted to know if it was true. I told him it was and then he asked me for her telephone number."

Words

Within a year I had been promoted. Nineteen and I was making an astounding $75 a week with a business card bearing the self-invented title Director of Exhibitions. The first exhibition I organized (it would have been very pretentious then for a dealer to say they "curated" an exhibition) I called *Words*. The criteria was very simple: paintings by modern and contemporary artists from Magritte to Warhol that contained words. The first artist I approached was Ray Johnson, at the time widely known by the New York community of artists, less so by dealers and even less by museums and collectors. Thirty-eight in 1965, athletically built and bald with Nordic features, Ray had a disconcerting blue-eyed stare. He had attended Black Mountain College with Buckminster Fuller, John Cage, and Robert Rauschenberg, and in the 1950s he was the first American artist to use images of popular stars like Elvis Presley and James Dean. His work was filled with words as well as images, and I tried

WORDS

ENRIQUE CASTRO-CID
JOSEPH CORNELL
MARCEL DUCHAMP
OYVIND FAHLSTROM
ROBERT INDIANA
JASPER JOHNS
RAY JOHNSON
PAUL KLEE
ROY LICHTENSTEIN
ROBERT RAUSCHENBERG
PETER SAUL
RICHARD FEIGEN GALLERY KURT SCHWITTERS
NEW YORK OCTOBER ETC.

Ray Johnson advertisement for *Words* exhibition in *Artforum*, October 1967

to make a date to visit his studio. How naïve I was! He was called "New York's most famous unknown artist" not only because his work was as yet undiscovered by the public, but also because very little was known about his hermetic personal life. His address, well known to his New York Correspondance (sic) School contacts, was 176 Suffolk Street in the Lower East Side.

"Well, sure," he said when I called. "When?"

"How about Monday?"

"Could we make it Sunday?"

"Yes, what time?"

"Let me think about it."

The next day I received a page torn from the 1939 *Women's Almanac* with a photograph of Her Royal Highness Crown Princess Louise of Sweden, across which was typed:

```
Michael It is not possible to meet as we
planned next Sunday at 176 Suffolk but I
hope to see you to talk. I have no chairs.
Ray Johnson
```

This was followed shortly by a brief handwritten message:

Dear Michael Findlay - I do not have a studio.
Ray Johnson

Having led me on this merry chase, he became vital to the success of my show not only by lending his work but by approaching close friends like Jasper Johns and Bob Indiana to lend paintings and even design my advertisement in *Artforum*. I was proud of my first exhibition and not at all disappointed by faint praise from the *New York Times*:

"The show has sparkle, but it is not a serious investigation
and in no way justified the attention being given it one
day by some students who, taking notes, must have been
fulfilling a classroom assignment." — John Canaday,
"Art: Lures for the Connoisseur's Eye,"
The New York Times, October 21, 1967

Students taking notes? And me barely starting my learning curve.

Richard Feigen was a confirmed believer in Ray Johnson's genius, and in the same year as *Words*, persuaded him to exhibit in both his Chicago and New York galleries. My education got a boost when I worked with Ray installing his New York exhibitions. Most solo shows were simply called *New Work*, but Ray had a flair for showmanship and gave his exhibitions specific titles such as *A Lot of Shirley Temple Post Cards Show*. The words and images in these collages not only referenced "America's Little Darling," Shirley Temple, but Peaches Browning and Roscoe Arbuckle as well, both of whom scandalized the American public in the 1920s.

Ray Johnson's notoriety among artists was enhanced by his position as founder of the New York Correspondance School, which used the postal system to facilitate the exchange of ephemeral, visually witty texts that he would send to one individual with rubber-stamped instructions to "send to" another. This was a far-flung, ongoing network of evolving communications that was divorced from commercial considerations. Ray might find the address of a man named George Segal in Youngstown, Ohio, and send him an envelope containing a collage with instructions to send it to George Segal the actor, in Hollywood, or George Segal the sculptor, in New York. "Send to" instructions did not always include an address, so as a recipient one had to decide to send as instructed, send elsewhere with additional instructions, or simply keep. To this day I have mail from Ray

The author with Ray Johnson installing
A Lot of Shirley Temple Postcards exhibition, March 1968

still unopened. Yet. "Correspondance" was misspelled deliberately to invoke the "dance" orchestrated by Ray using the postal service as his platform. He was the progenitor of what is now called Mail Art.

Ray had a loyal sidekick who added to, rather than solved, the mystery of his private life. Her name was Toby Spiselman, a dark-haired, shorter female version of Ray. The first time I saw them together they materialized in front of my desk at Feigen, side by side, smiling, wearing jauntily angled navy-blue knit caps sporting identical toy sheriff's badges and buttoned navy-blue peacoats. My first thought was of Batman and Robin. Toby built computer systems for banks and had been one of the first female mathematicians hired by IBM. As Ray's alter ego she was part of his ongoing performance of his own life. At the opening of the Museum of Contemporary Art in Chicago, her simple black dress sported an original work of art labeled *"Dead Woodpecker on Board* courtesy Ray Johnson." The dead woodpecker was real.

Look, Meet, Learn

There is no better way to get to know a work of art than to catalog it. And I did this with Impressionist and modern works that came into the Feigen Gallery. This was part of my job. If it was a painting, I looked at it carefully from a reasonable distance, then very carefully up close. After taking it out of its frame, I measured it and noted where and how it was signed. I copied every text on the front or back of the work itself and on any labels on the wooden stretcher or on the back of the frame. Following that, a close surface examination with a magnifying glass to look for signs of paint loss or repair, and then, in the dark, further scrutiny with an ultra-violet light to look for signs of restoration. Then I looked it up in reference books

and exhibition catalogs at the Frick Art Reference Library on East Seventy-First Street.

On my way back from the Frick I might duck into the deli next to the Madison Pub on the corner of Madison Avenue and Seventy-Ninth Street and grab a roast beef on rye with pickle and a can of soda, then find a bench in front of what caught my fancy in the Impressionist galleries at the Metropolitan Museum. They used to be divided into cozy corners, almost like private rooms. There were very few visitors, and the guards were used to seeing me. For all practical purposes, Cézanne's *The Card Players* (1894–95) was mine for an hour.

Collectors, curators, critics, and other dealers came to the gallery to see shows as part of their daily routine, rarely making appointments. There were only three of us, so it often fell to me to meet and greet, particularly when it came to reviewers: Stuart Preston and John Canaday for the *New York Times*, neither of whom had much time for contemporary art; gossipy Emily Genauer for the *New York Post*; and the endearingly arch David Bourdon from *Life* who helped make Christo famous with full-page photographs of his wrapped buildings. The most feared on the circuit was the gruff and acerbic Donald Judd, writing for *Artnews*.

I had met many artists at the opening of the *Artists Collect* exhibition that preceded the dinner at Grotta Azzurra, including Jasper Johns, Robert Rauschenberg, Arman, Tom Wesselmann, and Roy Lichtenstein. It was a supportive and multi-generational community of artists that included some of those already in the pantheon, like Barnett Newman, a regular gallery-goer, friendly and garrulous, and Mark Rothko, who said less but gave every exhibition he visited slow and methodical attention. In time I got to know most of them well. James Rosenquist became a particularly close friend. One of the first conversations I had with him was about the monumental,

multi-paneled painting *F-111* (1964–65) that he was working on for his first show at Castelli the following year. Born in Grand Forks, North Dakota, and raised in Minnesota, Jim had the blond open features of his Swedish forbears and a manner engagingly direct about aspects of life that he approached in an oblique and novel way. Just as he juxtaposed images of the ordinary to make extraordinary impact in his work, so his verbal narratives frequently veered offtrack.

The Museum of Modern Art's senior curator, Dorothy Miller, tried to see every exhibition of new young artists; she was unfailingly nice to me and it was a privilege to answer her questions. She sometimes brought trustees like Lily Auchincloss and Eddie Warburg. Sam Hunter was an active client when he was buying for the Rose Art Gallery at Brandeis and a frequent visitor when he was director of the Jewish Museum. The rotund and jocular James Johnson Sweeney had retired from running the Guggenheim Museum but kept up with the latest shows.

One of my first areas of responsibility was to deal with the Art Lending Service at the Museum of Modern Art. Quaint as it may seem to us today, this allowed collectors who were indecisive or of modest means to take a work of art home for up to a year for twenty dollars a month, after which they could either return them or pay the balance of their cost to own them. This was organized and run by knowledgeable volunteers, all female, to whom I offered domestic-size works on paper under glass, such as a gouache by Pollock, a collage by Kurt Schwitters, or perhaps a pencil drawing by Agnes Martin. This helped people take the plunge in becoming collectors without spending a lot of money. There were no art fairs, and even if it meant taking a work off the market for a year with no guarantee of a sale, the pace of business was slow enough and the opportunity to make a new client strong enough that no one thought twice about helping MoMA's Art Lending Service.

The curator I learned the most from was Kynaston McShine, who made the rounds of all the galleries showing new work and was a regular at the Tuesday evening openings that would be coordinated between Leo Castelli, Richard Feigen, and Jill Kornblee, all within a five-minute walking distance. Kynaston didn't suffer fools at all and used his gruff wit to advantage, but he was a very loyal friend and a trailblazing curator that many artists have thanked for giving them early visibility. He spent a lot of time at Feigen when he was putting together the exhibition that would introduce the world to what is now generally referred to as Minimalism. This was *Primary Structures: Younger American and British Sculptors at the Jewish Museum* (1966). Five of the British artists exhibited at Feigen, and we wanted to make sure they were represented with the best possible works. These were David Hall, Phillip King, Gerald Laing, William Tucker, and Derrick Woodham.

McShine defined the Minimalist movement at its inception and articulated its parameters for the artists as well as the public. Woodham was just twenty-six and in the process of graduating from the Royal College of Art. Laing had turned to sculpture from painting less than two years earlier. Not all of the artists in the exhibition had galleries; Sol Lewitt had very recently been working at the Museum of Modern Art bookstore. Visiting studios and galleries, McShine saw the emergence of a new language being used in different ways by a new generation of artists. He made more than one oblique reference to me that it was an uphill fight convincing some of his colleagues and the museum trustees to support *Primary Structures*, which gave me a valuable understanding about how museums work. In the end his angels were Harry Abrams and Joe Hirshhorn, with a lot of help from visionaries Vera List, Ben Heller, and Harriet Mnuchin.

Although used only once in McShine's catalog essay, and not men-

tioned at all during the lively symposium I attended with panelists Donald Judd, Robert Morris, and Mark di Suvero, moderated by the critic Barbara Rose (at the time married to painter Frank Stella), the word "Minimalism" stuck. I soaked it all in like a sponge and felt very privileged to be included among the art crowd, artists, collectors, and critics who gathered at Kynaston's parties on Astor Place, with added but essential ingredients like poet John Ashberry, novelist Frederic Tuten, and other young curators like the iconoclastic yet cherubic Henry Geldzahler.

Henry dubbed me "the most mysterious young man in New York," which mystified me at the time, although it occurred to me later that the mystery, to Henry, was perhaps whether or not I was gay. I didn't lack for female companionship, my preference, but looking at photographs taken then I see a pale, thin, androgynous youth with hair longer than was yet fashionable, who, thanks to growing up with Quentin Crisp as a family friend, was comfortable in the company of gay men. But I was still naïve enough to be surprised when a married, socially prominent young collector living on Fifth Avenue just happened to run into me as I was coming home late one evening to Amsterdam and West Eighty-Eighth Street. Tie-less, he was lurking on the steps of my building, somewhat the worse for drink, and wanted to know if he could "come up for a chat." Sorry.

Shakers and Movers

I was used to talking to collectors when they visited our gallery exhibitions, but I had yet to be privy to what went on behind closed doors when Richard was selling backroom inventory.

"I'm in Chicago tomorrow, Michael. Mrs. de Menil is coming in to see the Clyfford Still tomorrow at two. Just show it to her."

"What do I say about it?"

"Nothing, she knows the price. She just wants to see it."

All well and good. I had met Dominique de Menil, and her daughter, Adelaide, was a photographer who often attended our openings and took discreet pictures of the goings-on. The next morning, I made sure my shoes were brushed. At eleven Richard called from Chicago.

"I just spoke to Emily Tremaine, she wants to see the Still. I told her to come at three, OK?"

"What if Mrs. de Menil buys it first?"

Richard laughed. "I'll just have to find another one for Emily. Don't worry, things don't happen that fast."

It was an impressive painting by Clyfford Still, brilliant yellow, ten feet high and nine feet wide. The gallery's rear office was an open-rack storage area and fairly cramped. Promptly at two Dominique and John de Menil arrived. In heels, she was taller than him and led the way. I had done my homework, so I chatted with John about the Still while she took it in. After a couple of minutes she took John aside and they conferred quietly while I pretended I had something to do at the desk. They both shook my hand as they left.

"Thanks, Michael. Say hello to Richard and tell him we'll be in touch."

In other words, yes, no, or maybe. Mr. and Mrs. Burton Tremaine were also prompt. Emily's heels were even higher than Dominique's and she also took the lead. Burton was bear-like, tall, and amiable. He usually deferred to his wife for the final decisions. She had started buying Picasso and Braque during an earlier marriage, then Kline and de Kooning, and had been among the very first collectors to buy paintings by Roy Lichtenstein, Andy Warhol, and Tom Wesselmann in 1961 and 1962. They had missed out on Still when he showed with the Betty Parsons Gallery over ten years earlier and now wanted one for their house in Connecticut.

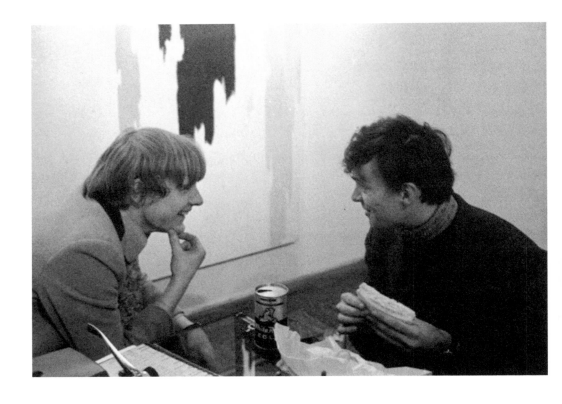

The author and John Willenbecher at Richard Feigen Gallery, c. 1966

Emily and Burton stood in the center of the room looking at the painting. I stood behind them with my back to the rear wall. *Intake*, a large black-and-white painting by Bridget Riley, too big to fit in the racks, was leaning against this wall. Without taking her eyes off the Still, Emily started to walk backward, slowly. I could see that eventually her spiked heel would connect with the bottom of the unframed Riley. I became mesmerized by a vision of her heel penetrating the bottom of the canvas, my telephone call to Bridget, and the nightmare that would follow. Then she stopped, her right heel in the air just inches away. Seconds passed, and, wild relief, she started to walk forward again.

"What is the size?" she finally said.

I told her.

"Do you have a tape measure?" I did. Emily measured the work to confirm what I had told her.

"Can you take two inches off the top? It simply won't fit."

"Er, ummm"

"Michael, I was joking. I love it but it's too big. Thank you!" And she strode out leaving Burton to shake my hand.

Most of the galleries showing progressive contemporary art were either on Fifty-Seventh Street or on or near Upper Madison Avenue, while most of the artists lived and worked and partied downtown. Collectors, for the most part, lived on the Upper East Side, and while some, like Robert and Ethel Scull, enjoyed entertaining artists, many were content to limit their interest to buying what they liked and leaving the artists to their own devices. My ignorance of the supposedly nonexistent class system in the United States, and particularly in New York, was much to my advantage as I navigated between my ragtag playmates on Amsterdam Avenue, artists' studios on the Bowery, and drawing rooms on Park Avenue.

I got even closer to the corridors of power when I found myself elbow-to-wineglass with the upper ranks in the new, enlarged Abby Aldrich Rockefeller Sculpture Garden of the Museum of Modern Art, listening to the dulcet Southern tones of Lady Bird Johnson. Six months earlier her husband had been sworn in as president on a plane carrying the body of his deceased predecessor. She spoke eloquently about the diversity of culture . . .

The hand puppets of a Black Beauty and Daniel Boone proudly displayed by the youngsters of the Lick Branch School, or they may be the works of excellence which we have sent abroad to our embassies to represent our best in the capitals of the world . . .

In doing so she touched on two controversial issues. The previous day the Voting Rights Act had been introduced and was being rancorously debated in Congress. This historic legislation was a direct outcome of the nonviolent movement led by Martin Luther King Jr. that continued to engender murderous acts of hatred in Mississippi and elsewhere. The words "Black Beauty" were ambiguous to some of her listeners. The less controversial issue, one argued about only in the art world, was that the Art in Embassies program clearly favored Abstract Expressionism over figurative works of art. This was conspiratorially linked to the aesthetic bias of the Museum of Modern Art, considered by some to be an annex of the Rockefeller family's living room. A less sinister explanation is that abstract imagery is unlikely to offend the social and religious sensibilities of other nations. Mrs. Johnson was opening not only the garden but a new wing designed by architect Phillip Johnson, also a trustee of the museum. He was eminently recognizable behind his thick, round, black-framed spectacles, as was the tall, amiable, and stately museum director Rene

d'Harnoncourt. I said hello to Dorothy Miller, the one curator I had dealings with, but did not have the temerity to approach the god of modern art, Alfred Barr Jr., a slight, elderly gentleman with a bird-like profile who was the museum's founding director.

We were about five hundred in the garden. Security was tight because of the First Lady's presence. The applause for Lady Bird Johnson was polite but restrained. I wondered if many in the garden weren't thinking of the woman she had replaced at the podium and in the White House, who would have been among friends and family in this gathering. I could claim my presence was the result of a swift and ruthless climb up the social ladder, but in fact I got in with a forged invitation. Feigen artist John Willenbecher took it upon himself to borrow Richard Feigen's invitations to such events, and with judicious use of the gallery copying machine, collage materials, and good stiff cardboard, he manufactured a limited edition of facsimiles for select friends that passed muster in the pre-clipboard days when invitations were like tickets. This came to an end following a black-tie event at the Guggenheim Museum when someone examined the invitations after the fact. Later, the forgeries were mentioned with some humor by *New York Times* reporter Grace Glueck in her weekly column.

Art and Fashion's First Date

Money and fashion rule today's art world. Successful artists are courted by haute couture brands and every private banker needs to know how much to lend against a blue Picasso or a white Ryman. Fifty years ago, art as an asset class was unheard of, and the marriage between art and fashion was still at the first-date stage. One first date did not end well.

By 1965, Pop art was peaking, and the chattering classes were clamoring for the sequel, unfortunately dubbed Op art, which was ushered in when *The Responsive Eye* opened at the Museum of Modern Art in February. This was the first "blockbuster" exhibition opening party I attended, this time with solid credentials. I was working on Bridget Riley's first New York exhibition which was to open at Feigen the following month. Her paintings in the MoMA exhibition included *Current*, painted the year before but already purchased by MoMA from Feigen and featured on the cover of the catalog, and *Hesitate*, which Feigen had sold to the prominent collector and dress designer Larry Aldrich, who later founded the Aldrich Contemporary Art Museum in Ridgefield, Connecticut. At thirty-three, Bridget put her dark hair in a bun and often wore white pants and a black top (her paintings at that time were all black and white). She had a wry smile, a quick sense of humor, and a disarming, no-nonsense directness. Anticipating her first visit to New York, she expressed interest in meeting fellow artists like Barnett Newman and Larry Poons but none in the trappings of art stardom, which were about to be thrust upon her. She had taught at London's Croydon School of Art with fellow Feigen artist Allen Jones, who was camping out in Larry Rivers's studio at the Chelsea Hotel and fast becoming well known in New York. Lean, fashionably dressed with thinning black hair, Allen was low key, serious, and at the forefront of the British Pop movement. His paintings of careening red London buses and entwined male and female figures were in demand. Allen, who had already had successful one-man exhibitions at Feigen's three galleries in Los Angeles, Chicago, and New York by the time Bridget came to New York, took it upon himself to make sure she was in good hands and was at her side when she parried the first major attempt to exploit her unique imagery:

One day soon after the opening of my exhibition at his gallery in New York, Richard Feigen told me that there was a very important person who had a surprise for me and wanted to meet me. This didn't sound like a proper invitation to me and so I didn't take it up. Next day, Richard repeated this more insistently and Allen Jones offered to come with me. Richard gave him an address which was at the other end of town. Allen was very much *au fait* with how to get about in New York and thrilled with the logic of its grid, so we walked.

Eventually, we turned off into a smaller road and I noticed pieces of material with my grey ovals on them sticking out of rubbish bins on the sidewalk. We found the address and took a two-person elevator up to the right floor. We came out onto a small, carpeted area. No one greeted us. We pushed open a door into a room with a door on the left and a long blue curved banquette with buttoned cushions. We waited for quite a long time. On one wall between two windows, I saw a large painting by Monet of flowering wisteria—familiar from his Japanese bridge paintings in Giverny—an amazing sight.

The door opened and a short, slight man came in pushing a rack of dresses, which I could see were covered with my black and grey ovals. A group of photographers rose up from where they had been hiding behind the banquette, snapping as they appeared. The man with the trolley took one of the dresses and walked over to me with it. "This is for you," he said. "No, it isn't," I replied. "It's your dress," he said. "Take it." "I don't want it," I said. "Look," he said, showing me the label, "It's got your name

in it." I asked him if the Monet painting was his and how could he own a flat painting and imagine it transferred into something 3-dimensional like a dress?

There was nothing more to be said. I had refused the dress. An awkward pause followed, so Allen and I left. Later I learnt that the man's name was Larry Aldrich, that the photographers came from a newspaper, and that he had a painting of mine called *Hesitate*.

The "awkward pause" eventually led to American copyright law coming into line with European statutes that protect artists. Barnett Newman (who had his own run-ins with the fashion industry) introduced Bridget to the prominent collector and New York City Bar Association Art Committee member Leon Mnuchin. Supported by a number of other artists, it took Mnuchin two years in succeeding to get what Newman called "Bridget's Bill" passed in Congress. After her debacle with Aldrich, she told me she had no intention of becoming a public entertainer and pointedly referred to what James Joyce said in *A Portrait of the Artist as a Young Man*: "I will try to express myself in some mode of life or art as freely as I can and as wholly as I can, using for my defense the only arms I will allow myself to use—silence, exile, and cunning."

Working with Bridget on the four exhibitions she had at Feigen from 1965 to 1968 was enlightening for me. Her insistence on the paramount importance of perception and feeling in her own and others' work made a lasting impression on me and became an article of faith. It is how I try to approach all works of art, regardless of their nature. Riley's paintings from 1964 and 1965 are visually disorienting and many people at the time claimed to experience vertigo or even nausea. This made them ripe for slick promotion and the "Op" label. I had the pleasure of living with them daily during

her exhibitions and discovered that, given time, each one delivered a unique emotional sensation.

Serving My Country but Which One?

I got my green card quickly and easily. I duped the US Department of Immigration into thinking that I was living in Canada at my brother's address and applied for a permanent residence in the United States. I needed to have guaranteed employment, so I authored and typed a letter which Richard Feigen was pleased to sign, stating that Michael Findlay of Fredericton, New Brunswick, Canada, was the only qualified candidate to be director of exhibitions in his establishment. In keeping with regulations, the gallery had placed an advertisement in the Help Wanted column of the *Village Voice* and interviewed two applicants who were found not to have the necessary qualifications. Not mentioned was that I had placed the ad and conducted the interviews.

Within a month my brother forwarded my green card. I am not proud to have been one of the last beneficiaries of a racist system of apportioning the majority of available permanent residencies to applicants from the United Kingdom and Europe while limiting those from Latin America, Africa, Asia, and the Middle East. A year later in 1965 Congress passed the Hart-Celler Immigration Act which gave priority to skilled labor and reuniting families and would have likely relegated me to the end of the line.

America was at war and as soon as I became a permanent resident, I became eligible for the draft. President Lyndon Baines Johnson needed cannon fodder to send to Vietnam. In March 1966 I found myself at the Selective Service induction center on Whitehall Street. *Have you ever worked for the government of a foreign country?* I

was staring at this question on a military intelligence question-naire slapped down in front of me and nineteen other inductees who had just been declared healthy enough to die for the United States of America. For a male of my age, citizen or not, it was mandatory to register for the draft and then mandatory to respond to the invitation to take the medical exam that preceded induction into the armed forces. Full-time students were deferred, and if you could afford the services of a friendly doctor, dying on the battlefield could be avoided by claiming to have, for instance, heel spurs.

Many of my fellow inductees were, like me, not citizens. Some were born in the Commonwealth of Puerto Rico and others in Mexico and Central America. Waiting for the medical examination, I was in line behind an engaging young man named Diego who seemed bewildered when the staff sergeant in charge asked the peremptory question.

"Are you prepared to serve?"

"No entiendo." Diego looked blank.

The sergeant vigorously mimed shooting and then nodded at Diego who shook his head. Too bad, Diego.

Not widely known then or now about the Vietnam draft is that legal aliens were given privileged status—we were sent to the front of the line. There was a bonus for us, however. Military service was a fast track to citizenship, conferred after two years of service. Or death. Whichever came first. Why grant citizenship to a dead legal alien? On the *CBS Evening News*, Walter Cronkite solemnly announced the number of US soldiers who had been killed in Vietnam each day, all of whom had to die as US citizens. The army did not want the public to hear, "In a battle at Dong Ha earlier today, sixty-three US soldiers and twenty-seven legal alien soldiers were killed."

Once I entered 39 Whitehall Street, it was if I had become Prop-

erty of the US Government. The physical examination was cursory and fifteen seconds with the shrink even more so. Arthur Pearl, a gay Londoner, was called up two weeks before me and arrived wearing mascara and blush, declaring his enthusiasm for "sleeping in a room full of randy soldiers." "You can control yourself," the army shrink told him. He was in.

After passing the physical, we found ourselves at battered desks being barked at by a senior officer. There was a mandatory one-page questionnaire prepared by military intelligence on each desk. Once this was filled out, we had the choice of either choosing the army, the navy, the air force, or the marines and start basic training immediately, or wait four to six weeks and be assigned a branch.

The only preparation I had made was to find out that a permanent resident with legal alien status had the right to leave the United States rather than serve. Arthur Pearl returned to London the next day, well aware that he would be permanently denied re-entry. Gloomily, I calculated my future as I gazed down at the form in front of me. US Army and a shortcut to citizenship quite likely meant a short life—or should I abandon what had fast become my true home?

Are you the sole support of a household of two or more children? No
Have you ever been convicted of a felony? No
Have you ever worked for a foreign government? No

Wait a minute. *Yes.*

I had no notion that what I was about to do would have surprising consequences. Intimidated by my circumstances into uncharacteristically engaging honestly with authority, I checked the "yes" box next to the last question. All my other boxes checked "no."

A junior staff officer passed each desk and snatched up the forms. He glanced quickly at each one then stuffed it into a folder. This was routine. When he came to mine, he stopped and stared.

"You've worked for a foreign government?" He sounded astonished.

"Yes, I . . ." but before I could explain he said, "Get up, come with me," and steered me very quickly out of the room and into a corridor.

"Don't move," he said, then disappeared. I didn't move and five minutes later he brought two soldiers who positioned themselves on either side of me. Did they think I was going to charge the front door? Another ten minutes and the junior staff officer returned with a senior staff officer. There was a palpable change in the atmosphere. I had become a special person, no longer a future grunt. After all, Soviet spy Rudolf Abel had been nabbed at the Latham Hotel on Twenty-Eighth Street a few years earlier.

It was mid-morning and I stayed at Whitehall Street until late afternoon. Much of that time was spent sitting and waiting for something to happen. Eventually my guards took me into a small office where I was allowed to sit down. I was told to make a written statement explaining why I had checked the "yes" box for that particular question.

In August 1963 I was employed by the Provincial Government of Ontario in Canada to mark examination papers submitted by students seeking scholarships for college entrance.

That was the truth. In addition to working in a wretched factory getting covered head-to-toe in glass fibers, I spent evenings scoring ill-written essays by Canadian high school students. This was arranged by John Williamson, a young conservative politician in local

government who had been my brother John's roommate at the University of New Brunswick.

When this pitiable excuse was being read, I expected to be thrown back into the cannon's mouth. Instead, I was taken two flights up a central staircase and deposited in a larger, more comfortable office. I was guided to an upholstered chair in front of a large desk.

"Someone will be coming to interview you."

At this point I started to feel guilty that I was *not* a spy. Perhaps I would be penalized trying to dodge the draft with a flimsy excuse. I waited at least an hour when suddenly a plump man in civilian clothes bustled in and waved me down as I stood up. He was holding a slim, green file folder.

"Sit down, sit," he said quite pleasantly. About forty, toothbrush mustache, rumpled sports coat, rep tie, and slacks, he looked more like the manager of a suburban country club than what he turned out to be, a military intelligence officer. A spy catcher. He took out a fountain pen and slowly unscrewed the cap. As he began to write on a legal pad, he said, "My name is Roger. I'm going to ask you a few questions." He took what I thought was a bizarre approach. Nothing about me as the hireling of a foreign power. His first questions were about my parents. I had met my father's new, long-suffering wife, Freda, once, briefly, and my mother's equally long-suffering husband, Sam, not at all. After asking me for my parents' full legal names, he turned to "your stepfather and stepmother," a reference that at first mystified me until I realized I did indeed have one of each, although it had not crossed my mind that they were actually related to me. Roger became deeply suspicious that I did not know my father's wife's maiden name. I did not know it then and, may Freda rest in peace, I do not know it now.

"So you don't know your mother's maiden name, is that correct?"

"She's not my mother. My father introduced me to her once, in a pub. I'm sorry, no, I don't know her maiden name."

He took down my answers on his legal pad, occasionally shaking his fountain pen. Looking into his green folder he read for a while then looked up.

"When you applied for your green card, you mentioned the names of organizations you had belonged to in England, correct?"

"Yes."

"Can you tell me what they were?"

"The Junior Drama League and the Chertsey Young Liberals Club."

"And those are the *only* political organizations you belonged to?"

"The Junior Drama League isn't political, it's for young actors."

"What is the 'Committee of 100?'"

Sensitive to the tendencies of my host country to find communists under the bed and socialists *in* the bed, I had been selective about my teenage, save-the-world, left-of-center activities when applying for my green card.

"It's an anti-nuclear bomb organization in England."

"And are you a member?"

"No."

"Were you ever a member?"

Gulp. "Yes."

"Were you detained by the police on April 11, 1963, in Trafalgar Square in London for participating in a violent demonstration?"

"The police were violent, not the demonstrators." I was thrown into an empty police van and gashed my head on the metal seat. "It was a peaceful demonstration outside the South African Embassy. I was taken to Bow Street then released. I was underage, there were no charges." Except someone had kept a record and Roger had it in his hands!

Long pause. Roger appeared to be thinking. Then he asked me the sixty-four-thousand-dollar question.

"Michael, if you were serving in the United States military and war was declared between the United States and Great Britain, would you fight against the British?"

At that very moment former British soldiers were being hired by the US government as civilian specialists to train American troops. Now it was my turn for the long pause. Not for effect. I knew that if I played the conscientious objector card I was as good as sent back to Blighty, never to return.

I decided, always against my better judgement, to be honest: "No, I would refuse to fight against the British army."

"OK, thank you," and Roger capped his fountain pen and got up to go.

"What happens now?" I figured I had nothing to lose.

"You'll review a transcript of what we have discussed. It will be typed and then you will be expected to sign it."

He left the room. I sat there for about fifteen minutes until my guards returned and escorted me three flights down to the noisy, bustling basement of the induction center. There were rows of desks; at each one a woman no younger than fifty sat typing, some were talking to each other and others had nervous young men seated by their desks.

"Are you Michael?" said mine, a plump matronly woman with silver hair and a broad smile. She was opening what appeared to be Roger's green file. I could not see clearly across her typewriter.

"Yes."

"I'm Rachel, bear with me while I type up your statement. I may ask you to clarify some of the words. This will take a while." She seemed nice, hardly what I would have expected from the army.

It took about two hours. I had to go over everything line by line;

she had trouble with Roger's handwriting. There was plenty of time for me to look around and I spotted Diego. He was at a desk on the far side of the room and seemed to be engaged in the same exercise as me, except he looked extremely agitated. Suddenly he got up and headed for the door. Rachel looked up sharply then rose and shouted at him in her outdoor voice.

"Where do you think you're going?"

"Guadalajara. No army," said Diego.

"First. You. Will. Go. To. Jail. For. Five. Years!" Rachel boomed across the room. As Diego retreated, she sat down, smiled at me sweetly, and said, "Well, Michael, you can always go back to England, can't you?" Not exactly what she had just yelled at Diego.

I read and signed my statement admitting I had concealed my membership in and activities with anti-government organizations when applying for a green card, and that if inducted into the US Armed Forces, I would refuse to fight in a war against the United Kingdom.

"Now what?" I asked Rachel.

"Now you can go. You will get your classification in the mail."

She obviously knew her stuff. I left the building in a state of nausea and relief, looking over my shoulder to see if I was being followed. I had missed my chance to choose a branch of service, so like the rest of the inductees I had to wait four weeks before the small, white card came in the mail with one of thirty-two possible classification codes on it, of which only two mattered: 1–A: Available for unrestricted military service; or 4–F: Registrant not acceptable for military service.

I never got that white card. In fact, I never heard from the US Army again. No mail. No card. No classification. In a valiant yet futile attempt to deny George W. Bush a second term, I applied for US citizenship in 2004 and was required to produce evidence that I had

registered for the Selective Service. I hoped that might be an opportunity to find out why I had been caught and released. I obtained the evidence that I had registered but learned that in 1978, by an act of Congress, all Vietnam-era Selective Service records other than registration were destroyed, I presume to cover the tracks of former draft-dodging members of Congress.

Not long after this I was at a drinks party where I was introduced to a tall, bearded fellow and told he "used to be in army intelligence." I took the opportunity to tell this stranger a brief version of my tale and ask him what he thought had happened. "I know exactly what happened. You were considered too subversive to be in the army but not subversive enough to deport," he said with a smile. "They didn't have a classification for that, so they chose to ignore you. Homegrown protestors were classified A–1 as a punishment. You were damn lucky." You can say that again.

In the art world, opposition to the Vietnam War was fierce and engaged a wide range of artists: Allan D'Arcangelo, William Copley, Leon Golub, Charles Hinman, Louise Nevelson, Yoko Ono, and Ad Reinhardt to name just a few. In Los Angeles, sculptor Mark di Suvero and painter Irving Petlin collaborated on a *Peace Tower* with funds donated by Robert Rauschenberg. Richard Feigen reacted swiftly and creatively when his friend Claes Oldenburg was injured during the police riots in their native Chicago during the demonstrations at the Democratic National Convention in August 1968; Mayor Daley had purportedly ordered the police to "shoot to kill" protestors. Prior to this Feigen had arranged for Oldenburg to have a fall exhibition in the Feigen Gallery in Chicago, but after Oldenburg himself was injured, he and Feigen replaced his show with *The Richard J. Daley Exhibition*, which opened in late October and featured over forty artists, half of whom created specific anti-Daley works. Barnett Newman submitted his steel *Lace Curtain for*

Mayor Daley and James Rosenquist and Oldenburg both submitted portraits of Daley, Rosenquist's on mylar, sliced in ribbons, and Oldenburg's of the infamous mayor's head on a platter. The exhibition opened in terrible winter weather so the liquor flowed freely. Discussions became heated and as the opening closed, I stumbled across Claes Oldenburg and the distinguished Chicago-based poet Paul Carroll engaged in fisticuffs and rolling on the ground in the snow. No injuries this time.

On Being "In"

Unaware that at some other galleries staffers received commissions on sales, I was satisfied with my wages but always interested in the possibility of supplementary income. I found myself moonlighting as a low-budget male model. After all, I had bangs and a pair of elastic-sided boots. For Hohner's catalog I strummed a guitar; for the Montreal World's Fair, full-page color in the *New York Times*, I danced wildly in my own flowered shirt; and in *Women's Wear Daily* I advertised the new miracle fabric "Vycron" wearing wide-striped pants and a polka-dotted shirt.

Taking my mod image seriously, I kept an eye on London fashions which were at least two years ahead of New York. Feigen's British artists had dealers in the UK like Robert Fraser and the Rowan Gallery, and once or twice a year I was back in what was now billed to American tourists as "Swinging London," no longer austere but super mod and kicky. Sometimes I called my father for a drink near his *Daily Express* office in Fleet Street, or my mother to take her for lunch near Carnaby Street where she had a job managing the upmarket Galt toy store. I returned with the latest gear which earned

BUYING A GUITAR?

HOHNER, THE WORLD'S LARGEST MAKER OF MUSIC MAKERS, HAS THE RIGHT ONE FOR YOU IN THEIR NEW CONTESSA LINE.

Whether you're a young strummer just learning or a callous-fingered pro with his own rock and roll group, you'll find a guitar for you in the Hohner line of Contessa guitars.

Advertising Hohner Guitars, c. 1966. Author is second from left

Montreal.
What you don't know about it, we'll tell you.

If you're planning to go to Montreal in '67 to see what is probably the best World's Fair ever, then there are a few things you ought to know before you get there.

Like the names of some really good restaurants. And the prices at some of the better haute couture. And some suggestions about where to swing after midnight.

That's where Venture comes in. In our current issue, we'll tell you all about Montreal, and the pleasures—familiar and esoteric—you can pursue while you're in town. Where do you go to hear Hungarian folk music? What's the best place to look for Eskimo sculpture? Where can you pick up a smart timber wolf vest? Venture will tell you.

We'll also tell you the best place to go for pigs' knuckles. And what shops are big on mini-skirts. And the prettiest parks to stroll through on sunny afternoons.

You can really get to know Montreal from reading Venture. In fact, you can learn a lot about the rest of Canada, too. Venture travels from the majestic Laurentians all the way to the frosty lakes of British Columbia. With good, lively writing, and superb photography, we cover it all.

Getting to know a place (as opposed to just visiting it) is something Venture has become famous for. With the help of talented people like James Morris, S. J. Perelman, Graham Greene, and Gordon Parks, we've probed and poked around, and gotten familiar with such places as Alaska, Bali, Bhutan, Malta, and Coney Island. That's our business. And we think we're pretty good at it.

Venture, which regularly costs $12.50 for a year's subscription, is available at the special introductory and gift rate of $9.50. It is published every other month and printed on two kinds of fine paper stock. It is also the only magazine with a 3-D photograph on every cover. Each issue comes richly encased in a smart portfolio binding. To become a subscriber, just fill in the coupon and mail it to us. If you like, we'll bill you. If you're not happy you get your money back on all unmailed copies.

Venture, Dept. V6, 488 Madison Ave., New York 10022. Please enter my subscription to Venture at the special introductory price of $9.50 for a year's (six issues) subscription.

Name_____

Address_____

City_____ State_____ Zip_____
New orders only. ☐ Bill me. ☐ Remittance enclosed.
☐ Charge my American Express Credit Card #_____

VENTURE...The Traveler's World.
Published by Cowles Communications, Inc. ©1967

New York Times Magazine, March 26, 1967

me door privileges at burgeoning clubs like the Electric Circus on St. Mark's Place and Cheetah on Broadway and Fifty-Third.

I was not content just to be a patron. When the June 9, 1966, issue of the *Village Voice* hit the stands, a story in "Scenes" announced that four youngsters were looking for backers to open a new club in the Village. Readers were told our "great looks assure them entrance to everyone's party, invited or not," with an accompanying photograph by Fred McDarrah of Marsia Trinder, Karla Munger-Chubb, Steve Lawrence, and myself.

Marsia was the daredevil daughter of Sir Charles Trinder, the Lord Mayor of London, and had been at St. Martin's School of Art with Gerald Laing. My own green card freshly minted, I offered her a fictitious job at the Feigen Gallery so she could get hers. She found her own first job sewing Claes Oldenburg's *Soft Drum Set*.

Karla I met at the Betty Parsons Gallery where she worked. I had gone to see Richard Tuttle's exhibition but found the gallery empty until Karla told me to look down at the discreet balsa wood forms around the six-inch high baseboard. I found myself also looking at her long legs encased in shiny white, calf-length vinyl boots. We became an item, and she introduced me to her photographer friend, Steve Lawrence. One evening Marsia joined us for dinner and after a few or perhaps many drinks we decided that New York needed a really groovy new night spot.

Richard Burton's ex-wife, Sybil, had just opened her nightclub, Arthur, on East Fifty-Fourth Street. Her backers were Julie Andrews and Stephen Sondheim. Trude Heller's in the Village had caged go-go girls and live bands like the Young Rascals, and The Scene, owned by Steve Paul, was where I had seen Andy Warhol arrive with Edie Sedgwick to debut their matching silver hair. Paul had managed the Peppermint Lounge, home of "The Twist," which had lost its appeal for anyone under fifty. In 1967, The Scene launched the Jimi Hen-

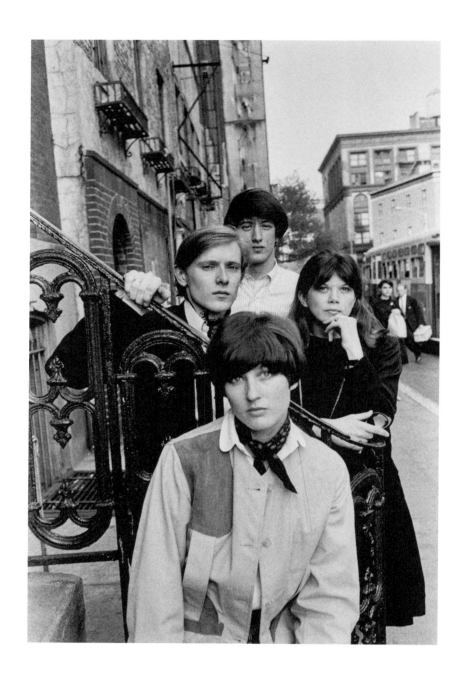

Fred W. McDarrah for the *Village Voice*, June 9, 1966.
Clockwise from left: the author, Steve Lawrence, Karla Munger-Chubb, Marsia Trinder

drix Experience; later, the best Steve could serve up was Tiny Tim. We thought we could go one better.

Karla, Marsia, Steve, and I aimed to attract a youthful art-cum-rock crowd. We chose the name AT, as in "where it's all *at*." We planned it to be very big and very loud. Marsia was well-connected with the Brit rockers in London and New York, and together we assembled an impressive who's who of boldfaced names pledged as "founding members," including Pop artists like Billy Apple and Tom Wesselmann and rockers like Keith Moon, Ray Davies, assorted Zombies, and three-quarters of the Beatles. There were only two things stopping us from becoming the Rubells and Schragers of the Sixties—money and location.

Meanwhile, the *Village Voice* described our vision: "They aim to locate their discotheque at the old burned-out Stonewall Inn on Christopher Street across from Sheridan Square. The place is probably massive enough for their planned moveable dance floor, retractable banquettes, Carnaby-style boutique, sculpture garden, rear-screen projection and vending machines that will dispense food, papier-mache jewelry, fish-net stockings and 45 r.p.m. records."

Papier-mache jewelry. Wow.

Mob Rules

We needed to find out who owned the Stonewall. Realtors in the Village either could not or would not tell us. We hoped this mention in the *Voice* would flush out the landlord. It worked.

Two days after the *Voice* came out, Karla was approached by a friend of a friend who claimed to represent the Stonewall's owner. Would we be prepared to meet with Angelo, no last name, at his apartment in the East Sixties one evening the following week? I met

Karla in the lobby of a nondescript postwar building between Second and Third. We asked for "Angelo" and the doorman sent us to the penthouse where we were greeted by a tall, beetle-browed young man not much older than us wearing a conservative dark suit, white shirt, and a very thin black tie. He ushered us into a blandly furnished living room, gestured for us to sit on the couch and took a reclining chair next to us.

"I don't want to alarm you," he said, taking a handgun out of his pocket, "so I'm just going to put this on the coffee table." Which he proceeded to do, slowly. He did not mention it again, but it was hard to ignore. Angelo was genial and well-spoken but definitely no angel.

"Do you have a business plan?" he asked.

We showed him our fancy binder with renderings of what AT would look like and the impressive roll call of our celebrity founding members.

"I can have The Stonewall lease for your signature by tomorrow morning," he said. He named a monthly rental slightly under market. Excited, we said that would be wonderful, we just had to consult with our two other partners.

"There is just one thing" he added, casually. "We would be supplying all your liquor."

It was the "we" more than the "liquor" that alarmed us.

"You guys get the liquor license," said Angelo, "but we don't want you working with any outside suppliers, OK?"

Promising to get back to him promptly, we said hurried goodbyes. Our partners needed little persuading that mixing with the mob was not on. We never did find out the family name of our very own Michael Corleone but were enlightened by Ben Fishbein, the proprietor of Café Figaro, the Eighth Street coffeehouse.

"Look around," he told us. "Every place in the Village that serves

liquor is either getting it from Vito Genovese or paying him protection or both. They don't touch me because I don't serve booze."

"Isn't he in prison?" I asked, for which I received a scathing look.

"Think that makes a difference? The guy you met was probably his brother Carmine's boy."

Ben might have been exaggerating, slightly, but a few years later when The Scene closed, the rumor was that young mobsters had started fights there to scare the patrons because Steve Paul refused to pay protection. When I got to know Mickey Ruskin, he told me that one of the reasons he opened Max's Kansas City in no-man's land on Park Avenue and Seventeenth Street was to keep it off the mob's radar.

It didn't take Angelo long to find a taker. Later that year the Stonewall Inn was in business under its old name. Vito Genovese had owned stakes in gay bars and clubs in New York since the 1930s. The rest is history.

Close Encounter with the Haves

Never mind. I still had my day job. I was getting paid to learn about art firsthand, meet artists, and study how the art business worked. This was remuneration enough, so I was content with just a simple thank you from my employer when I punted him the clients that gave him the biggest sale to date of his career.

A young couple wandered into the gallery asking for me by name. They had just left Leo Castelli Gallery and had asked him where else they might go to see emerging artists. He very generously sent them in my direction. The young lady was Susan Engelhard, recently graduated from New York University and accompanying a family

friend visiting from England where his address was Number One, London. His name then was Charles Douro, now he is better known as the Duke of Wellington. Both were intrigued by shaped canvases, and I was able to show them recent paintings by Richard Smith and Charles Hinman. Their canvases, while very different in some aspects, were similarly sculptural and projected from the wall. Susan's parents were Jane and Charles Engelhard, famous for goldmines, Triple Crown–winning racehorses, and impeccable taste.

In time I got to know Susan, her four sisters, and her parents. Occasionally I was invited to lunch at their estate in New Jersey, where big-donor democrats and Senate Majority Leader Mike Mansfield might be guests; or to dinners in their apartment at the Waldorf Astoria where Brooke Astor was once my friendly dinner partner.

My First Big Sale, Sort Of

Jane and Charles Engelhard collected many things, from Japanese netsuke to Impressionist paintings. I worked at a gallery that sold Impressionist paintings. Not long after I was welcomed into the Engelhard household, Feigen got hold of a masterpiece, one of only four paintings Monet made in 1881 of *The Artist's Garden at Vetheuil*. Each painting is slightly different but all four are soaring vertical compositions with a strip of cerulean blue sky at the top, a profusion of sunflowers on either side of a central path and garden staircase, and big, blue Chinese vases of gladioli at the bottom. In what became known as the Engelhard version, two young girls in white dresses and sunhats stand on the steps. Feigen's asking price was a then staggering one million dollars. The justification for this was the recent sale at Christie's of the larger, earlier, and even more alluring *Garden at Sainte-Adresse* (1867) for $1,400,000. That sale

Claude Monet, *The Artist's Garden at Vetheuil*, 1881

Oil on canvas. 59.6 × 47.6 in. (151.5 × 121 cm). Perenchio Foundation

made front-page news, and the painting has since become beloved by jigsaw puzzlers everywhere.

I invited Susan's parents to come and see the Monet, introducing them to Richard Feigen, who, however, did not include me in the closed-door viewing of the work. Richard had the gift of the gab. His regular clients knew that he did not consider a sale successful unless it had been accompanied by a lengthy monologue, to his credit mostly on point. I was not surprised when after thirty minutes they were still closeted. Eventually the door burst open and the Engelhards strode out followed by Feigen talking ten to a dozen behind them. As I saw them to the front door, Jane rolled her eyes at me and said, "We bought it in five minutes. Please tell him to stop talking!"

When word spread that Richard Feigen had sold a Monet for almost a million dollars, it was if a new era had dawned, and perhaps it had. Good Impressionist paintings were selling south and perhaps slightly north of five hundred thousand dollars in the late 1960s, so this price set a new benchmark for sellers and buyers.

SoHo is Born

The beginning of SoHo as a creative community was when Fluxus artist Alison Knowles moved into 423 West Broadway in 1959, to be joined soon after by Dick Higgins. Japanese artists Ay-O, Yoko Ono, and Mieko Shiomi were also early settlers. Many artists rented lofts for work and lived in them illegally, not always with amenities, genuinely *la vie bohème*. Feigen bought two buildings on Greene Street not long after "SoHo" was coined as an official designation for the area *South* of *Hou*ston Street. He had been visiting artists in their lofts and not only sensed the stirrings of culture in the neighborhood, but he had a keen interest in architectural history. In the mid-nine-

teenth century Greene Street was home to fifteen brothels, one of them at 139 Greene Street, a Federal-style dormered residence with an arched doorway. Feigen's curiosity about this building and the three-story manufacturing loft building next door at 141 Greene Street was piqued when he learned that a very similar house opposite, long since demolished, was the birthplace in 1840 of muse, patron, and collector Isabella Stewart Gardner.

In 1967, the streets of SoHo during the work week were as noisy and busy as train station shunt yards. Strolling was impossible as flatbed trucks moved in and out of loading bays, blocking pedestrians and cars. Apart from a cup of soup and a beer at the Fanelli Cafe at Prince and Mercer there was nowhere to eat or drink. On weekends, SoHo was deserted, no trucks and very few cars, the streets and sidewalks none too clean. I had gotten used to piloting adventurous collectors on Saturday visits to artist's studios in the neighborhood. They got a kick out of buying at the source and meeting the artist.

One Sunday morning found me waiting on the empty SoHo sidewalk outside Charles (known to everyone as Chuck) Hinman's studio to greet Joe Hirshhorn and his curator Al Lerner. They arrived promptly in a long, black chauffeured limousine. Friendly and garrulous, Joe clapped me on the shoulder and plunged into the building. Al and I panted after him as he dashed up four flights of steep loft stairs. "What do we do if he has a heart attack?" Al huffed, concerned about his own future.

Joe burst into Hinman's studio where the soft-spoken artist, a dead ringer for Nureyev if Nureyev had been a cowboy, was standing surrounded by brightly colored, hard-edged, three-dimensional shaped canvases on stretchers made with the engineering precision of a master boatbuilder. Joe shook his hand vigorously and proceeded to march around the studio examining each of the new paintings Hinman had completed for his upcoming exhibition. Most

were hanging, one or two still sitting on the floor. In less than five minutes Joe pointed to three.

"I want this one and those two over there. Come here, Chuck." He grabbed Hinman by the arm, not easy considering their disparity in height, and turned him away from me. "Let's you and me do this, we don't need Findlay."

Al had the decency to remind Joe that I was the dealer in charge, and besides, Chuck was giving me the "what-the-hell-do-I-say" look.

"The red-and-white one is $1,200, the other two are $1,500 each, so the total is $4,200," I told Joe in as firm a voice as I could muster.

"You know they're building a museum for me in Washington? These will go into that museum so there is no way I am paying your crazy prices. You'll give me a 42% discount."

At school I was in a class for seniors affectionately called "maths for morons," taught secretly so as not to set a bad example for the juniors who could do arithmetic. I could manage fifty percent in my head and that was it.

"Joe," I said. "I can give you a discount, but certainly not that much. Why don't I jot down the number . . ." This started a process I used every time I negotiated with Hirshhorn. He grabbed the paper from me.

"That's not a price! That's a telephone number!" he yelled, angrily crossing it out and writing *his* number underneath. Eventually we got to the bottom of the page, where we had a deal.

"I'm famished," said Joe. "Where can we eat?"

When dining with the great and near-great, Joe liked to kid his hosts by telling them their food was delicious, but he would have preferred a plate of fish heads. His taste for them, he would explain, dated from his childhood on the Lower East Side. His widowed mother, a Latvian immigrant, would beg fish heads from seafood merchants. She had thirteen children of which Joe was the twelfth.

"The only place open is Katz's," I said, and in a couple of minutes we were parked ostentatiously outside the strictly kosher delicatessen. It was noon and packed inside with garment workers and a rabbi or two. Joe marched to the counter and smiled at an elderly sandwich maker who might well have been at Katz's since it opened in 1888.

"Pastrami and Swiss on rye with a glass of milk," he ordered loudly.

The entire restaurant went silent. The counter man looked like he'd been shot. Joe turned around to us, clearly bewildered.

"Joe," Al Lerner cupped his hand over his mouth and leaned toward his master's ear, "We're in the most famous *kosher* deli in New York."

The only places to eat in or near SoHo were Katz's and the slightly more upscale Emilio's Ballato, also on Houston Street. If yarmulkas and payot were the order of the day in Katz's, it was gold chains and muscle T-shirts at Ballato's.

On the Town

I took dates to Chinatown or Little Italy where the food was good, the service friendly and prompt, and the price right. Then a nightcap at the Ninth Circle on West Tenth Street, a rowdy bar for poets and painters with barrels of free peanuts (you threw the shells on the floor). It was owned by Mickey Ruskin, later to become the benign proprietor of Max's Kansas City. If I wanted to splurge, we would go to Lüchow's grand, art nouveau restaurant on East Fourteenth Street with tablecloths and waiters draping napkins on their arms and order the homemade bratwurst with sauerkraut and cream potatoes for $1.95, which included appetizer and dessert.

New York then was grubbier but much more congenial. People spoke to each other in the street and not only to shout and argue. We said hello and good morning to each other regardless of age, race, and economics. Before chain banks and drugstores and coffee houses each neighborhood had its own distinctive flavor and a relatively sedentary local population. When I lived on Amsterdam and West Eighty-Eighth Street, I knew and was known by the people in the stores on Broadway—the laundry, the diner, the bodega. When I went to my gallery job on the East Side, I bought my Benson & Hedges 100's from Madame Juliette, the gravel-voiced French tobacconist on the corner of Madison and Eightieth Street who called me "daaaarlink" and smoked a small black pipe.

You had to travel around town to get different products, not just lox at Zabars on the Upper West Side or a suit with two pairs of pants in the garment district. Gerald Laing was living and working in a loft on Bond Street, the same building as Tom Wesselmann, just off the Bowery. Once in a while I went with him on supply runs to Pearl Paint on Canal Street, the business almost as vital to a New York artist as their gallery. On the way back we would be in and out of almost every store on Canal Street, with bins on the sidewalks filled with every conceivable kind of hardware, plastics, and Plexiglas. More works of art in this era were born out of visits to Pearl Paint and Canal Street than inspired by a muse. Central Park was not as manicured as it later became and at night it belonged to men seeking each other's company. During the day it was well used by mothers with children, young lovers and elderly women, and men busy sitting on benches. Tourists and joggers were scarce and cyclists nonexistent.

The skyline was lower back then, which made the Empire State and Chrysler buildings all the more impressive, and the balance between townhouses and apartment buildings was more equitable, so

one could walk street after street and see plenty of sky. And while Midtown bustled during the day and Macy's and Bloomingdale's thronged with crowds on Saturdays, in those days the streets were emptier.

My friend David Askevold was an artist living on Ann Street just below City Hall who could be relied on to have safe LSD. After one Saturday night party in his loft, we accompanied two female friends on a long hallucinatory trip through the empty streets of the financial district.

Experiments in Art and Technology

The New York art world of the 1960s was transitioning from the hegemony of Abstract Expressionism to a multiplicity of newborn, evolved, and adapted approaches, including the object-oriented Pop art, Op art, Minimalism, hard-edge abstraction, and the performative and conceptual. Some of the Pop artists such as Tom Wesselmann, Claes Oldenburg, and George Segal had participated in performance art pioneer Allan Kaprow's *Happenings* in 1961 and 1962, which were loosely scripted events combining performers and audiences with no discernible beginning, middle, or end. An equally anarchic approach was fostered in the late 1950s at Black Mountain College in North Carolina, a cauldron of progressive interaction between artists (Jacob Lawrence, Robert Rauschenberg, Josef Albers, Cy Twombly, Ray Johnson), poets (Charles Olson, Robert Creeley), composers and dancers (John Cage, Merce Cunningham), and polymaths like Buckminster Fuller.

A benefit of my lack of formal art education was that I had no hard-and-fast principles about what art should or should not be. I simply accepted and enjoyed what was on offer based on whether

or not it engaged me. Consequently, I was excited to find myself on a hard bench in the 69th Regiment Armory on Lexington Avenue and Sixty-Eighth Street, attending three performances of *9 Evenings: Theatre and Engineering*. Billy Klüver was an intense young Swede, toothy with balding, flyaway blond locks who seemed to be everywhere in the art world. He was an electrical engineer at Bell Laboratories in New Jersey and had teamed up with the good-looking, high-energy forty-one-year-old Rauschenberg, a seasoned performance collaborator who had worked with dance mavens Merce Cunningham and Yvonne Rainer. Klüver and Rauschenberg had previously worked together on and off for several years.

It was a public wedding of art and technology. Far from slick, often ad-libbed, and sometimes involving the audience, the evenings were a bouillabaisse of dance, sound, and film. Participants including John Cage, Öyvind Fahlström, Yvonne Rainer, and Robert Whitman were matched with Kluver's Bell Lab colleagues. The audience was treated to an extraordinary array of live performances aided and abetted by Doppler sonar devices, FM transmitters, closed-circuit television, fiber-optic cameras, and all sorts of screen projections. Over thirty years later, watching a spellbinding performance of Mikhail Baryshnikov moving to the amplified sound of his own heartbeat, I was reminded of Alex Hay doing much the same thing.

The armory was cavernous. We were on bleachers and there was no barrier between performers and audience. Equipment was not only visible, but it also constituted the set. The events were well attended but not packed, the advertising budget was slim. Word-of-mouth was the social media of the times. Rather than ponder what it all meant or where it was going, I was spellbound by the combination of the performers' graceful confidence and the acceptance of random event and accident.

A Meeting of Friends

I was to be even closer to the action a year later when Ray Johnson planned the first meeting of the New York Correspondance School. Ray conferred membership on me shortly after we met by sending me odd notes and clippings, some of which he rubberstamped "SEND TO", followed by the name of just about anyone, from a well-known artist to a long-dead movie star to a random name from the telephone directory.

In February 1968, Ray had sent out notices for what he billed as a First Meeting of the New York Correspondance School. On April 1st, I found myself at a "meeting about the meeting" in the studio of assemblage artist May Wilson with five other collaborators: Ray, Toby Spiselman, John Willenbecher, George Ashley, and myself. A sampling of the minutes meticulously recorded by George follow:

Ray Johnson said, "I always thought a Meeting is when you say, 'How Do You Do?'"

General Discussion on avoiding the Draft and / or Being Rejected by the Draft Board. Michael Findlay was rejected because he could not tell the examiner his step-mother's first name.

Question: Is it really true that people who are obscenely tattooed will not be drafted? No-one present would admit to being obscenely tattooed.

John Willenbecher put on a yellow rain slicker and left.

We had each been given packets of invitations to mail out and we duly reported:

May Wilson said, "I later discovered I had mailed out all the announcements in a packet that was intended for George Ashley."

The actual First Meeting was held at the Religious Society of Friends Meeting House on Rutherford Place. According to the press release, thirty-seven people attended, including "Mr. Levi, Quaker watchman." Some of the other attendees were:

Michael Findlay, Feigen Gallery, poet
Alexandra Findlay, famous collage artist
H. Pietkjewicz, tree collector
Joe Filzen, photographer, "Peanut Butter Movie"

Everyone who had been at the "meeting about the meeting" was also present, as well as art critics David Bourdon and Piri Halasz. The venue was elegantly simple, a high-ceilinged, light-filled hall with gray pews and a balcony. Four years later I described the event to Richard Bernstein for *Interview* magazine:

Everybody arrived and there were quite a lot of people there in this circular (sic) building with pews on four sides and sort of an empty space in the middle. Of course there was no precedent for the meeting and everyone expected something to happen which it promptly didn't you see and so (a) few people felt compelled to get up and do something and then they felt foolish and sat down. Meanwhile everyone was just wandering around shaking

hands, chatting, sitting next to each other in this church like atmosphere, rather more subdued than one would be at a party, for instance. It lasted not more than an hour and was absolutely delightful. It certainly struck me, recollecting it a few days later, that in fact it had been a collage, a human collage. Ray had not orchestrated anything, he was there almost as another guest, one of the members.

Dutch Courage at Max's Kansas City

Alexandra Findlay, "famous collage artist," was the former Alex Malasko who had volunteered her services to Joseph Cornell. Now my wife, she was a student at the School of Visual Arts. We met at the 1965 New Year's Eve party on Montague Street in Brooklyn given by one of her teachers, Herbert Gesner. The following summer we bummed our way to Aspen to hang out with Charles Hinman and Gerald Laing. Collector John Powers was supporting the Aspen Institute for Humanistic Studies founded in the late 1940s by an enlightened group that included the Bauhaus artist and architect Herbert Bayer. John and his wife, Kimiko, invited artists and scientists and poets and philosophers to participate in panels and informal discussions in the quiet surroundings of Aspen in the summer. That year Laing and Hinman were joined by painter Friedel Dzubas and critic Max Kozloff to represent the fine arts. Most of the time they were free to work in donated studio spaces. Alex and I had to find work. I painted fences and she got a job as a motel maid until her mother found out, ordered her home, and declared me *persona* very *non grata*.

At the end of that summer I was back in New York and still eighty-

sixed from Alex's life by her furious mother. Like many men, I want most what I can't have. Alex was back at the School of Visual Arts. I mounted a surreptitious campaign which involved enlisting the help of her classmate, Billy Sullivan, to place notes in her locker while I tried to waylay her as she left school. It's called stalking. Not clever. But when all else fails, propose marriage. This worked like a charm. Immediately. Overnight I went from never-darken-our-door-step ne'er-do-well to most-favored-son-in-law-to-be. It is possible I was played by the lady who was about to become my mother-in-law.

I was all of twenty-two, my bride nineteen. What we knew about the institution of marriage was slender indeed, neither of us having grown up in two-parent homes. While we may have been clueless about marriage, we had very strong opinions about the next most important thing, the wedding itself.

For purely atmospheric reasons we wanted a church wedding. I was a lapsed Catholic and Alex was lapsed Albanian Orthodox, so those options were out. Research led me to the Church of the Transfiguration, aka the Little Church around the Corner, on Twenty-Ninth and Fifth Avenue, famous since the late nineteenth century for being willing to marry those spurned by other churches, usually because they were in the theater. The kindly Episcopalian pastor in whose cluttered study we demurely sat for an interview made two things very clear. The first was that by being married in an Episcopalian ceremony we would be automatically excommunicated by the respective religious gangs we were born into. Presumably he had to say this because there is a noncompete clause between Christian denominations. The second clarification, stated emphatically, was that under no circumstances was the bride to wear a miniskirt. Our good minister had recently been pilloried on the front page of the *New York Post* as "The Miniskirt Priest" because he had officiated at the wedding of an actress wearing a "micro" miniskirt.

The author with Alex Findlay outside Wendy's
Children's Store on Madison and Eightieth Street, 1966

Alex and I had no problem with changing denominational lanes, and we had a plan for the miniskirt issue. Both of us were well under twenty-five, which we now know is when the brain matures, so we can be forgiven for prioritizing what we wanted to wear at our nuptials over the more mundane aspects of marriage, such as, in my case, the wedding vows. I had recently visited a young artist named John Van Saun whose work I was very interested in, especially a large stain on the ceiling of his East Village tenement and a plexiglass container of months-old Wonder Bread sporting fascinating shades of green mold. John's wife designed clothes for women, and we commissioned her to design our wedding garb. Alex cunningly circumvented the miniskirt ban by wearing a mini *dress*—A-line, very short, white with large yellow-and-white daisies, and a flapper-style cap of the same daisies. I wore an azure shirt with pleated cuffs and collar and a shot-silk white Nehru suit.

Our wedding, indeed, our marriage, revolved in and around Max's Kansas City, so we have to start there. Located on Park Avenue South and Seventeenth Street, owned and managed by the aforementioned Mickey Ruskin, it was becoming the watering hole for down-and-out and rising and risen artists and musicians. An unsung patron of the arts, Ruskin took works of art in exchange for virtually limitless bar tabs. Some of this art was intrusively installed in the restaurant, like the dangerously large, crushed-metal sculpture by John Chamberlain between the front door and the bar, where you might well find the dangerous, large artist himself; Frosty Meyer's laser beam originating from across the street which sliced through the entire bar and backroom at head height ("are you bleeding?"); and the triangular, bright-red Dan Flavin neon sculpture jutting horizontally across what should have been the best corner table in the backroom if not for the cruelly unflattering effects on one's complexion, especially for drag queens.

Max's was a public bar and restaurant, but in order to keep his creative patrons safe from curiosity-driven cultural tourists, Mickey installed doorkeepers, the first of which was Dorothy Dean, a diminutive African American satirist and Harvard grad who worked for drinks, a lot of them. Any well-groomed couple getting out of a private car was told the place was full. Inside, the loose protocol was that macho, two-fisted artists jammed the bar and the booths in the front room. The tables were wide enough that Carl Andre (Minimalist bantamweight) could swing his fist across at Bill Anastasi (Conceptual welterweight) without connecting. The front is where you would find the likes of painter Bob Stanley and Al Hansen (Pop), Larry Zox (hard-edge), and Larry Poons (Op). The backroom was more gender fluid, scattered with refugees from Andy Warhol's Factory, including the very talented playwriting team of Candy Darling and Jackie Curtis. Holly Woodlawn entertained private guests in a badly lit corner booth. There was a door from the backroom to the rear alley where mutually beneficial exchanges took place and illegal substances were consumed, although Brigid Berlin injected through her jeans without leaving the table.

The waitresses at Max's were acclaimed for their charm, intelligence, and ability to quell roaring beasts. Two stand out in memory, Helen Marden (at the time Helen Harrington), who now enjoys a successful career as a painter and Carol Ames who so charmed an Italian lad (now a minor master of the universe) that, when his wife is out of earshot, he still asks me about her even though his sojourn in New York was a brief two weeks half a century ago.

Almost any evening I could be found having dinner in one of the banquettes across from the bar before graduating to a barstool and then, after midnight, moving to the rear. If the backroom was the playpen, the bar was the stage where debates did not always end peacefully. One night, then artist Tony Shafrazi swaggered in after

having been arrested for spraying "Kill Lies All" on Picasso's masterpiece *Guernica* at the Museum of Modern Art. He went to the museum with his unsuspecting fellow artist Larry Bell, whom he had asked to bring a camera. Larry thought Tony wanted a photo of himself in front of the Picasso, but when he started to deface the painting Larry beat a hasty retreat.

The bar was welcoming to single women, not the swinging singles variety, but more along the lines of painter Francine Tint or activist Johanna Lawrenson, soon to go into hiding with Yuppie leader Abbie Hoffman, or photographer Linda Eastman, who one evening casually mentioned she was going to marry a Beatle, which raised a few eyebrows, particularly of those patrons who did not know that her father was not only Willem de Kooning's lawyer but also Paul McCartney's.

At 10 a.m. on June 10th, 1966, Max's was empty except for two men sitting at the bar, Mickey Ruskin pouring them drinks. My best man Gerald Laing had suggested we fortify ourselves for my wedding one hour and fourteen city blocks away. I was in my finery, Gerald less flamboyantly attired in a blue blazer with white piping. Ten years older than me, Laing had been an officer in the British army, stationed in Ireland, before going to art school. He enjoyed much about America but was otherwise a product of his British generation. Men like Gerald and my two brothers, who had experienced the Second World War as young boys, tended to be more traditionally conservative than those of us born at the end of the war. This war generation moved through the turbulence of the 1960s with a greater degree of objectivity than me and my fellow baby boomers.

Laing saw astronauts, race car drivers, and skydivers as heirs to a tradition of male heroism stretching back to jousting knights and more recently the Spitfire pilots who defeated the German Luftwaffe in the 1940 Battle of Britain. His seminal Pop paintings are pae-

ons of tribute to the latter-day daredevils. His essentially romantic sensibility required a succession of fair maidens, and in New York he became attached to a gamine stunner named Galina Golikova. This while still living with his fetching English wife, Jenny. A job for which I did not volunteer was arbiter of this triangle, yet on any given day Jenny might call and say, "Michael, is Gerald going to divorce me and marry Galina?" Or Galina might call with basically the same question. Meeting Gerald for a drink the same evening, he would bemoan, "Michael, I don't know what to do!" Eventually he left the first of his three marriages as I was entering the first of my three marriages. Gerald and Galina's wedding was celebrated on board the *QEII*. Roy Lichtenstein brought the cake sporting Scotland's flag, and so much merry was made that some of us barely made it down the gangplank before the happy couple sailed for England.

Max's was not generally open at 10 a.m. Mickey had come in as a favor to me and Gerald, which he owed us for having been instrumental in his venture's success. I kid you not. We had been among his first patrons who, after a couple of weeks of being forced to listen to "King of the Road" by Roger Miller and "Make the World Go Away" by Eddy Arnold on the tableside jukebox, took him aside and informed him that not everyone loved country music. We suggested a wider selection might be appreciated by his largely urban clientele. We feared he might be offended, but instead Mickey proffered us the brochure from the company that serviced the jukeboxes and said he would order whatever we wanted. Within two weeks patrons could choose between "Substitute" by The Who, "Land of 1,000 Dances" by Wilson Pickett, and "Under My Thumb" by the Rolling Stones, this last being particularly fortuitous since Max's first rock-star patron was Brian Jones.

At the appointed time Gerald and I marched twelve blocks north and across to Fifth Avenue. It was a very hot day. I can't say what

Wedding reception for Gerald and Galina Laing. From left: the author,
Dorothy Lichtenstein, Roy Lichtenstein, Galina Laing, Richard Feigen

made our plump cleric sweat more profusely, the heat or the mini-ness of Alex's outfit. The raucous Albanian-style reception was at Alex's home in Merrick on Long Island. Gerald, with his inamorata Galina, drove us there in his convertible. Many rolls of film were taken by a helpful guest who put them in a brown paper bag which is still missing. Most wedding gifts came in the form of useful envelopes of cash, others in the form of electric carving knives, five in all, less useful. Possibly they were on sale locally. We honeymooned in Venice and returned to throw a twenty-third birthday brunch for Gerard Malanga, our first and last attempt at large-scale entertaining in a small apartment on a nonexistent budget.

Briefly in a Movie, in Briefs

Alex was a good sport while our marriage lasted, which thanks to me, was not long. We went to a lot of parties and openings and often ate at Max's. Warhol's entourage included a young Harvard-educated promotor named Chuck Wein, who had met Radcliffe-educated Edie Sedgewick in his therapist's office and introduced her to Andy. Chuck thought that Alex and I would make good extras in a non-Warhol movie starring Edie and Paul America, another Factory star. There was a script rarely adhered to. Edie played "Susan Superstar" and Paul played himself.

Filming took place on an abandoned farm in Orange County, New York, and Alex and I joined other scantily clad extras playing follow-the-leader across open, rocky fields. The leader was poet Allen Ginsburg. I was less than awed by this encounter with my boyhood hero, particularly when he started to paw my bare chest with his clammy hand. Other than that, we did a lot of nothing. Often the wait was because the stars, director, and crew were squabbling over the dis-

tribution of amphetamines. The project collapsed only to be revived three years later with recent color footage of Edie, now ravaged and fragile, playing herself on an abandoned estate in California, recounting her glory years. What we had filmed in black-and-white was spliced in as flashbacks. *Ciao! Manhattan* (1972) is a cult classic; if you don't blink you can catch me and Alex leaping around in the almost altogether.

Our bliss was short-lived, killed off by my perfidy. Our marriage ended in Max's, where it had started. Alex tossed her glass of red wine into my face when I truthfully answered her query regarding my whereabouts the previous night. We were divorced in Juarez, on my twenty-fifth birthday. Alex moved on to a warmer climate, found a better partner, had a wonderful son, and a thriving business. We met for a gentle, friendly non-wine-tossing lunch when we were much older and I was, possibly, a little bit wiser.

Film poster for *Ciao! Manhattan*, 1972

Chapter Three

*Michael is a good dealer,
but he doesn't know anything
about art.*

GERALD LAING

•

*Do you really like art
or is it just a job?*

JANE FORTH

More Words

Idling at my desk one afternoon in the spring of 1968, I looked up to see a bearded, young giant holding a flat, yellow Kodak box which I guessed contained photographs of his work.

"Can you leave them with me and come back in a week?" I asked as politely as possible. That was the usual system followed by galleries when artists brought in images of their work, most often 35mm slides.

"I'm from California and I may not be here that long," he said with a jovial smile. Something about his bearing and expression prompted me to take the risk of looking at them in front of him, a dangerous thing for any dealer to do, although by then I was adept with ambiguous responses such as "Very interesting" and "I have never seen anything like this."

I opened the Kodak box and took out a pile of 8 × 10 black-and-white photographs of canvases that had words on them in block letters. One of them was:

WHAT IS PAINTING?

DO YOU SENSE HOW ALL THE PARTS OF A GOOD PICTURE ARE INVOLVED WITH EACH OTHER, NOT JUST PLACED SIDE BY SIDE? ART IS A CREATION FOR THE EYE AND CAN ONLY BE HINTED AT WITH WORDS.

I cracked up. I still do. The hallmark of a successful work of art is that it keeps delivering over time.

"These are terrific," I said. "What's your name?"

"John Baldessari."

First Galleries in SoHo

I included John Baldessari in a group of four artists who constituted the first exhibition in the first gallery to open in SoHo. I had taken over 141 Greene Street and was living on the top floor. At first, I used the lower two floors for open storage of gallery artists' large works. Instrumental in demonstrating to me and Feigen that the space could be viable for exhibition purposes was the painter Richard Smith, who encouraged me to hang his new monumental, shaped canvases at Greene Street, even if only for private viewing.

Smith was the first British artist of his generation to have a strong presence in New York. With Robert Morris, Donald Judd, Dan Flavin, and Claes Oldenburg, he was a founding artist in 1961 of Richard Bellamy's short-lived but already legendary Green Gallery. When this closed in 1965, Feigen gave Smith a contract and two very successful exhibitions followed. Smith's early flat abstractions based on the forms and color of popular advertising had given way to solid color, three-dimensional, shaped canvases. I had clients who wanted to see them but there was no space for them to be stored uptown. I already had track lighting, so I painted one long brick wall white and hung *Clairol Wall*. This is where Kynaston McShine saw the painting when making his choices for a three-man exhibition at the Jewish Museum (Gene Davis, Robert Irwin, and Richard Smith).

Quietly authoritative, Smith combined the erudition of a soft-spoken English academic with a deep understanding and attachment to American culture. He also had a love for Italy, where he exhibited at Beatrice Monti della Corte's Galleria dell'Ariete in Milan, the top gallery for postwar Italian and American art. In London, he showed with the Pop-pioneering Kasmin Gallery. Gerald Laing had been a student of Smith's at St. Martin's School of Art, and when Laing scored a cheap return ticket to New York for the summer of 1963,

Smith gave him the telephone numbers of four artists to visit: Robert Indiana, Roy Lichtenstein, Jim Rosenquist, and Andy Warhol.

At this time, I was visiting studios of young artists, like Alex's former fellow SVA student, Billy Sullivan, who in the course of our lifelong friendship has painted each of my three spouses. Billy introduced me to Ronnie Cutrone, who made plug-in floor works of electrical filament encased in oblong blocks of translucent resin. One artist led to another. Feigen was very open to the idea of making the space accessible to the public and suggested I run a shoestring operation which became known as Feigen downtown. I had no rent to pay and two peers who were willing to help me, Fredericka Hunter, a protégé of the de Menils who was taking a break from her studies at the art department of the University of St. Thomas in Houston, and Brian Poitier, an artist born in Mauritius who had been at St. Martin's School of Art in London with Gerald Laing.

Feigen downtown's first show opened on October 12, 1968, with John Baldessari's "word" paintings, David Milne's big illusionistic, hard-edge canvases, Ralph Pomeroy's Minimalist, monochromatic, shaped canvases, and Carol Browne's large, multicolored lightboxes.

Artist-owned and run co-operative galleries had been flourishing below Fourteenth Street for decades, mostly in Greenwich Village. One of these was the Park Place Gallery which in 1965 was on La Guardia Place and West Broadway just north of Houston Street. Paula Cooper, the director of Park Place Gallery, opened the first exhibition of her own gallery at 96 Prince Street ten days after Feigen downtown. This landmark Minimalist exhibition benefiting the Student Mobilization Committee to End the War in Vietnam included works by Jo Baer, Dan Flavin, Donald Judd, Sol LeWitt, Robert Mangold, Doug Ohlson, and Robert Ryman.

Before we opened Feigen downtown, Richard invited Leo Castelli to share the building. We had 7,500 square feet on two and a half

QUALITY MATERIAL ---

CAREFUL INSPECTION --

GOOD WORKMANSHIP.

ALL COMBINED IN AN EFFORT TO
GIVE YOU A PERFECT PAINTING.

Photograph by Dean Brown showing Brian Poitier
and the author at 141 Greene Street on October 12, 1968.
Opening day of the group exhibition *John Baldessari, Carol Brown,
David Milne, Ralph Pomeroy*. Collection Center for Creative Photography

floors. Castelli could use his half for storage or exhibition or both. Ivan Karp was his director at the time, and they instead opted to open Castelli Warehouse on Amsterdam Avenue and 108th Street in December, 1968, where they exhibited projects by John Chamberlain and Robert Morris. Castelli finally opened in SoHo in 1971, after Karp had left and opened his own gallery, OK Harris Gallery, on West Broadway in 1970. This allowed Karp to claim, "The first gallery on West Broadway," now memorialized on a bronze plaque.

Who was first in SoHo? On West Broadway? On Prince Street? Does it matter? At the time we were simply glad to have company in an offbeat neighborhood advantageously near our artists but still light years from where most collectors lived. It was easy enough to stroll a few blocks from their homes on Park or Fifth Avenue to see the new shows on Madison Avenue, quite another to venture below the Village to a part of town that was noisy and unpassable during the week and totally deserted on the weekends. What to wear? Where to eat?

The December 1969 cover of *theArtgallery* magazine was a photograph of five dealers on a climbing tree in the playground of the I.M. Pei's housing complex for New York University on the north side of Houston Street. They are Max Hutchinson, David Whitney, Ivan Karp, Paula Cooper, Stephen Radich, and myself. This illustrated *Where It's Happening*. Genial Max was from Down Under and showed his compatriot sculptor Clement Meadmore. Max claimed to be the first Australian art dealer not to sell paintings of koala bears; David Whitney championed color field painters Ronnie Landfield and Philip Wofford; Ivan Karp showed photorealists Robert Cottingham and Robert Bechtle; Stephen Radich, famous for risking jail defending his artist Marc Morrel against a charge of desecrating the American flag because he used it in works protesting the Vietnam war, also showed Yayoi Kusama.

Downtown avifauna.
From left to right:
Max Hutchinson,
David Whitney, Ivan
Karp, Michael
Findlay, Stephen
Radich and Paula
Cooper

theArtgallery magazine, December 1969
From left: Max Hutchinson, David Whitney, Ivan Karp,
the author, Stephen Radich, Paula Cooper

The press coverage may have been premature. The art world did not flock to SoHo. A handful of dedicated collectors used to visiting studios came in dribs and drabs but the cream of the Upper East Side stayed in their safety zone. My first visitors were artists (Rosenquist, Bob Indiana, Chuck Close, Norman Lewis, Marisol) and British and German art dealers like Nigel Greenwood and Conrad Fischer. My first show was not entirely a flop. Carol Brown, David Milne, and Ralph Pomeroy made sales, although Baldessari puzzled almost everyone. New York found his work neither fish (hard-edge abstract painting) nor fowl (brow-knitting Minimalist and Conceptual art), and besides, it was seriously funny. He got a better reception in Germany thanks to Fischer, who saw his work in my exhibition. Other early visitors were busloads of art lovers from New Jersey, almost exclusively ladies of a certain age, and often in the mornings before their Broadway matinees. I had a comfortable chair next to the front desk which was right by the entrance off the loading dock. Once in a while, Alice Neel would stop in to take a load off, leading on one occasion to a well-coiffed matron whispering loudly to her friend, "That's a bag lady!"

Monet Over Manhattan

Meanwhile I was also taking care of business at Feigen uptown, which was thriving with sold-out solo exhibitions, not only of Richard Smith; both Laing and Riley had four in four successive years. With these successes and a thriving secondary market business, Feigen was ready to make an ambitious move. Claes Oldenburg introduced him to Hans Hollein, a young Austrian whose reputation as a radical architect was established with a small candle shop in Vi-

enna. Feigen purchased a five-story townhouse at 27 East Seventy-Ninth Street and hired Hollein to turn it into both a gallery and a residence. The goal was to earn a permanent place on New York's cultural and social map for the Richard Feigen Gallery, as well as Richard and his new bride, the former Sandra Canning Walker.

Hollein was surprisingly collaborative. Richard, Sandy Leonard, and I sat on the floor when he showed us his blueprints. He was flexible about major issues such as how to get from the first to the second floor. Instead of a discreet one-landing staircase, we opted for mini-Spanish Steps sweeping up two stories from the very high foyer—at the cost of valuable gallery space. Feigen's office was a circular, brushed chrome–sheathed sanctum where clients were sealed inside its womblike interior on a round, plush-red banquette. My office was on the second floor, reached by a chrome-topped balcony resembling the bridge of a Bauhaus yacht. Hollein's original idea for the façade was three giant Oldenburgian doors the height of the building, but settled on two chrome columns which were magnets for amateur photographers.

Claude Monet was our inaugural exhibition, with an entrance fee that benefited the Metropolitan Museum of Art. There were almost fifty paintings borrowed from various museums, as well as a who's who of private collectors from Walter Bareiss and Nate Cummings to Arthur Murray and Sheldon Solow. Monets Feigen had sold to David Kreeger were given pride of place, as well as Mr. and Mrs. Engelhard's *The Artist's Garden at Vetheuil*. The opening party was wall-to-wall with New York's most arrived. Mrs. Feigen was described the next day in *Women's Wear Daily* as "his pretty wife, who looked very Belle Epoque in her black taffeta and lace Adolfo." Bull's-eye! Sandra and Richard were congratulated by movers and shakers like Barbara Walters, Mort and Linda Janklow, and Bob and Ethel Scull. Carol Channing looked stunning on the marble staircase as

Richard Feigen Gallery, *Claude Monet* exhibition, October 1969

Ethel Scull and the author at the opening of the
exhibition *Claude Monet*, October 1969

did Charlotte Niarchos (formerly Charlotte Ford, soon to be Charlotte Forstmann), and Mr. and Mrs. Gil Shiva. Claes Oldenburg and Hannah Wilke were then very much a couple. Jewelry store scion Ronnie Winston arrived with Naomi Sims, a striking fashion model who had recently appeared on the cover of *Life* magazine—my first glimpse of my future wife. Lavish, pre-opening dinner parties were given by Nan Kempner and Mrs. Shepard Norris in their grand salons.

While I could hold my own with the great and the good, my boss tasked me with a diplomatic blocking action between his mother Shirley and the froth of the *crème de la crème*. Feigen's father was recently deceased, leaving Mrs. Feigen with a healthy chunk of Chicago real estate proceeds, some of which funded the chrome palace. Shirley, salt-of-the-earth, proud and loud, was wonderfully warmhearted but possibly not the best guest to be interviewed by the reporter from *Women's Wear Daily*. She deserved to share her son and daughter-in-law's social coronation but not perhaps from the front row. I steered her away from the ladies who lunch toward the less judgmental artists.

Missionary Work

Richard collected well-known people whether they collected art or not. If they did not, it was his mission to show them the light. To keep tabs on the Feigen/Palmer Gallery, he often went to Los Angeles where he was a welcome guest at the homes of Hollywood royalty like Danny Kaye and Kirk and Anne Douglas. He forged a close friendship with Tony Curtis, who collected works by Joseph Cornell. Richard had arranged for Curtis and his wife Christine Kaufmann to visit the artist.

One afternoon Feigen wanted me to meet with "a new client, your age" at the Palm Court of the Plaza Hotel at five o'clock. I arrived before Richard, which was unsurprising as he was chronically late because he wouldn't get off the telephone. I gave his name to the maître d' and was steered to a table at which sat a young man indeed about my age, preppily attired with abundant well-coiffed blond hair and a petulant frown.

"Are you Findlay? Where's your boss?" he growled charmlessly. "I don't have all day."

I had no clue what Richard wanted with this fellow, but I fished around for his interest in and knowledge about art, which appeared to be zero. He volunteered that his family business was real estate; we were at a 0–0 tie. An awkward silence prevailed as our tea cooled. Just as my guest rose to leave in a huff, Richard breezed in, sat down, and launched into a sales pitch for Artemis, his newly formed art investment company. I should have guessed that was his mission. Our young mark listened impatiently with no comprehension.

"Don't worry," Feigen assured me when the young man left. "I'll get him eventually." That was the first but not the last time I was enlisted in an unsuccessful attempt to interest the self-proclaimed billionaire who was to become the forty-fifth President of the United States in acquiring real works of art. He found it less expensive to insist that his reproductions of Renoirs well-known to be in major museums were original.

Artemis was a late-1960s version of the art investment schemes that bloom when the art market is strong and wither away when there is a "correction." Feigen's partners were David Carritt, a legendary discoverer of Old Masters, and the Belgian banker and collector Baron Léon Lambert. It barely got off the ground and floundered over issues of proportionate investment and return, as well as com-

missions for sourcing and sales. This was my first lesson in the pitfalls of art funds, and I have kept my distance ever since.

Men (Only) on the Moon

The good Baron Lambert was advised by Pierre Apraxine, an affable young Russian count who was introduced to me by Kynaston McShine, whom he would later work with at the Museum of Modern Art. Pierre and I became friends, which resulted in an invitation to witness a historic moment in the company of European nobility.

Possibly mistaking my team colors, Pierre invited me to spend the weekend of July 19, 1969, with him and his employer in Brussels. Since I was to be in London the week prior, I was happy to accept. He and I would be staying at the good baron's residence, and I was eager to see what I had been told was a magnificent collection. The address I arrived at turned out to be the gleaming headquarters of the Banque Lambert. A Skidmore, Owings & Merrill building the size of a city block, it was designed by a man whose work I particularly admired, Gordon Bunshaft, who had designed Lever House in New York.

Lambert's private residence was the entire top floor of the building. I was escorted to a private elevator that quickly and silently delivered me into a vast hall dominated by three solemn and formidable bronze casts of *Femmes de Venise* by Alberto Giacometti. I was greeted by the forty-one-year-old Lambert, not as blond and tall as Pierre, but exuding the same nuanced combination of warm, courteous formality. He and Pierre gave me an in-depth tour of his collection, which included a magnificent early Francis Bacon pope portrait, a beautiful blue, white, and yellow Rothko, a 1938 Picasso

portrait of Dora Maar, as well as major paintings by Dubuffet, Magritte, and Miró. This was the first time that I had visited a major private collection in Europe in the company of its owner. What struck me was that Lambert spoke eloquently about his personal feelings for each work, in contrast to my experience with New York collectors who tended to emphasize the circumstances of acquisition.

The three of us had a light dinner served by an ageing retainer named Alphonse. As night fell, Lambert took us out to a balcony that ran around the entire building. Fireworks exploded overhead in celebration of Belgian National Day. Our host pointed out, well below us, the Royal Palace. The next morning Pierre informed me that we would be driving to the Baron's beach house in Ostend to enjoy the sun and sand and watch the much-anticipated landing of the first men on the moon. We were to be joined by two US soldiers stationed in Brussels. By now Pierre realized that he had mistaken my gender preference but was at pains to make sure I would be comfortable. I told him I was happy to be part of the group, although I might not participate in all their activities. In due course we were joined by the civilian-dressed soldiers and the five of us set off in a cramped red Porsche, the baron driving.

In less than two hours we arrived at a white, two-story cottage on the beach. To my surprise Alphonse was already there to carry in our luggage. There were three bedrooms; I was given one to myself. I changed into swim trunks and found my way to the enclosed patio where my new friends were sunbathing *au naturel*. I was somewhat amused they felt the need to adjust their towels but suppressed my desire to say, "At ease, soldiers."

The afternoon was lazy and pleasant. We went into town for dinner after which Pierre explained we would be visiting a men-only bar. Used to the high-camp flamboyance of many New York night spots, gay, straight, or mixed, I was surprised at how subdued and

conservative this turned out to be, the atmosphere more country club than carnival. We were back at the cottage by 1 a.m. and settled in to watch Apollo 11 land on the moon. The living room, like the television, was small. We sprawled in armchairs and on floor cushions with the only light emanating from the glimmering screen. The somnambulant commentary was in Belgian, and I nodded on and off until it was almost dawn, when it became apparent, six hours after the landing itself, that Neil Armstrong was about to step on to the lunar surface. As he did so, I heard the baron's low tone behind me.

"Alphonse, *le champagne, s'il vous plait.*"

The elderly butler tottered into sight, white gloves holding a tray of Moët et Chandon and five glasses.

The Grand Canal Goes Green

Two Feigen artists, painter Bridget Riley and sculptor Phillip King, were chosen by the British Council to represent the United Kingdom at the 34th Venice Biennale. I was invited to be part of the support team and marveled at how skillfully Dame Lilian Somerville installed the two together so that their works were complementary. Over sixty, thin as a rake with steel-gray hair and strong features, Somerville was the longtime ruler of the fine arts division of the British Council and a veteran at choices and installations that outdid the competition in international art events. Bridget Riley won the International Prize for Painting, the first for a Brit and the first for a woman. One of her paintings was the stunning *Cataract 3* (1967), her first move toward color after only working in black-and-white. King's flat-on-the-floor, brightly colored, conical fiberglass sculptures upended sculptural tradition. Despite her patrician bearing, Dame Somerville was a formidable supporter of the avant-garde.

I met and bonded with Diana "Wonky" Kingsmill and Alex Gregory-Hood, partners in the Rowan Gallery, Riley's London dealers. Wonky had the smarts and Alex had the bearing, having jettisoned his position as a colonel in the Grenadier Guards to become an art dealer. Alex introduced me to David Gibbs, a fellow Guards officer who had followed him into the art trade in London. A few years hence David would play an important role in my life.

At the 34th Biennale I witnessed an unsanctioned art intervention pioneering the social activism that would become a keynote of radical art then and now. This satisfied my love of the dramatic as well as my lip service to *épater le bourgeois*. The opening in June was less than a month after protests and a general strike had brought France to a halt. Italian universities were closed, occupied by students and artists among other demonstrators. At the entrance to the Biennale grounds there were barricades to keep protestors out.

I had been tipped off that something would happen early Wednesday morning on June 19 at the Piazza San Marco, so I was there when the young Argentinian artist Nicolás García Uriburu poured a harmless dye called Fluorescein into the Grand Canal. The dye made its way swiftly through the estuary as the waters turned a vivid green. This was not just an aesthetic gesture but purposely focused attention on the pollution of Venice's legendary waterways.

Shock and Awe in the Fatherland

While serious in intent, an action like dyeing the Grand Canal green cannot be done without some degree of festivity and gleeful disruption which I found appealing. There was more in the same vein, some serious, some comical, waiting for me when Feigen and I made our

way to Kassel in Germany for documenta IV, a hundred-day international exhibition that takes place every five years.

Dominated by American Pop, this documenta of more than 150 artists also introduced color field painting, Op art, and Minimalism to a European audience with recently completed works by Roy Lichtenstein, Tom Wesselmann, Bob Indiana, Robert Morris, Dan Flavin, and Sol LeWitt, some made specifically for this exhibition. It was also a launching pad for young British artists, five of whom Feigen represented: Allen Jones, Richard Smith, and William Tucker, as well as Riley and King.

For me it was an opportunity for a first look at the work of young European artists like Alain Jacquet, Konrad Klapheck, Martial Raysse, and Walter Pichler. An even more festive, and comical, outdoor event than Uriburu's greening of the Grand Canal was provided by Christo, whose efforts to erect his *5,600 Cubicmeter Package* (1967–68) was a daily saga. Almost 200 feet high, he billed it as the world's tallest inflatable structure without a skeleton. It looked like a gigantic condom. Two attempts failed, but when several of the tallest cranes in Europe were requisitioned, it was finally raised, wafting proudly in the gentle breeze.

One morning before the official opening of documenta, I wandered into a series of rooms which had an instant and indelible impact on me. I did not know if it was the work of one artist or more than one, or if it was storage for works yet to be assembled and installed. This was *Raum Plastik* (1968) by Joseph Beuys, an artist I had never heard of and virtually unknown in the United States at the time. Two chin-high piles of large felt squares, two copper tables, a sparking conglomeration of an ancient battery, wire-and-glass cylinders on the floor, steel girders of various lengths leaning against the wall, and two rows of five decrepit, open wooden lockers, each

containing unruly collections of everyday objects one would normally discard—dusty, glimpsed, yet potent. This last was the only part of the work that echoed anything in art that I had experienced before—what I glimpsed of the rickety shelves of bric-a-brac in Joseph Cornell's basement studio back in Queens, New York.

I was emotionally overwhelmed. While I found the individual objects enigmatic, I engaged with the whole as a landscape of feeling that returned me to the Blitz-ravaged London of my childhood. I was not surprised to learn that Beuys had been a Stuka tail gunner in the Second World War. Stunned and fascinated I returned to this installation a few days later and became determined to get hold of as much of his work as I might be able to afford. I was fortunate to meet Lo Grigat, a young, freelance German dealer who was as passionate about Beuys as I was. She helped me acquire *Evervess II* (1968), a multiple in an edition of forty that had just been published by art dealer René Block in Berlin. This consisted of a small wooden box containing two bottles of soda, one with the labels obscured by felt. I bought it for myself and foolishly carried it through customs with my hand luggage and engaged in a knock-down-drag-out argument with the inspector, who insisted that I open the soda bottles. I am not sure what clear liquid he thought I might be smuggling.

I made an attempt to engage with Beuys to discuss an exhibition at Feigen and enlisted the help of Hans Hollein, who the artist had supported for an appointment to a professorship at the Kunstakadamie Düsseldorf. Hans reported that Beuys showed some interest but was noncommittal, mentioning he had also been approached by Castelli and, more to the point, had little work available. Most he sold directly to collectors.

A year later, with Feigen's backing and help from Ms. Grigat, I bought a new work by Beuys, *The Sled* (1969), and offered it to Kynaston McShine, who acquired it for MoMA despite grumbling

from some trustees who thought it crazy to pay $25,000 for a wooden sled with a felt blanket, flashlight, and lump of wax strapped to it.

I Know Nothing about Art

Gerald Laing's musing in his unpublished autobiography that "Michael is a good dealer, but he knows nothing about art" reflected his negative opinion about Beuys and other artists I chose to show at Feigen downtown. Predictably the only one he expressed admiration for was David Milne, who had followed him to New York from England, worked in his studio, and made irregularly shaped hard-edge paintings remarkably like Laing's own flat abstract sculptures.

Gerald was not alone in his opinions. What I showed that season barely fit most people's definition of art. My second show was an exhibition of Frank Lloyd Wright windows that Dick Feigen had salvaged from the architect's 1904 Chicago residence for Darwin D. Martin in Buffalo, New York. Framed in pine and hung from the sprinkler pipes, they attracted the attention of architecture students; I sold several. I followed this with fiber artist Claire Zeisler's first New York show. Now heralded as a pioneer in the medium, many visitors told me that her large abstract wall hangings and free-standing sculptures with knotted threads were more craft than art.

Inspired by the happenings of the early 1960s and Uriburu's and Beuys' transgressive, poetical, and ecological actions, I used Feigen downtown as a performance venue. After Zeisler's exhibition I turned the three floors of the building over to John Van Saun for a performance titled *Fire*, which took place in the late afternoon of Sunday, March 23, 1969. Unaided by advice from either the fire department or the gallery's insurance company, John conducted a series of simultaneous slow burnings, all of which were mesmerizing.

I left the galleries unlit and as daylight slowly bled into dusk the whole building glowed. One floor was scattered with small sterno cans constantly burning, another with quickly igniting plastic tubing rigged in parallel rows the width of the gallery, and the third floor held clumps of steel wool that when lit on fire appeared to be slowly consumed by fiery red ants. *Don't try this at home.* We had almost two hundred visitors paying one dollar each. It was all over in three hours, but I had a photographer on hand and archived the event with a modest catalog.

At the time, the United States was slightly behind Europe when it came to performance art, with the exception of Japanese-born artists Yoko Ono and Yayoi Kusama. Ono's *Cut Piece* from 1964 invited audience members to cut pieces from her clothing. In 1965 and 1966 I saw Kusama paint bold polka dots on her naked self and others in street performances. But Van Saun's *Fire* heralded a new wave of performance art that was to flourish in the 1970s with works like the self-mutilating *Shoot* (1971) by Chris Burden and the self-satisfying *Seedbed* (1972) by Vito Acconci. The difference being that Van Saun did not set himself on fire, although a year after *Fire* I invited him to be, literally, the gallery's artist-in-residence. John lived and worked in a small tenement apartment on the Lower East Side. He taped the dimensions of his home onto the floor of the gallery, moved some of his furniture into the spaces, and spent a fair portion of each day in his home away from home, sometimes entertaining friends with a beer and maybe a toke or two. On the walls I hung photographs of his photo-documentary work. In his transported environment John paid no attention to gallery visitors and behaved as if the taped outlines were actual walls. Most visitors took the cue, studying his photographs and taking only surreptitious glances at the resident artist.

Other performances were more conventional. Robert Bücker was an impish young painter enamored of thirteenth-century Florentine

art who created meticulously painted hard-edge abstract interpretations of works such as the *Crucifix* (c. 1265) by Cimabue. Bücker's partner in life and work was sculptor Ralph White; together they designed and built beautifully bizarre and imaginative harpsichords, clavichords, and cembalos. Like Bücker's paintings on wood, the paneling was perfectly finished, the colors often bright, and it was not unusual for an instrument to have each of its four legs quite different in design. Following the success of Van Saun's *Fire* I invited the burgeoning SoHo community to a concert opening of an exhibition of Bücker and White's cembalos.

Andy on Location

Once in a while an even less conventional use was found for one or other of the three floors of the gallery building. What was now my apartment on the third floor had previously been an office space, so I had his and hers restrooms, a tiny kitchen, two bedrooms, and a good-sized living room, as well as 1,200 square feet of empty space ideal for parties. Shortly after coming to one, Andy Warhol asked me if he could bring a crew and film a scene for a movie in my third-floor space, just one day. Of course.

At the time I had taken on a new gallery helper, Todd Makler. His parents, Paul and Hope, were Philadelphia gallery owners and friends of mine. They wanted him to get some experience in New York and I was happy to have him on board. Tall, fresh-faced, and personable, he was the apple of his mother's eye. Hope made it clear to me that he was placed in my care to learn about art, not life.

Fate decreed that I should be out of town the day of Warhol's filming, but I left Todd in charge and told him there would be visitors to the third floor. When I returned to the gallery the filming was long

over. At the front desk, Todd was in a state of barely contained excitement and had traces of lipstick and eye shadow.

"It was fantastic!" he exclaimed, eyes glistening. "I got to lie on the floor and play a dead transvestite!" Andy paid me in kind, with four signed 16mm movie reel canisters. I wish I could remember what I did with them.

My First Rodeo

I was surprised and delighted when a contingent of lively Texans arrived at Feigen downtown during my first exhibition. Art lovers from out of town, whether from Cologne, Germany, or Fort Worth, Texas, thought nothing of finding their way to SoHo at a time when New York collectors and curators who lived on the Upper East Side were loath to journey to the lower depths.

My seven well-heeled, young collectors were brought by the white-haired, mustachioed Henry Hopkins, who had more the bearing of a four-star general than a museum director. In his lowkey, prescient way, Henry was ahead of many artworld curves and had recently become the director of the Fort Worth Art Center. He was leading a mission of his hometown supporters to downtown New York. Young marrieds, Sid and Anne Bass, Jim and Cornelia Blake, Ed and Ann Hudson, were joined by ringleader James J. Meeker. It was a spirited visit and Meeker, as he was known to all, invited me to dine with them that very evening at the Knickerbocker Club on Fifth Avenue, which was socially as far from gritty Greene Street as one could get. Meeker's family was in oil, as in wells, and he was a second son sent to Dartmouth and allowed to indulge his passion for art. Unmissable in cowboy boots and pinstripe suits, a frizzled combover, and an

Portrait of the Art Dealer as a Young Man

excited drawl, he was fast becoming familiar to artists and dealers in New York and California.

It did not take much for me to accept Meeker's gracious and very sincere invitation to visit him and his friends in Fort Worth. One Friday afternoon a month hence, when the airport taxi dropped me at his spacious, rambling house off Camp Bowie Boulevard, the door was wide open. As soon as I set my suitcase down, Meeker handed me a Styrofoam cup of cold beer and a set of car keys.

"Go pick up your date. We're having a party. Guests arrive in half an hour."

"My date?"

"Melanie Sturgis, you'll love her. She's practically next door."

"But I've never driven a car."

Stunned silence. I had once spent fifteen minutes behind the wheel of my erstwhile mother-in-law's Thunderbird in an empty parking lot, a deeply humbling experience. Meeker was incredulous. And persistent.

"It's a Lincoln, it drives itself and she's just a mile down the road."

I looked down at the beer in my hand.

"That's a roadie," he said, which is what they called drinks to go back in the day. "There's a cup holder on the dash."

Terrified but emboldened by a couple of deep swigs, I managed to lurch out of the driveway and jerk my way onto the main drag. A minute later the car just stopped, miraculously by a service station. Out of gas. Back on the road I managed to find the address. At least I wouldn't have to drive back once I picked up my date. Or so I thought. I knocked on the door of a residence the size of a small palace and was greeted by an attractive young woman with a brunette bouffant wearing a very small black dress and holding a very big glass of wine. Clearly not her first. She stepped outside, gulped

half the glass, and took my arm. When I said, "Please drive," Melanie gave me a very wide smile and shook her head vigorously.

By the time we got back to Meeker's the party was in full swing. Henry Hopkins was there with his wife, Jan, as well as the Basses, Blakes, and Hudsons, local artist Jim Ganzer, fellow New York dealer Brooke Alexander, and a houseful of celebrants. As I was to learn, this was typical of a Friday night with Meeker. Quality booze, quality smokes, and quality folk from Texas and parts west. It was through Jim that I first got to know the work of the Californians he and his friends collected—Ken Price, Ed Ruscha, Billy Al Bengston, and Larry Bell. I learned not to be surprised by whomever might roll out of one his many guest bedrooms to enjoy his housekeeper Arnetta's endless breakfast hours. One Saturday morning it was a genially tousled Kris Kristofferson followed by an equally genial but untousled Samantha Eggar.

The next morning I was up with the lark and dragged downtown to buy a pair of Tony Lama silver-tipped cowboy boots—yes, I still have them—for the shit-kickin' Fort Worth Stock Show & Rodeo. Despite the boots, I stood out worse than a city slicker. There were as yet no cowboys in Texas with hair anywhere near their ears. Jim wanted me to meet Beggs, a young friend of his who was a rodeo star. As we wandered through the cattle pens, I noticed a cowboy the size of a small barn door who appeared to be dogging our footsteps.

"Meeker, that big guy over there keeps looking in our direction. It's making me nervous."

"Don't worry. That's Lee Jonas, he's your bodyguard. I don't want anyone messing with you on account of your long hair."

Lee caught up with us and this immediately reduced the indignant stares and muttered comments aimed at me. No wonder. Uncompromisingly short-haired and rugged in a big, black cowboy hat, all-Texan Lee was well over six feet and muscled like the college line-

backer he was. Eventually we came to an open arena where an ex-
tremely agile seventeen-year-old horsewoman in blue-suede cowboy
boots was winning a barrel-roping contest. Brown eyes, blond hair,
and Texan to her toes, this was Janie Beggs.

"Ain't she pretty?" Meeker drawled *sotto voce* out the side of his
mouth. "And her daddy gave her a heard."

I puzzled over this until this was translated to me by Lee Jonas.
Beggs had a *herd* as in cattle, which meant old money, since in Texas
cattle came before oil. Janie loved art, horses, rock 'n' roll, and rock
'n' roll singers.

That afternoon Meeker dragged me to a local art gallery to see the
work of a young Texan painter. I went peaceably enough, figuring
it a small price to pay for his hospitality. I had visited enough stu-
dios by now that I knew how to be polite and supportive and non-
committal. Besides, the artist wouldn't be there.

Which turned out to be a pity because I fell for the work, big time.
Free-floating, rhythmic skeins of subtle colors that nodded in the
direction of color field painting but were much more dynamic and
unrestrained. One, which I bought on the spot, was a deep, rich,
chocolate brown ground deckled with bright-green slashes. I asked
Meeker who did them.

"Young kid from the University of Texas in Austin, Stephen Muel-
ler."

"Can I meet him. Where's his studio?"

"I think he's in New York hanging out with Andy Warhol."

Stephen Mueller was indeed in New York. When I invited myself
to his studio, I recognized the elegant young man who friends had
brought to a party at my Greene Street loft a month earlier.

"Why didn't you approach me then?"

"I guess I didn't want to bother you." He was diffident if not down-
right shy. I loved the work he had been doing since he came to New

Opening of Stephen Mueller's exhibition at Tibor de Nagy Gallery in 1971
From left: Delia Doherty, Berry Berenson, Billy Sullivan, and Amy Sullivan

York. It was clear even then that his work was unique and that he was forging his own path with his own language. I included him in a group show, and he had his first sold-out solo exhibition at Feigen downtown in 1970 before he quickly moved uptown to the distinguished Tibor de Nagy Gallery on Fifty-Seventh Street.

A Texas Five Step

My friendship with Jim Meeker and his crew of young Fort Worth movers and shakers flourished. An alcohol-fueled weekend at his house usually ended with deep discussions about art and life at 3 a.m. in the shallow end of his pool, our homemade smokes held carefully above water level.

As star and director of *Easy Rider* (1969), Dennis Hopper epitomized the antihero of the Sixties. Recently married to and quickly divorced from singer and actress Michelle Phillips, he exuded the macho insouciance that appealed to Meeker and his friends. One of the crazy ideas thrown at me through the fog over Meeker's pool was, "Hey, why don't you get Andy Warhol to do a portrait of Dennis Hopper?"

The notion survived the early afternoon hangover, and the die was cast. Warhol was nothing if not hungry for portrait commissions and I rarely ran into him without him saying some version of "Aww, Michael, you know all those rich people. Get me some portrait work."

His fees were straightforward and not outrageous. One 40 × 40 in. canvas was $35,000, and any number of additional canvases, colored differently, were $15,000 apiece. My commission was 10%.

The Warhol-Hopper commission was conceived largely to honor Henry Hopkins, held in high regard by the younger people he had encouraged to become serious collectors. The decision was made to

commission five canvases, the cost split between five individuals, and initially each person would take possession of one canvas. But then all five agreed they would gift their work to the Fort Worth Art Center, which would then own the complete set. Of the five collectors, four were men and one was a woman. Spoiler alert: the paintings never made it to the museum, now the Fort Worth Museum of Modern Art, and only the woman collector still has hers. To be fair, the buyers were young at the time and stuff happens.

Andy was thrilled with the commission. Dennis was on the Hollywood A-list, and the portrait had strong publicity value. Warhol's technique for his Marilyn Monroe and Liz Taylor portraits was to select an existing photograph on which to base the image. When he began to accept commissions, he asked the subjects to come to the Factory for a sitting which amounted to him taking Polaroid photographs while providing the subject with plenty of dining-out gossip.

Since Dennis was a movie star, Warhol decided to find an existing publicity headshot that he could use. In fact, he wanted *me* to choose the image.

"You know your clients, Michael. I don't know what they would like."

Time-out for an aside about Warhol's personality. He appeared to be non-decisive, deferring to chance or the preferences of his subjects or, when making movies, the ad lib whims of his actors. In practice he was like the magician who says, "Take a card, any card," and makes you take the card he wants you to take. The photograph of Hopper that Andy used, which I believed at the time that I had chosen, was, I am now sure, in fact *his* choice. It then somehow became my job to get permission from Henry Grossman, the photographer who had taken it. Warhol could have taught a master class in passive manipulation. After a lot of haggling Grossman agreed to take a Warhol "Flower" print in exchange for signing the release.

The Dennis Hopper portrait marked a development in Warhol's technique that influenced many subsequent paintings. Warhol's practice was to paint more portraits than had been commissioned and let the client make a choice. The rest he kept. Andy kept everything.

When the Hopper portraits were finished, Meeker and I went to the Factory in eager anticipation. Warhol presented us with two completely different sets of five portraits. The first set involved a standard technique, the outline of the image silkscreened slightly off-register onto squares of hand-painted color occupying the middle portion of each canvas. The second set were surprisingly different. The silkscreen outline had been applied to the canvas first and then Warhol had painted over each image with a different combination of colors in thick, heavy brushstrokes that subverted and almost obliterated the outlines of the image of Hopper's face.

"I'm going abstract," Warhol deadpanned, "but you can have whichever set you like."

At this time no one outside the studio had seen these brand new "abstract" Warhols, so I give Meeker and myself some credit for choosing them over the standard-issue set, hoping that the co-owners would not object. In fact, they were all delighted with the choice.

A year later I had a phone call from Hopper, who had just finished directing and starring in *The Last Movie* (1971). Rumor was that it had gone vastly over a budget which had included a generous allowance for performance-enhancing product.

"Hey Michael, this is Dennis, Dennis Hopper. You got Andy to do that portrait of me, right? I've been making a movie down in Peru with Peter Fonda and Michelle Phillips and we've just finished recording the soundtrack. It'll come out as an LP, and I want to use one of those portraits of me on the cover—can you ask Andy? It'll be great publicity for him."

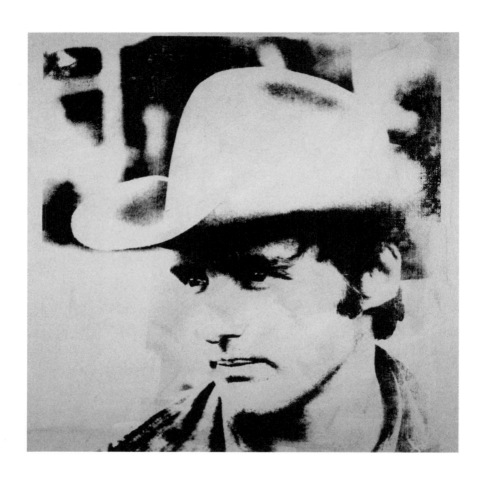

Andy Warhol, *Dennis Hopper*, 1970
Acrylic and silkscreen ink on linen. 40 × 40 in. (101.6 × 101.6 cm). Private Collection

My subsequent conversation with Andy was hilarious.

"Hey Michael, I read about how much that movie cost. What do record companies pay for covers?"

Andy knew better than I did. He had designed jazz album covers during his illustration days and was at the time working on the cover for the Rolling Stones album *Sticky Fingers*.

"I don't know, Andy, around $10,000?" I guessed.

"Yeah, tell Dennis I want $15,000."

When I called Dennis back the conversation was very short and not sweet.

"Fuck him! He's charging me $15,000 for my own face!"

In the end I negotiated what I thought was a very fair agreement whereby Dennis would only pay $1,000 for the right to use the image on the album cover; for an additional $8,000 he could choose one of the portraits of himself Andy still possessed. The money was to come from the movie's profits. Dennis was convinced it would outdo *Easy Rider* in success and fortune. Sadly not. *The Last Movie* won an award at the Venice Film Festival but was otherwise a critical and financial failure immortalized in *The Fifty Worst Movies of All Time* (1978). The film's soundtrack was never released.

This was not the only portrait I commissioned from Warhol. Jane Engelhard asked me to arrange one of her daughter Susan. I sat in on the process, which began with a Factory assistant making up his subject's faces. Warhol took Polaroids of his subjects in whiteface as the basis for the silkscreen of the outline of their features. Susan was chatting while this was applied, and the makeup artist complimented her on the color of her eyes. "It would be nice to have green eyes," Susan said quietly. Warhol overheard, and lo and behold, she got her wish.

Factory Girls

Warhol's power to persuade me went beyond finding him portrait commissions. When my marriage to Alex ended, he took it upon himself to arrange my personal life. Deciding I needed to learn from an older woman, he introduced me to Isabelle Dufresne, aka Ultra Violet, the most cosmopolitan of his superstars. Born into a wealthy family in Grenoble, she was by far the most sophisticated of Andy's crew. Warhol met her when invited to tea by Salvador Dalí at the St. Regis hotel in 1963 and cast her in a movie the next day. She had been the mistress of the Russian American artist John Graham and lived well off the gradual sale of baubles received during an affair with a wealthy married man. Her spacious apartment was on the same block as the Guggenheim Museum. Looming over her generous bed was a six-by-twelve-foot canvas of a giant red and a giant purple flower, one of Warhol's first large-scale "flower" paintings. Younger than Andy but considerably older than the other superstars in his orbit, she was twenty years my senior, an age difference that diminished in time. When she died in 2014 at 79, she was only ten years older than me.

Subterfuge was involved in our relationship, more her need than mine. After goading her toward me, Andy gossiped about us. This was his style, his idea of fun. Once he found out I was no longer an overnight guest at Ultra's, he persuaded me to date his newest superstar, Jane Forth, an elfin young lady with petite features which she accentuated with tightly polished hair and 1920s makeup, eyebrows plucked to invisibility. Her appearance owed much to her friend, Corey Tippin, a Factory habitue and makeup maestro for many of Andy's stars, including Donna Jordan and Geraldine Smith, although he freely admitted some of his best ideas came from the fabulous Candy Darling.

Andy's late-night telephone buddies were Ray Johnson and David Bourdon. Both informed me some years later that he had fixed me up with Jane "because don't you think she looks like his wife Alex?" Ultra Violet was well known on the party circuit and did not need me to take her out and about, but Andy was launching Jane as a new superstar, the female lead in *Trash* (1970). Andy wanted me to take Jane to gallery and museum openings as indeed I did.

Our first date was, naturally, Max's Kansas City, guaranteeing maximum blab. Jane confided in me that she was from Detroit and, rather emphatically, the smart suburb of St. Clair Shores. She had a slightly nasal voice, bud-like lips, and faraway eyes. Her father was a friend of Andy's from the 1950s. She had a natural talent for deadpan humor that was put to good use in Warhol's improvised movies. She once asked me, at a delicate moment, "Do you really like art or is it just a job?"

Andy was on the phone to David Bourdon after our first date.

"David, do you think they slept together?" A somewhat naïve question given the mores of the time.

We hit the town hard and were together for a year, during which time Jack Mitchell persuaded us to bare all in a risqué photo shoot for *After Dark* magazine. Jack was the premier photographer for the dance world and, helped with my introductions, was turning his attention to people in the art world.

I took Jane to a party that Ronnie Winston gave for Dr. Timothy Leary, his former professor at Harvard. Ronnie was still dating Naomi Sims whom I had more than noticed when he had brought her to the grand opening of Feigen's new gallery back in 1969. Naomi was more intrigued to meet Jane than me. As we left, I noticed Naomi on a couch next to the party's honoree, patiently but firmly fending off the advances of the "turn on, tune, drop out" avatar of LSD, more ageing satyr than counterculture hero.

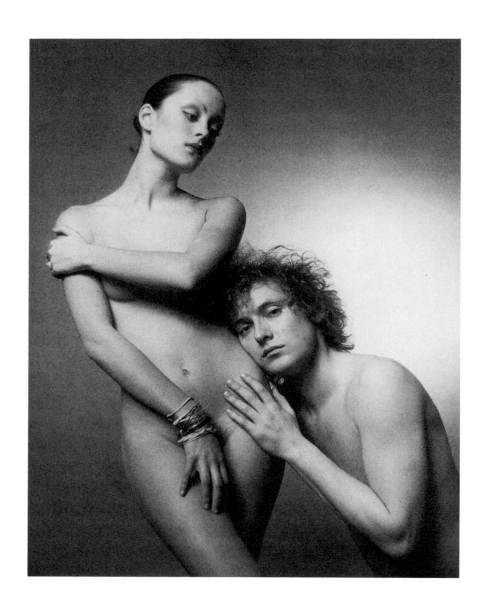

Jack Mitchell, the author with Jane Forth, 1970

My most memorable date with Jane started out as a routine dinner at Max's. As we made our way to our regular table, we encountered a mini filmset. Large lamps on tripods lit up a table for four in the middle of the backroom. Seated at this table were Warhol movie stars Candy Darling (*Flesh*, 1968) and Eric Emerson (*Lonesome Cowboys*, 1968), along with the hottest couple of the day in "real" films, Jane Fonda and Roger Vadim. Vadim wanted to make a documentary about Jane and himself in New York, and this was the "hanging out with the underground" scene. Like most of the other regulars Jane and I were not too happy being involuntarily cast as extras in a manufactured event for celebrity tourists. Cameras were rolling and Candy and Eric looked uncharacteristically uncomfortable, nodding politely, trying not to talk with their mouths full.

This stilted *cinema verité* ended abruptly with the loud entrance of Andrea "Whips" Feldman, who also called herself Andrea Warhola. Another of her nicknames was "Crazy Andy." She worshipped Warhol and was more energetically dysfunctional than all the Factory girls and boys put together. A frequent patient in the psychiatric unit of Bellevue Hospital, she had major roles in three Warhol movies, including *Trash*, and was a good friend of Jane's. It was difficult to tell if her speech and appearance at any given time was the result of alcohol and drugs or calculated theater, but this evening she was in rare form and leaped onto the table next to the overground and underground movie stars. Andrea and fellow Warhol acolyte Donna Jordan were known for late night performances of "Showtime," which involved jumping on tables to reveal undergarments, or lack of, as the case might have been.

Jane and I looked at each other apprehensively, expecting Andrea to go full monty for Vadim's camera. Instead, she rocked unsteadily on the table, spread her arms dramatically, and, looking directly at

Ms. Fonda, loudly proclaimed, "You, Jane, are a very great actress, but I, I am a STAR!"

With this Andrea launched herself onto Barbarella's lap, gluing their lips together. Owner Mickey Ruskin and his beefy manager heard the ruckus and rushed into the backroom. They grabbed Andrea like a sack of potatoes and carried her horizontally through the narrow restroom passage to the front room, past the banquettes, and pushed her, screaming, headfirst through the gaggle of artists cramming the bar, and out the front door, where they threw her into the gutter of Park Avenue South and Seventeenth Street.

High Rollers in Riverdale

This was the era of no-holds-barred loft parties, one of the wildest of which was given by Walter Gutman, an ebullient stock market analyst, artist, and underground filmmaker who was enthralled by strong, as in iron bar–bending, women. His current amazon was employed by Barnum & Bailey's circus, then in town. He invited the stars of the art world to meet the stars of the circus world. The dashing blond lion tamer Gunther Gebel-Williams turned out to be likably modest, and I met a fetching aerialist who subsequently allowed George Segal to turn her into the white plaster sculpture *The Girl on the Flying Trapeze* (1969). I was thrilled when she waved at me from the roof of the tall tent in Madison Square Garden.

It was at that party where I spotted a lanky young lady with long, brown hair, a radiant smile, and sparkling eyes dancing with my friend Mike Abrams, son of the collector-publisher Harry Abrams. He didn't introduce me, but when the circus and my trapeze lady left town, I tracked her down and asked for a date. I was bunking in a

George Segal, *The Girl on the Flying Trapeze*, 1969

Plaster, metal, and rope. 96 × 59.8 × 24 in. (243.8 × 152 × 60.9 cm). Private collection

one-bedroom basement apartment on West 9th just off Fifth Avenue, subleased from a young man named Justin gently touched with Asperger's syndrome. He collected vintage policeman's helmets which he often wore. He aligned the furnishings of his apartment symmetrically against the west and east walls. The rent was affordable, but I was obliged to maintain the integrity of his placement.

Carly Simon arrived on my doorstep and since it was pouring with rain we went next door to the Penguin restaurant, later the infamous Marylou's. We got along and by dessert had exchanged well-edited life stories, as one does. She had a brief stint at Sarah Lawrence College but wanted to pursue a singing career. She had been on a musical television show, *Hootennany*, with her sister, Lucy, when in high school, and their older sister, Joanna, was a budding opera star. Younger brother Peter wanted to be a photographer. She told me her father was in publishing, but I did not make the connection to Simon & Schuster. I had bought, but not yet played, Bob Dylan's new album *Nashville Skyline* (1969), so we went back to my place and put it on the turntable.

Carly's mother, Andrea Simon, was a powerhouse Civil Rights organizer, and our next date was at her family home in Riverdale, at a "casino" evening to raise money for the NAACP. This was my first time in the Bronx, and I was amazed at the grandeur of the homes. Although it was a crowded event, Carly made sure I met her siblings and her mother. Energetic and vivacious, Andrea greeted me warmly and urged me to purchase as many poker chips as I could afford while wishing me good luck in losing them! I had no idea how poker was played, so I headed for the spinning wheel. I won big, beginner's luck. I had bought about $20 in chips and by the end of the night I had almost $60. When it was time to leave, I asked Andrea where I cashed in my chips.

"Didn't Carly explain? You donate them back for the cause. Gam-

bling in homes is illegal, we are just having fun and raising money. Thank you!"

We were together about a year, had a lot of fun, and parted friends. Her uninhibited enthusiasm for life and her passion for music were manifested by bursting into song, even as we walked down the street. No ticket required.

A Model Art Dealer

As the courtship between art and fashion was growing steamy, I took the high ground when it came to copying paintings onto dresses, but eagerly grabbed a promotional opportunity that the fashion world served up to me. I was inordinately attached to a high-collar, double-breasted, ankle-length, black, crushed-velvet coat picked up at Granny Takes a Trip on the King's Road in London. One morning I had a phone call from Chris von Wangenheim, a young German photographer I had recently met at a dinner party given by Fred Hughes.

"Do you still have that black velvet coat?" he asked.

"Sure," I replied. "Why?"

"If you can be at my studio by 2:30 p.m. wearing that coat I think I can get you some publicity."

"What do you mean 'publicity'?"

"You'll see. Just come and wear one of your silk art deco scarves."

It was a typically quiet day on Greene Street. At two o'clock I found myself escorted off the elevator in a Chelsea loft building by a young assistant who marched me straight onto a brightly lit, all-black set and, grabbing my shoulders, positioned me next to a tall, blonde woman and told me not to look at her but the camera. Chris was facing us behind his equipment. All I could think of was David

Hemmings playing the raffish, David Bailey-inspired London photographer in the movie *Blow Up* (1966). I had no idea what to do but was wheeled through the shoot by Chris's good humor and the whispered advice of the young lady next to me, obviously an experienced model. The results were published in *Harper's Bazaar* a few months later where I was mentioned as a "Young mover . . . [and a] quick-minded force behind the growing art community in New York." This was followed by a portentous quote with strange syntax: "'We hold within us the capacity to destroy what we were looking for,' says Michael Findlay, vice president of the Richard Feigen Gallery. 'I don't want the Cast Iron District with people uptown to become chic, selling their townhouses and moving down.' Rather he envisages a community of artists and artisans that will preserve the architectural and social integrity of the resurging neighborhood." More than ironic given the chicness of the spread itself and the itemized high-end designer items worn by my companion. I also seem to have given myself a promotion.

After it was a wrap, I found myself in the elevator with the model who in a light-German accent introduced herself as Margrit Ramme. This was the first time we had really looked at each other. She was as friendly off camera as on, so I took a chance and, yes, she gave me her telephone number. Shortly after that she terminated her relationship with Errol Wetson, heir to the Wetson Hamburger chain. Margrit, a former Miss Hamburg, was one of Eileen Ford's top models. With the high demand for blondes, Eileen scoured Germany and Scandinavia for new talent. Eileen was an excellent mother hen and fiercely protective of her brood, particularly those from overseas. Our first date was a party at Eileen and Jerry Ford's home where I was given the once-over and deemed suitable. I was surprised to run into the artist Jack Youngerman, who at that time I admired as much for having been married to actress Delphine Seyrig as for his paintings.

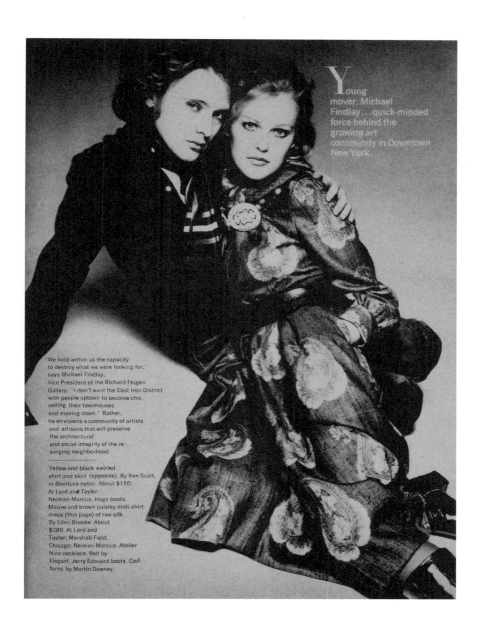

"We hold within us the capacity
to destroy what we were looking for,"
says Michael Findlay,
Vice President of the Richard Feigen
Gallery. "I don't want the Cast Iron District
with people uptown to become chic,
selling their townhouses
and moving down." Rather,
he envisions a community of artists
and artisans that will preserve
the architectural
and social integrity of the re-
surging neighborhood.

Yellow and black swirled
shirt and skirt (opposite). By Ken Scott,
in Bandura nylon. About $150.
At Lord and Taylor;
Neiman-Marcus. Haga boots.
Mauve and brown paisley midi-shirt-
dress (this page) of raw silk.
By Ellen Brooke. About
$280. At Lord and
Taylor; Marshall Field,
Chicago; Neiman-Marcus. Atelier
Nina necklace. Belt by
Elegant. Jerry Edouard boots. Coif-
fures by Martin Downey.

The author with Margrit Ramme, *Harper's Bazaar*, June 1970

That same black velvet coat also won me the most lucrative sixty-second gig of my life. Once again, a late-morning telephone call came in while I was agonizing over whether to make a sandwich or go out to lunch at Fanelli Cafe. It was Mary Louise Weller, an actress and model and a friend of a friend.

"Do you still have that coat? My boyfriend is shooting a commercial, the studio is in the Village, can you be here by one o'clock?"

"I was just going to have lunch."

"No lunch, but if it runs, you'll get residuals."

"I'm in." I knew from Margrit that "residuals" were the modeling world's pension plan.

"One other thing, do you have a pair of shades?"

"Sure."

"Wear them," and she gave me the address.

It was a wide, two-story building with black garage doors and a bell that was hard to find. Mary Louise slipped me through a side entrance into a cavernous space and steered me to a tape-marked spot in the middle of the floor facing a group of people I couldn't see because of the bright lights blinding me.

The boyfriend emerged from behind the lights and shook my hand.

"Did you bring your shades?" he asked. I took them out of my pocket.

"OK, so what you are going to do is put them on and stand with your back to the camera. When I say 'go,' just turn around, look at the camera, and take them off with your right hand, got it?"

I was too naïve to ask him what the commercial was *for*, but I assumed this was some kind of warmup exercise and that my acting talents would be required for the real shoot. I played along, and when I got the word, turned slowly, looked toward the bright lights, took off my sunglasses, and tried not to blink.

"Great!" I heard from Mary Louise now behind the camera. "We just have something for you to sign."

"That's it?" I must have failed the screen test.

"Yes, you were perfect, one take was all we needed." And I was back at my desk, hungry, by a quarter to two.

I had almost forgotten about this when, a few months later, Gerald Laing said he thought he'd seen me in a television commercial, or at least "someone wearing your pimp coat."

Two weeks later I got a check for $350, and on the first of the month for the next two years, one for $163.75. The commercial was for Folgers Coffee. It began with singer John Sebastian of the Lovin' Spoonful sitting on the steps of St. Joseph's Church on Sixth Avenue in the Village, chatting with the pastor, followed by a series of shots of hippish youngsters, one of which was yours truly.

Not long after that I had another super-swift photo session that brought slender fame and no fortune, this time with Irving Penn. I got a call from *Vogue* to be at his address on very short notice, and I arrived to find I was one of eight youthful art dealers to be in a group photograph. An assistant hustled us into a brightly lit space, directing us not to remove our coats as she quickly arranged us behind and in front of a long banquette facing a mounted Rolleiflex camera. Once we were settled, Penn walked in quickly with a cheerful "good morning," looked briefly through the lens, then up at us, and said, "Ready." He pressed the shutter release and with a nice "thank you" marched straight out again. Under a minute. I was very impressed.

Margrit and I were popular guests at swanky events. We were willing to dance for our supper, and to my eternal chagrin this was immortalized by a photograph of us in full motion taken at the Centennial Ball of the Metropolitan Museum of Art by Garry Winogrand. Margrit's bust is testing the boundaries of her Ossie Clark dress and

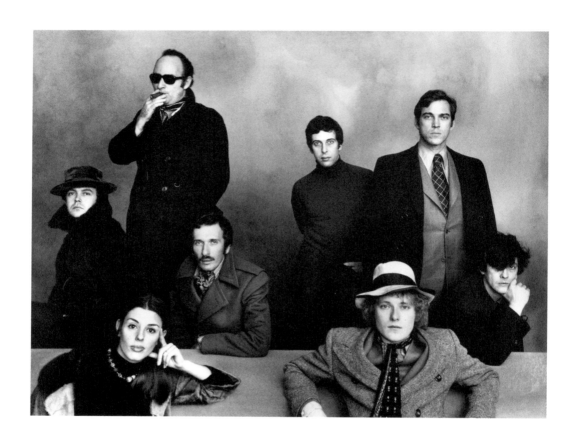

Irving Penn for *Vogue*, 1970. Standing from left: Ivan Karp, Klaus Kertess,
Fred Mueller; seated middle row from left: David Whitney, Arne Glimcher,
Dick Bellamy; seated front row from left: Paula Cooper, the author

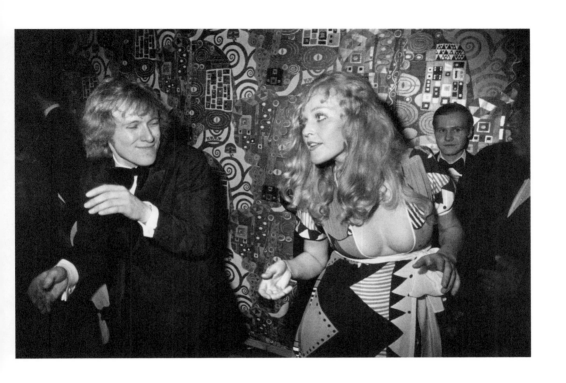

Garry Winogrand, *Untitled*
(The Centennial Ball at the Metropolitan Museum of Art), 1969
8 ¾ × 13 in. (22.2 × 33 cm). Private collection

I am leering at her while inventing the moves that Elaine Benes made famous in a *Seinfeld* episode. Another photo of Margrit gazing dreamily at me made *Newsweek*. She was upset that only my name was mentioned. But neither of our names made it into the photograph of us in the controversial memoir *Making the Mummies Dance* (1993) by former Met director Thomas Hoving, who presided over the centennial celebration. Smiling broadly, I am squeezed between Margrit and her fellow model Princess Elizabeth of Toro, later Uganda's foreign minister under President Idi Amin. I had an exciting turn dancing with Princess Elizabeth since her décolletage proved that with enough bounce escape was possible.

Who's on First?

Not all artists were outraged to see their work translated onto fabric. The photographer and entrepreneur Bert Stern had a mutually profitable approach that appealed to a number of leading contemporary artists. Stern had made his name as the director of a documentary about the 1958 Newport Festival, *Jazz on a Summer's Day*. With his wife, reigning ballet star Allegra Kent, he was a dedicated and respected collector of contemporary art. A sought-after fashion photographer, his vast studio was a former public school on Sixty-Second Street and First Avenue which bustled with celebrity visitors from the worlds of fashion and art as well as the movies, theater, and dance.

When Bert opened an emporium called On First devoted to functional goods designed by artists, the cover of *New York* magazine blared "New Action On First Avenue," and the lead article was about "the Superstore." For its brief, shining life on First Avenue and Sixty-Third Street, this was a mecca for what Julie Baumgold in her

article describes as "professionally happening people," mentioning then New York Senior Senator Jacob Javits's wife Marion, as well as mega collectors Cecile Bartos and Vera List.

For sale were silk scarves by Bob Indiana, paper plates by Gerald Laing, plastic lamps by Billy Apple, wallpaper by Roy Lichtenstein, and a six-foot ribbon of transparent silk that creator James Lee Byars proffered as "Mask or Underwear." Also available were scarves that Stern himself silkscreened with his photos from Marilyn Monroe's last photo shoot. Despite such innovations as two-way mirrors in the dressing rooms, catering to both exhibitionists and voyeurs, On First lasted less than a year. Bert's friend Warner LeRoy did better next door, turning a small movie theater into the hugely successful singles bar Maxwell's Plum, which had a twenty-two-year run. My then wife Alex was the chief salesperson at On First, which was managed by Gerald Laing's then wife Galina, who played a major role in persuading artists to design for the store.

The Girl with a Gun

Galina's big catch was Warhol. Galina and Bert invited Andy to lunch on Monday June 3, 1968, for a pitch meeting. Andy was encouraging but noncommittal, and a follow-up meeting was scheduled. When Warhol returned to the Factory, he was shot three times with a .32 Berretta by Valerie Solanas, a young woman who accused him of stealing the script of her play *Up Your Ass*. Two bullets missed but the third penetrated his stomach, lungs, and spleen. She shot once at visiting writer and curator Mario Amaya, wounding him in the hip, then turned her gun on Fred Hughes, but it jammed, and she fled.

I got the news two hours later during the opening party for the exhibition of Bridget Riley's new work at the Feigen Gallery. I was

standing at my desk, a glass-topped table by Diego Giacometti, talking to Robert Scull when my phone rang.

"Michael? It's Bob. [Robert Indiana] Andy's been shot. At the Factory."

"That's awful? Is he OK? Not Dorothy again?" Performance artist Dorothy Podber had visited the Factory in 1964 and put a bullet through the foreheads of four paintings of Marilyn Monroe stacked one behind the other.

"No, that nut Valerie Solanas. Andy's in the hospital, it's serious. Mario also got hit, but not as badly."

I hung up and turned to Bob Scull.

"You look terrible," he said. "What's the matter?"

"Andy's been shot at the Factory. He's in the hospital, it looks very bad."

Scull took in what I was saying as I waited for his expression of sympathy and concern. He was one of Warhol's first major collectors and had commissioned *Ethel Scull 36 Times* (1963), soon to be shown at the Metropolitan Museum. He owned many major paintings by Warhol. Andy considered Bob and Ethel not only patrons but friends. The taxi magnate kept looking at me. I could almost hear his brain ticking until he finally spoke. "Andy brought this on himself," he said. "Surrounded by all those druggies at the Factory." He turned on his heels and left.

The same day that Warhol was shot with a gun that Valerie Solanas had stored under artist May Wilson's bed, May's close friend Ray Johnson was mugged at knifepoint. Two days later Robert Kennedy was assassinated. 1968 was turning out to be a violent year in America. Reaction was swift. Ray moved to Locust Valley on Long Island to spend the rest of his life in "a small white farmhouse with a Joseph Cornell attic" and Fred "narrow escape" Hughes transformed Warhol's Factory from an emulation of the *Satyricon* to what

might pass for the offices of a hip advertising agency. Fred, a protégé of Dominique de Menil, came from Texas. When he arrived in New York he was dubbed "Penny Hughes" by Ray Johnson, an homage to Fred's well-worn penny loafers, though before long he was wearing Armani. Fred was joined by Vincent Fremont, a talented young man from San Diego, and together they steered Warhol out of the shadowy underground into the limelight of uptown publicity. Appointments had to be scheduled and there was always someone by the front door, which was co-guarded by Cecil, a large taxidermy Great Dane that once belonged to Cecil B. DeMille. Catered lunches were served to B-list celebrities and socialites, potential portrait commission subjects. Warhol was moving his circle away from Holly Woodlawn looking for love in the back room at Max's Kansas City and closer to *Vogue* editor Diana Vreeland looking for fashion news in the front room at La Grenouille.

The Press finds SoHo

Meanwhile, the downtown scene was becoming respectable. Rosalind Constable was the Vasco da Gama of the New York underground, bringing tales of exotic art and artists, and even art dealers, to the attention of the suit-and-twinset wearing readers of family magazines—thus "New Sites for New Sights" in the January 1970 issue of *New York* magazine extensively covering the Paula Cooper Gallery, Ivan Karp's OK Harris Gallery, and "the downtown Feigen Gallery managed by Michael Findlay without uptown interference." We were finally on the map, and on Saturdays intrepid collectors from the far reaches of the Upper East Side ventured below Houston Street, some for the first time in their lives.

The surprise I had for them in March 1970 was John Baldessari's

first solo exhibition in New York. What seemed to him and me an elegantly simple proposition ended up bewildering most of the New York art world. Based on a comment by abstract painter Al Held that "Conceptual art is just pointing at things," Baldessari assembled a selection of 35mm slides of photographs he took of his friend George Nicolaidis pointing at a variety of household objects. He then commissioned Sunday painters, some of whose work he had seen at county fairs, to each choose an image which they were to render on a supplied canvas. Below each finished work he had a sign writer letter the name of the artist: THIS IS A PAINTING BY HELENE MORRIS. There were fourteen such works in the exhibition.

The images on Baldessari's commissioned canvases were all accomplished amateur examples of photorealism, but the works themselves were conceptual. Or were they? Furrow-browed, black jeans–wearing conceptualists thought them frivolous, and, after all, painting was dead. The reigning professional photorealists thought Baldessari was mocking them by demonstrating that Sunday painters could match their skills. Publicity like Constable's article in *New York* magazine was now drawing art lovers from as far away as the Upper West Side and New Jersey. I spent a lot of time explaining why, despite fourteen paintings clearly labeled as by fourteen different artists, it was not a group show.

My art education was practical rather than academic, and I would have been hard put to describe my taste. I was partial to off-menu artists like Baldessari and Bruce Nauman who had yet to be categorized. I did not have a lot of time for contemporary work that seemed to hew to traditional approaches. Other than Billy Sullivan's portraits, I had a blind eye for painterly figurative work. I saw Francis Bacon's exhibition at Marlborough Gallery in 1968 and thought the work overrated and the gold frames pretentious. When the Guggenheim showed *Picasso—The Last Years* in 1984, I still did not warm

Rosalind Constable, "Art Moves Downtown,"
New York magazine, January 12, 1970

to them. Like many others, David Hockney being a notable exception, I was too married to the cooler movements of the day to engage with their florid eroticism and drama. At the other end of the spectrum my cosmopolitan and erudite dealer friend Tibor de Nagy tried in vain to interest me in his artist Fairfield Porter, whose restrained landscapes I deemed old-fashioned. However, on a visit to London I came across a landscape *sculptor* whose work first intrigued me and then wreaked havoc.

Tremendous Chaos Ensues

One of my friends in London was cherubic, curly-haired Bernie Jacobson, a successful publisher of prints by British artists. He had recently added paintings and drawings to his repertoire—and apparently small sculptures. Chatting with him in his office my eye caught sight of what appeared to be a brightly colored miniature rockery, imitating what might be found in a typical English garden, complete with grass, flowers, trees, and shrubs. It was made of plywood, urethane foam, and flock fiber. Not more than sixteen inches square and eight inches high, it had a surreal quality, a garden more remembered than real.

"Who made this Bernie, and what is it?"

"He's great," Bernie replied. "He's going to be very important." Art dealers are not known for understatement. "His name is Ivor Abrahams. He's a genius. You should show his work in New York. How long are you here? We can visit his studio."

We did. Ivor turned out to be as strange as his work, if not stranger. In his mid-thirties, he had the wizened appearance and gruff attitude of an aging gnome, appropriate for a man making faux gardens. He had the flat Lancashire accent of Wigan, where he was born, and

a hand-rolled cigarette glued to his bottom lip. Ignoring the fact that his London dealer had brought a New York dealer to see his work, his conversation was a bitter litany of complaint about lack of recognition. He had the determined negativity of a much older artist.

Ivor's studio was very much like the man himself, small, cramped, and disheveled, and there was not an abundance of work to see, but I was taken enough by what he was doing to suggest that if he could make eight to ten sculptures similar in size and type to what he was working on, I would give him an exhibition at Feigen downtown the following December or January, the details to be worked out between me and Bernie. I finally got a cracked smile and a nicotine-stained hand to shake.

I modestly envisioned that a nicely installed, well-lit exhibition of his colorful and intriguing little gardens would appeal to some of my clients, and that at around a thousand dollars each I might sell a few. I would share my commission with Bernie, of course, and there would be shipping costs, but I was quite optimistic. I only needed to use the first floor, which would leave the second floor free for a group show at the same time. One luxury I enjoyed at Feigen downtown was an abundance of space.

Transatlantic communication was still largely by mail, with the occasional phone call. I kept in touch with Bernie, who told me that Ivor was very excited and working hard over the summer on the exhibition for me. "I've described the gallery to him, and he can't wait to see his work shown in New York." By October I was asking for photographs of what he was doing both to show clients and for advertising, but it was like pulling teeth.

"He wants it to be a surprise," Bernie told me when I finally called him. "He won't even let me see what he's doing. Call it *Ivor Abrahams—Recent Sculpture*." Naïve or distracted, I ignored the warning signs even when Bernie wrote to tell me that the works had been

shipped, by sea rather than air, "to save money," and I should expect them the last week in November. The show was advertised to open on Saturday, December 12, 1970.

At the end of November, the Port of New York longshoremen went on strike. The shipper told me crates with my sculptures were in a container that had to stay on the vessel. I called Bernie in a panic. He called back in a couple of hours.

"Don't worry Michael, Ivor will be in New York in a few days."

"So what! I need his bloody sculptures more than I need him. We open in two weeks."

"Ivor has a plan, just find him a place where he can work."

I appealed to Jim Rosenquist who was spending time in his Florida studio. He generously allowed Ivor the use of his studio on Chambers Street. Ivor worked night and day until Friday December 11th and made twelve stunning works on paper, each 20 × 30 inches. Bright-green flocking and citrus-yellow gouache conjured up the same eerie magic as his miniature gardens. People loved them.

The "emergency" exhibition was up a week when the strike ended. I got a call from my shipper.

"The container's been released. We can have it to you by tomorrow"

"I don't need the container. I just need the crates with the sculptures. There can't be that many."

"I'm not sure you understand. The whole container is yours. It has to go on an outsize flatbed truck and New York City regulations require a motorcycle escort."

I was dumbfounded.

"Costing how much?"

"About $500."

The next day I became deeply unpopular with my neighbors. Between Houston and Prince, Greene Street was blocked for several hours while a series of huge crates were unloaded from a container

on a fifty-foot-long flatbed truck. Luckily, we had a loading dock. Inside the crates were three disassembled, *life-size* gardens. Resembling stage sets, they were not heavy but huge and unwieldy. I begged the owner of the building opposite to let the riggers attach wires so we could swing a ten-foot high, thick-leaved arbor on crazy paving with a faux-stone bench into my second-floor space. The sculptures were made from the same fragile, highly flammable materials as his much smaller works—latex, styrene, polypropylene, and flock fiber. Of the three full-scale installations, only two could actually fit inside the gallery, the third never saw the light of day in New York. The arbor and bench was a piece called *Retreat* and eventually I found it a home at Vassar College.

I was fit to be tied, but it was useless getting angry with Ivor. Extolling the generous spaces at 141 Greene Street, Bernie had inspired him to reach for the stars or at least our very high ceilings. Ivor's version of events surfaced many years later in a published interview:

> *Bernard organizes a show in New York with Michael*
> *Finlay (sic) at the Richard Feigen Gallery. I take on Robert*
> *Fraser's old store in Tabernacle Street as a studio and*
> *work round the clock to get the show built. Everything is*
> *over-size and won't fit in the containers. Tremendous chaos*
> *ensues.*

When we finally got two out of the three big works installed, I had to admit they were very impressive and like nothing I had ever seen in a gallery before. The problem was finding buyers.

"Don't you like them?' Ivor asked.

"Ivor, I think they are great, but they can't go outdoors and are too big to fit in any collector's home."

"Well, Michael, they don't have to be expensive." Which was the first and last time an artist said that to me.

Just Mad about SoHo

The character of SoHo as the place for intrepid collectors to discover new talent while dodging trucks on unswept sidewalks lasted just seventeen months. In March 1970 this headline appeared in the *New York Times*: "Palley Gallery Opens Downtown in Uptownish Style."

Reese Palley was a flamboyant former economist who made a fortune selling porcelain birds by Edward Marshall Boehm in an emporium on the Atlantic City boardwalk. His new bandwagon was the Pattern and Decoration Movement. The *New York Times* article was by the perceptive and droll Grace Glueck:

> *The walls boasted huge color paintings by Robert*
> *Zakanych, happily ignored by several thousand guests.*
> *A fountain bubbled with sparkling wine (American), and*
> *clustered around it were long-haired artists and short*
> *haired collectors and girls wearing minimal bras.*

Palley boasted of supporting artists interested in "environmental and ecological problems," and that he was working on a holograph room so that artists could make three-dimensional photographs with laser beams, thus establishing that in terms of new artspeak at least, he was decades ahead of the rest of us. With intentional irony Glueck established a SoHo pecking order by reporting that Palley was "magnanimously welcomed" by his "chief competitor," Ivan Karp, who had opened just five months earlier. I liked Zakanych's work and dropped in to see the exhibition and meet Reese, a tall, bearded

Map for an art-themed tour of SoHo, May 2, 1971.
SoHo Artists Association Records, 1968–1978,
Archives of American Art, Smithsonian Institution

hustler sporting a trademark red beret. It was rumored, correctly, that when operating his gallery of ceramic avians, he billed himself as "Merchant to the Rich," and unabashedly advertised that a $700 bird would be worth $10,000 "when it grows up." Fast-talking Ivan Karp with his trademark cigar was going to get a run for his money. What innocence SoHo may have had was definitely now lost.

New Art Grows Up and Goes Up

Coincident with the greening of SoHo, works of art made in studios there in the early 1960s hit the big time in 1970 when twenty-one-year-old wunderkind James Mayor, on sabbatical from his father's gallery in London, organized a November auction at Parke-Bernet of Pop objects, including Indiana's first *Love* painting (1965) and Lichtenstein's two giant brushstrokes *Big Painting No. 6* (1965). Among the sellers was the still active collector Robert Scull, who consigned Jasper Johns's 1962 *Two Flags* and a life-size kitchen stove (pots and pans and tasty food included) made by Claes Oldenburg in 1962. Asked why he was selling, Scull told Grace Glueck, "We've decided to let these few things go out into the world because they're history, darling—and I'm not involved with history."

Parke-Bernet was now owned by Sotheby's, whose chairman and chief auctioneer was Peter Wilson, later to be revealed as a former MI6 agent and close friend of spies Kim Philby and Guy Burgess. Wilson had flown from London to take the sale and his advent in New York itself garnered publicity. Tall, impeccably tailored, and gifted with deep, round vowels, Wilson took one look at Oldenburg's *Stove* and emitted a snort of either contempt or amusement. The audience decided the latter and the room laughed loudly, paused, and after spirited bidding, it was sold for $45,000, making it the

highest-priced sculpture by a living artist sold at auction. The happy winner was a friend of mine, sitting in the row in front of me, the dealer Rudolf Zwirner. His client was chocolate manufacturer Peter Ludwig. You can see the stove today in the Ludwig Museum in Cologne. Rudolf also bought the Lichtenstein for $75,000, equaling the highest price paid for a painting by a living American artist. James Rosenquist's 1962 *Silver Skies* made $29,000, a record for the artist, and Jasper Johns's *Tennyson* sold for $70,000, although Scull's *Two Flags* by Johns failed to sell, as did Andy Warhol's painting of two pink electric chairs owned by the son of cosmetic mogul Max Factor, Donald.

These high prices for works recently mocked in the media were well publicized by Sotheby's and received serious attention from the investing classes. The previous May, Warhol's *Campbell's Soup Can with Peeling Label* (1962) sold for $60,000, an auction record for a living artist and on the day that the stock market hit the lowest point in seven years. Sotheby's director, Peregrine Pollen's, post-sale statement was widely quoted in the press: "Good art holds up even in a bad market."

People who had never been to the Museum of Modern Art, let alone a contemporary gallery, took notice. Instead of buying a Monet for $10,000 in 1950 and waiting twenty years to sell it for $200,000 in 1970, you could buy a Warhol in 1962 for $1,500 and sell it just eight years later for $60,000, forty times what you paid for it. Whether you liked the work of art or not was irrelevant, its investment potential made the nature of the object superfluous. No dinner guest will mock your Rauschenberg assemblage as a pile of junk if a similar Rauschenberg just sold for five or even six figures. These public sales stimulated a new breed of buying-for-profit collector who focused on artists that auction results suggested were good investment picks. Meanwhile, less speculative patrons were still buying

emerging artists for pleasure without letting their taste be determined by auction prices.

The rise of the asset-driven collector, one who would happily sell for more tomorrow what they buy today, was a mixed blessing for artists. In 1973 Robert Scull sold *Thaw* by Rauschenberg for $85,000 at Sotheby's. He paid $900 for it in 1958 when it was made. The artist, inebriated, accosted the collector after the auction, saying, "I've been working my ass off so you could make a profit!" Scull responded "How about the paintings that you're gonna sell now? I've been working for you, too. We work for each other."

Flamboyant and blunt as he was, Scull's large appetite for the new art was not fueled by mercenary motives nor even social ones, although Ethel liked to see herself in the gossip columns. He had an excellent eye and devoted a great deal of time visiting studios and galleries, talking to artists and their dealers. When Scull divorced Ethel he sold out of necessity, but otherwise the money he made selling work by artists who had become successful funded the acquisition of art by those yet to have made a name. With amazing faith in the artist's vision and no possible profit motive, he supported Michael Heizer's earth work, *Nine Nevada Depressions* (1968), stretching across five hundred and twenty miles of desert. Not exactly something you can hang on your dining room wall and brag about as a good investment.

And even as the philistines were gathering at the gates, ready to gamble on Leo Castelli's next discovery, there were many enlightened collectors sponsoring artists like Heizer and Robert Smithson of *Spiral Jetty* (1970) fame, who were making work that was either unfashionable or unsaleable or both, and John and Dominique de Menil of Houston, whom we can thank not only for the Menil Collection, the Rothko Chapel, and the Twombly Museum, but also, courtesy

of their daughter Phillipa and her husband Heiner Friedrich, the DIA Foundation, which sponsored many impossible-to-sell projects.

A Sisterhood of Art

"Why Have There Been No Great Women Artists?" The critic Linda Nochlin's shot across the bows of art history was not fired until 1971, hoping to make me and others aware of our shortcomings as art dealers. At the time there were a number of women artists enjoying successful careers who were every bit as likely to be candidates for greatness as any of their male peers. These included Lee Bontecou, Chryssa, Rosalyn Drexler, Janet Fish, Helen Frankenthaler, Kiki Kogelnik, Yayoi Kusama, Marisol, Agnes Martin, Charlotte Moorman, Yoko Ono, Bridget Riley, Dorothea Rockburne, Carolee Schneeman, and Marjorie Strider. All exhibited regularly in major New York galleries and other art capitals. Today, some are as well known as their male peers, some are better known, and others not. My guess is that most if not all of this generation preferred to be identified as artists who were women rather than women artists. This was not true of the rising generation that included artists like Judy Chicago and Lynda Benglis, whose gender was essential to their work.

In my experience the bias against female artists was more institutionalized than articulated. I did not hear it from the testosterone-filled bar stool occupants at Max's Kansas City, or in the more decorous meetings of the Art Dealers Association of America at Perls Gallery on Madison Avenue. If there were not enough female artists being shown by contemporary galleries, it was not only men who were keeping them out, as many leading gallery owners were women, including Grace Borgenicht, Virginia Dwan, Jill Kornblee,

Betty Parsons, Denise René, Eleanor Ward, and Virginia Zabriskie. It was certainly true that the senior ranks of the major museums were male bastions, with very few exceptions, and there was obviously a strong bias towards male artists at MoMA, the Whitney, and the Guggenheim. It would be foolish for me to claim that gender equality was on my mind then, but I was just as likely to visit the studio of a female artist as I would a male's. Despite the large number of women studying studio art in colleges and universities all over the country, far fewer of them made it to the starting line and knocked on gallery doors than men.

One who had no qualms in ringing my doorbell, loudly, was Gloria Ross, one of the three Frankenthaler sisters. Her older sister Helen was riding very high in the art world, married to the equally prominent Robert Motherwell—they were the golden couple of American abstract painting. Helen had been championed by her first lover, the powerful critic Clement Greenberg. Helen, Gloria, and Marjorie were the well-educated, Upper East Side daughters of a New York State supreme court judge. Marjorie was married to a successful attorney and Gloria to investment banker and philanthropist Arthur Ross.

Drawn into her sister Helen's circle of painter friends, Gloria conceived the idea of making hooked-rug tapestries based on their paintings. The prior generation of mostly European artists including Picasso, Chagall, and Miró had collaborated with weavers to produce limited-edition tapestries in the style of Aubusson medieval tapestries, flat and finely woven on looms. Ross's tapestries had a marked pile and were hand-hooked. What started as a hobby soon became a serious business, both artistically and commercially.

Immaculately coiffed and well-tailored, Gloria was more likely to be found lunching at the newly opened Pleiades Restaurant on Madison than Fanelli Cafe on Prince Street, but she jumped at the chance for an exhibition in SoHo and I invited myself to visit her

studio. In those early days, this was a converted child's bedroom in her gracious Park Avenue apartment. She had taught herself the basic skills and recently advanced to employing assistants, one of whom was her building's doorman.

If by showing Claire Zeisler I expressed a commitment to women working with fiber, I doubled down when I opened *Tapestries Designed by Gloria F. Ross*. This gave me the opportunity to bring some big names to SoHo for the first time: Paul Feeley, Helen Frankenthaler, Robert Goodnough, Robert Motherwell, Kenneth Noland, Richard Smith, and Jack Youngerman. Gloria was almost as skillful at marketing as she was at weaving and the exhibition was a great success. I included her in a Feigen downtown group show the following summer, and in January 1971 she had her second solo exhibition at Feigen's gleaming new premises on East Seventy-Ninth Street. Ross made each tapestry in small, signed editions at prices considerably lower than the paintings that inspired her works.

Not Only Art Dealing

My drug use had been limited to a few acid trips, the final one ghastly, which I recommend as an excellent cure. I would also enjoy the occasional joint if it was being passed around. At most gatherings of under-thirties uptown or downtown, there was pot on offer, varying in quality, but I was not in the habit of having it in my possession. Until, that is, I leaped out of bed at the sound of the doorbell at 1:30 a.m. one morning. SoHo was as quiet at night as a Kansas farm. What could it be? A friend in need? Police? Random drunk? I made it down the stairs and yanked open the door. Against a weak streetlight I could make out the silhouette of a large man carrying a small bag.

"Hello? Can I help you?"

"Hi Michael, it's me, Lee!"

"Lee?" I was bleary, slightly bewildered.

He stepped forward and I recognized Lee Jonas, my Fort Worth rodeo bodyguard, the genial giant who had been corralled into making sure my long hair didn't get me thrown to the bulls. The first thing I noticed was that Lee's hair was, well, not exactly long but definitely not a crewcut. Texas was catching up with the coasts.

"Lee! Hello. Come in, come in. I didn't know you were in New York. Are you OK? It's late."

"I just arrived. You said if I was ever in New York to stop by. Here I am!"

I never did find out what method of travel delivered him to Manhattan at two in the morning, Greyhound Bus perhaps, but I was not unhappy to see him. I was fond of the friends I made in Texas and happy to reciprocate their hospitality. By now he was in my living room.

"Can I get you something? A beer, a coffee?"

"I'm a bit hungry," said the big man in black cowboy boots.

Even though it was close to three o'clock in the morning this posed no problem for a man with a freezer filled with Stouffers Salisbury Steak dinners and Birds Eye Lima Beans.

Lee took a beer while I made him my favorite meal and we chatted about the folks I knew in Fort Worth. Finally, I said, "Well, Lee, what brings you here, just seeing the sights?"

He eyed his luggage, a canvas holdall.

"Some business. Some business perhaps you can help me with."

At a loss, I asked him to explain.

"You once mentioned that here in New York most folks bought nickel bags, five bucks for a few joints—right?"

The penny dropped, quickly.

Lee leaned over and unzipped his bag. It was filled with what appeared to be goldish-green bricks in Saran wrap. He took one out.

"Smell that," he said, handing it to me.

Lee traveled light—a toothbrush, clean underwear, and ten kilos of Acapulco Gold. I was overcome with a weird combination of fear and excitement. Had I double-bolted the front door? I didn't know what to say.

"Lee, you could get ten years for this!" Meaning *I could get ten years for this*.

"Well," he said in his easygoing Texas drawl, "that just ain't gonna happen, Michael."

And thank God it didn't. Lee's vague marketing strategy was that I surely knew people who would make bulk purchases. Possibly, but first I wanted the merchandise off my premises. I found a flashlight and led Lee back outside and into the basement of the derelict building next door. A row of bricks in the back wall were loose. We stashed the stash.

In the morning I made a list of acquaintances who I knew would be thrilled to get a key or half a key of high-end weed at a wholesale price. It was quite long. I made calls suggesting that my friend Lee from Texas had an "interesting organic product" they were sure to enjoy. Truly amateur hour. If my phone had been bugged, we would have been on Riker's Island in a New York minute.

Lee stayed with me for three nights. During the day he made house calls to the Upper East Side, the Upper West Side, the Village, and one or two nearby in SoHo. I won't name names, but you know who you are, and I guarantee you still remember the day Lee came calling. I told him this had to be a one-deal deal. My commission was half a key for myself. I gave most of it away, I wasn't much of a pothead.

Rock 'n' Roll Forever (Or Just a Few Days)

If there was a playlist for this time in my life it would include Thelonious Monk, the Band, the Rolling Stones, and Wilson Pickett. A well-meaning, opera-buff client had given me tickets to a performance of *Madame Butterfly* at the Metropolitan Opera, which I would have otherwise enjoyed had James Brown not been performing at the Apollo about the same time as the third act began. I sacrificed Cio-Cio San's final aria to race uptown and catch the Godfather of Soul.

Other than being able to listen, I have no musical talent, but that did not stop me from a side gig as a rock promoter. It was fully sanctioned moonlighting because the partner was my boss Dick Feigen's wife, Sandra. She and I were impressed with the Aluminum Dream, a band that Jim Rosenquist hired for his parties. They hung out at Mellon heir Billy Hitchcock's estate in Millbrook, New York, as the house band for Timothy Leary's trip-testing Castalia Foundation. Somewhere on the Jefferson Airplane/Kinks spectrum, they were a four-person group fronted by singer and guitar player Billy Barth, three men and one woman, vocalist Joan Silver. Sandra was a close friend of Atlantic records mogul Ahmet Ertegun and his wife Mica. Our scheme was for Feifin Productions ("Feigen" and "Findlay" mashed together) to groom and rehearse the Aluminum Dream, get an audition with Ahmet, and have them join Crosby, Stills, Nash & Young on his Atlantic Records label. Easy.

We needed a rehearsal space. Having done brief duty as a drug stash, the unrenovated building next door came in handy again as a no-cost studio and crash pad. The band could play as loudly as they wanted at night since I was the only resident of Greene Street within earshot. The Aluminum Dream were talented, they had opened for Janis Joplin and B. B. King, but they were not as disciplined as they

needed to be. Their one and only single, "Strangers Calling," was, alas, not a hit. In fact, other than well-meaning friends like Jim Rosenquist, Billy Hitchcock, and Feifin Productions, no one came calling. The band was never quite ready to audition for Ahmet Ertegun. My Brian Epstein days were short-lived. At least our business cards were impressively well designed.

My Cameo as an Artist

I had a slightly more robust career as an artist than as a music mogul. This began with a framed poem being included in a works-on-paper show at Feigen Gallery in Chicago. The exhibition was organized by the gallery director, Lotte Drew-Bear, a former Bauhaus student who had been a museum curator in Hanover before fleeing to America in 1939. Rake-thin with short black hair and a deeply accented tobacco-rich rasp to her voice, she had worked with the dealer Julien Levy before joining the Feigen team. She was a fount of wisdom about art and artists, particularly Surrealism. When Max Ernst arrived in New York in 1941 it was Lotte who looked after him and made introductions. I spent as much time as possible learning from her. Her choice of my poem for her exhibition was a very welcome surprise to me. I had an even greater surprise when she sold it for the magnificent sum of $75 to Dirk Lohan, a distinguished architect and the grandson of Mies van der Rohe.

The first inkling the public and many in the art world had of the Conceptual art movement was Kynaston McShine's 1970 exhibition *Information* at MoMA, which opened to a clamor of controversy. The first interactive exhibition in any museum, this included a work by Hans Haacke consisting of a ballot box with a photoelectric counting device and a wall text asking, "Would the fact that Governor Rocke-

The author's poem exhibited in *Twentieth Century Works on Paper*, 1970
Richard Feigen Gallery, Chicago

feller has not denounced President Nixon's Indochina policy be a reason for you not to vote for him in November?" Visitors were invited to place ballots in either the "yes" or "no" box. At the time, New York State Governor Nelson Rockefeller was not only a trustee of the museum but the son of one of the founders. There was palpable energy at the opening of this exhibition—a seismic shift was in the air.

Even more interactive was the September exhibition devoted to Ray Johnson's New York Correspondance School organized by Marcia Tucker at the Whitney Museum. Ray announced and created the exhibition at one and the same time: "Send letters, post cards, drawings, and objects to Marcia Tucker, New York Correspondance School Exhibition. Whitney Museum, Madison Ave. and 75 St., N.Y.C. 10021."

One early visitor to Feigen downtown was Dianne Perry Vanderlip, an energetic ringleader in the Philadelphia art world who ran the art gallery at Moore College of Art. Dianne invited me to give a talk to the all-female undergraduate students at Moore. This was no hardship, I had given two talks at Finch College on the Upper East Side, a liberal arts college for daughters of the financially secure. My notes were ready.

Dianne was one of the first curators to see Conceptual art forming as a movement. She identified most of the major artists involved with the landmark exhibition *Recorded Activities*, and generously invited me to participate as an artist. I was in excellent company. Dianne's show brought all the early practitioners together for the first time with a catalog that included a textually experimental essay by Lucy Lippard. Artists included Bruce Nauman, Joseph Kosuth, Vito Acconci, Robert Smithson, John Baldessari, Les Levine, and others. My contribution was a battered former biscuit tin containing found family photographs, many dog-eared and curling. The object itself and its contents did not survive my many moves, but I have the cata-

Michael Alistair Findlay
Born: Dunoon, Argyllshire, Scotland
Lives: New York, City

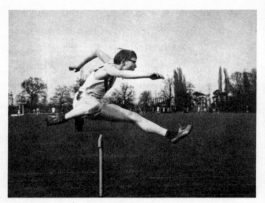

Michael Alistair Findlay

Item from an untitled work by the author exhibited in the *Recorded Activities*
exhibition at Moore College of Art, Philadelphia, October 1970

log to remind me that one of the photographs is of me at school clearing the high hurdles instead of learning to draw. Dianne followed *Recorded Activities* with another first, a solo exhibition of work by Moore College alumna Alice Neel.

Dianne brought me into to her circle of friends in Philadelphia, which included a very non-conceptual artist, the sculptor Charles Fahlen, a tall, lugubrious young man who taught at Moore and made mysteriously beautiful objects out of building materials. I included his work in my summer group exhibition and later gave him a solo show. Dianne introduced me to Anne d'Harnoncourt and her husband, Joe Rishel, up-and-coming young curators at the Philadelphia Museum of Art who put me on their visiting list when doing the New York gallery rounds. Art world parties in Philadelphia were maximum strength and Charles and his wife, Noël, gave the loudest and wildest. The first I attended ended in the small hours with an uninvited guest waving a loaded handgun in my general direction to be swiftly wrestled to the ground by burly sculptor Herbert George, who never shied from reminding me that he once saved my life.

Moving On

Shuttling between the chrome columns and gleaming marble of Feigen uptown and the grungier but more ample spaces at Feigen downtown, I had my hands full. Dick Feigen was wheeling and dealing with Monets and Dubuffets, very ably assisted by Sandy Leonard, so the contemporary artists exhibitions became my responsibility in both locations. Many of the gallery artists were less than thrilled with Hollein's design.

Bridget Riley, the gallery's best-known and top-selling artist flew to New York to look at the new space in anticipation of her fifth solo

Feigen exhibition. I was with her and Dick in the main gallery at the top of the marble staircase when she walked from wall to wall to wall and finally decided there was not enough space to get the appropriate viewing distance for her new, larger works. The consequence of this was that she left the gallery, a big blow to Feigen. She was not the only person at that meeting who thought it was time to move on.

Early in the year I had tried to have a conversation with Dick about my future. I wanted to go out on my own, although I had little or no idea of how I might accomplish that. He insisted I could run Feigen downtown any way I wanted. Dick was a great talker but a poor listener and I was not emphatic enough. The moment passed and I went forward with a group exhibition of mostly new talent that I had planned at Greene Street for the spring.

Only Two Out of Eleven

I had kept in touch with Hannah Wilke since first meeting her in Claes Oldenburg's studio in 1969, and in the fall of 1970, she invited me to see her fired-clay and folded, latex-rubber sculptures. I would love to tell you I instantly grasped their iconic importance as revolutionary gender constructs and heralded Hannah as the ur-feminist genius of her time. Instead, I simply thought they were beautiful and in-your-face funny, and Hannah herself, with her breathy Marilyn Monroe delivery, a savvy artist with a wicked wit.

In April 1971 I opened the group show that included Hannah Wilke and called it *Ten Painters and One Sculptor*. Of the ten painters only one was a woman, Pamela Jenrette, so my gender-equality ranking was low, although Wilke had the entire floor of the main gallery which was a few steps above street level and accessed from

a black-steel loading dock. There were no front windows, so visitors had to come right into the gallery to see what was there. I installed Wilke's sculptures in vitrines surrounded by the ten painter's works, which were all abstract and fairly large. Wilke had shown in group shows in 1966 and 1967, including *Hetero Is*, an erotic art exhibition at the New York City Arts Theatre Association, but this was the debut of what she delicately referred to as "my cunts."

As soon as the exhibition opened to the public, a specific visitor choreography established itself. As people entered, they were drawn first to the sculptures. Because they were relatively small, one had to move closer and look down and into the vitrines. My awkwardly worded press release, thankfully unread by almost everyone including the press, included a customer warning:

> These small, delicate, biomorphic sculptures are quite
> abstract and yet contain strong sexual overtones. Her
> imaginative use of fired clay in some and folded rubber in
> others is heightened by her subtle command of flesh-toned
> colors.

Any points earned for being gender progressive I lost with "flesh-toned." Visitors would glance into the vitrine casually, then stop and bend forward, looking harder. When it dawned on them that they were looking at a vagina, there was either a smile and raised eyebrows, or else their head jerked back, and a quick turn was made toward the painting on the nearest wall. By now there were regular busloads of elderly female art tourists from the New Jersey suburbs, and they would troop in, peer slowly, then turn quickly as if choreographed. While my ten painters were ignored by the critics, Wilke's sculptures sparked positive comment, notably in *Craft Hori-*

Hannah Wilke installation, photograph of *Ten Painters and
One Sculptor* exhibition at Feigen downtown, April 1971

zons by Ron Lusker, who remarked on the work's "organic sensuousness" and that Wilke's skill "demonstrated by juxtaposing suggestive form with textural opposites."

Despite being antsy to leave the Feigen empire, I completed the season at the uptown space with Ray Johnson's *Dollar Bills and Famous People Memorials*, accurately described in *Artnews* as "giddily tragic," and which were better suited to Hollein's intimate space than large-scale canvases. I followed this with a farewell grab-bag exhibition called *Americans*, exposing the Upper East Side to some of the Feigen downtown artists. I gave Wilke pride of place with a ceramic vagina greeting visitors as they ascended to the top of the marble staircase.

Chapter Four

*Art alone
makes
life possible.*

JOSEPH BEUYS

Anna May Wong

Then, all of a sudden, all heads swerved round to the back.
There she was! NAOMI SIMS!!! Stunning black goddess.
An apparition of onyx and ivory wearing a luscious
red Halston pantsuit with a mandarin collar and wide
inverted décolletage exposing a sexy flat brown tummy.
Slivers of elephant tusk by Elsa Peretti clacked at her
wrists as she moved in a swan glide down the aisle toward
the stage escorted by applause, popping flashbulbs, and
Michael Findlay in a dapper white suit. Cameras and bag
lunches fell from the laps of those whose chivalry guided
her up on to the stage. She took her position beside Ray,
and to that lofty place we humbly proffered our enquiries.
Do you eat orchids for breakfast? The whole thing was a
cross between the Dick Cavett Show *and the Mad (Hatter's)*
Teaparty.

So wrote magazine cover artist Richard Bernstein in the August 1972 issue of *Interview* magazine in his profile of Ray Johnson. And here was white-suited Findlay with supermodel Sims whose face had graced countless magazine covers including *Life*. What was going on?

The occasion was the June 3rd Second Meeting of Ray Johnson's New York Correspondance School at the New York Cultural Center, of which my friend Mario Amaya, of Andy Warhol–shooting fame, was the new director. If Ray himself and his approach to art challenged the art world orthodoxies of the time, so did the New York Cultural Center. Opened in 1964, it was the brainchild of eccentric A & P grocery chain heir Huntington Hartford, who conceived it as a bastion of figurative painting from Edward Burne-Jones to Salvador Dalí, and an antidote to the Museum of Modern Art's embrace

of abstraction. Described by an architectural critic as "a huge white marble mah jong tile on Columbus Circle," it never quite took off as a museum, but in its brief life and in an ugly-duckling way was part of the art scene particularly when the madcap Mr. Amaya was in charge. And it had a comfortable auditorium where the New York Correspondance School was to have its meetings.

The invitation to Naomi and me arrived, naturally, in the mail, with a copy of the announcement stating, "the role of Anna May Wong will be played by Naomi Sims," and Ray's explanation.

> *The enclosed page about the meeting does not mean that you have to point, go to the moon, impersonate Hedda Stern, construct a barb wire fence, fall off a horse, put tennis balls in a jar or fly to Kansas all you might do is be there June 3rd if possible.*

In a second letter that arrived the following day he asked:

> *If Naomi can't be there do you think the role of Anna May Wong should be played by Nam Jun Paik? Do you think we should ask Joel Grey to sing "Welcome" at the Meeting? Should we invite Liza Minella and Daisy Arnez?*

A similar announcement followed a few days later with much the same text but with a page of Ray's trademark bunny heads, each one labeled with a person's name, like "Anna May Wong," "Naoimi (sic) Sims," or "Michael Findlay." Ray was fascinated by people's names and in his collages inscribed names in rows of bunny heads with no distinction between the names of well-known movie stars and obscure personal friends. The connections he made often seemed opaque. What in his mind linked Naomi to Anna May Wong? A clue

COLLAGE BY RAY JOHNSON

Ray Johnson, *Naomi Sims*, c. 1971
Collage on paper. 8½ × 11 in. (21.6 × 27.9 cm). Collection unknown

might be in the several "Naomi Sims" collages he made at the time. One had two rows of five arrowhead shapes and the elaborately handwritten legend: "Naomi Sim's fingernails." Both Sims and Wong had long sharp fingernails. Another juxtaposed "Naomi Sims Collection" with "Anna May Wong's shoe," and the most enigmatic has a blacked-out speech bubble next to Naomi's face.

Unlike the relatively uneventful first New York Correspondance School meeting on Rutherford Place, this one promised to be action-packed. The stage was set for a panel discussion: a table with various objects on it and a blackboard. The audience consisted of the flotsam and jetsam of the art world sprinkled with a few well-known artists and writers. Proceedings began with Ray performing *Evaporations*, wiping the blackboard with a wet sponge and watching the moisture disappear. It was immediately clear that audience participation was welcomed on and off the stage. Toby Spiselman interviewed prospective panelists/performers. Rock critic and artist Richard Meltzer presented Ray with Tropicana juice jars of lime and cherry Jell-O embedded with dead mice. Ray had a birthday cake for Karla Munger-Chubb and photographer Marilyn Kroplick lectured briefly about nudity. Buxom, raven-haired former Jackson Pollock mistress Ruth Kligman breached the stage and engaged in a lively exchange with an ever-smiling Albert M. Fine. There was a fair amount of amateur photography, Instamatics held high. Ray saved *Anna May Wong* for the finale as Richard Bernstein colorfully reported.

Richard and Berry and Berry and Tony

I met Richard when he was dating the effervescent, blonde fashion photographer Berry Berenson. She and Susan Engelhard were my

best friends. Susan lived at the Waldorf Towers and the three of us would meet for breakfast at Oscar's in the lobby of the hotel. We gossiped gently about who was with who or who had left who and did not avoid the subject of our own amours. Berry was joined at the hip to the artist Richard Bernstein, whose celebrity portrait covers turned Andy Warhol's *Interview* magazine into a moneymaker. Like me he was a denizen of the backroom at Max's. I own a painting he did of that very backroom with the red Flavin sculpture casting an eerie glow over the corner table where no one wanted to sit. "BerryandRichard" were one word and were seen everywhere together. Berry as unselfconsciously gorgeous and vivacious as her more famous actress sister, Marisa, who was self-consciously gorgeous and not-quite-as-vivacious. Richard was talented, charming, endearingly witty, and knew everyone.

Susan and I planned to meet up with Berry when she returned from photographing and interviewing actor Tony Perkins for *Interview*. Andy had given her the assignment and Richard, as a fan of Perkins, had encouraged her. Berry bounced down onto the sofa, gasping with enthusiasm.

"Oh my God!" she looked at us both, her eyes wide.

"What is it? What happened?" demanded Susan.

"I'm in love," Berry said, giggling.

Berry had an infectious laugh—she would throw her head back and grin and laugh loudly then quickly cover her mouth with her hand. Susan and I exchanged quick, wide-eyed glances. We were both thinking, "She must know he's gay but so is Richard." We said nothing as Berry regaled us with her visit. Tony was warm, Tony was easy to talk to, Tony was wonderful. According to Berry, this was the real deal. And so it was, for Tony as well.

Things moved very quickly and the gossip around town was that Richard had attempted suicide, although nervous breakdown might

Richard Bernstein, *Backroom at Max's Kansas City*, 1974
Oil on canvas. 50 × 50¼ in. (127 × 127.6 cm). Private collection

better describe his reaction to being thrown over by someone he adored in favor of someone he would like to have adored. Richard survived this and stayed good friends with Berry who married Tony a year later, just five days after I married Naomi Ruth Sims.

Looking for Love at the Sign of the Dove

How did I find myself with Ms. Sims? My relationship with Margrit had ended abruptly when I asked her to leave after we had given a large, boozy party where I had decided she was paying too much attention to a hunky, all-American stranger who had tagged along with friends of friends. I was right and wrong. Right in that they became a couple, briefly. Wrong insofar as if I had not pushed her into his arms that might not have happened. I behaved badly. *Mea culpa.*

Smarting from the self-inflicted wound of Margrit's defection, I determined to pull my socks up and move on in the romance department. Coincidentally, Gerald Laing told me that his good friend Ronnie Winston was no longer with Naomi Sims. When he saw the flicker of interest in my eye, he sternly warned me that it had been a complicated breakup and clearly did not blame Ronnie.

"Not a good idea, Michael," he said emphatically as we walked home one night from Max's, me to Greene Street and he to Bowery and Bond Street.

Like a child told by the waiter not to touch a hot plate I immediately tracked Naomi down. She was with the Wilhelmina modeling agency, and I persuaded her booker to ask Naomi to call me. Amazingly, she did and accepted my invitation to dinner at the Sign of the Dove, an over-the-top, romantically baroque Italian restaurant

on Third Avenue and Sixty-Fifth Street better known for its celebrity clientele, venetian glass, and extravagant flower arrangements than for its food or service.

We got off to a splendid start. Naomi was elegant, warm, and prompt, a trait that distinguished her from others in her profession. She wore all-white and a distinctive scent of gardenia. We were at a table for two in the center of the outdoor patio area. Naomi was more interested in talking about the art world than the fashion world. She was effusive about the work of Xavier Corberó, a Spanish sculptor and the boyfriend of her best friend Elsa Peretti; she had recently stayed with them in Barcelona. Well-traveled, Naomi had just returned from working in Japan with so much local publicity that one newspaper even turned her into a cartoon character.

Spotted on the street by photographer Gösta Peterson when a student at New York's Fashion Institute of Technology, Naomi landed on the cover of the *New York Times* fashion supplement and a year later, in 1968 when she was still only nineteen, on the cover of *Life* magazine. By the time we met she was considered the first top African American model, although she herself always gave that credit to Donyale Luna, who had been on the cover of *British Vogue* in 1966 and later appeared in a few Andy Warhol movies.

So there we were, chatting easily about our lives, mentioning some previous romantic attachments but not our most recent breakups. She alluded to a Japanese man in the fashion business in Tokyo and I reminded her we had met when I was with Jane Forth, whose looks she admired. Cruising gently on the first-date conversation highway, I heard myself saying just as we were tackling the bittersweet chocolate souffle,:

"Well, Naomi, I am pretty sure we are going to get married."

Why did I say that? I was almost as shocked and surprised to hear

myself say that as was Naomi. Her reaction? Kind, she treated it as a joke, laughed politely and changed the subject. To my relief. Much later she told me her instinct was to head for the door. She thought I was deranged. Instead, resolving never to see me again, she humored me through coffee, said a very firm goodbye, and took a taxi home.

I had used my big ammo on the first skirmish, and it had been a damp squid. So long as you don't actually mean it, mentioning marriage is an excellent last-ditch strategy to hang on to someone when a relationship is failing, not to be wasted prematurely. Perhaps I meant it? Undaunted, I persevered in the traditional style, flowers and *billets-doux*. Cunningly, she had not given me her phone number, but I did manage to get her West End Avenue address. This was a lonely campaign. My friends did not support me, and her friends agreed with her that I was off my rocker.

It took me three months to secure a return match. I swore not to mention the "m" word ever again. I ditched the impress-her-with-an-expensive-Upper-East-Side-eatery ploy and went with the neighborhood diner and movie strategy. It worked. The movie, *A New Leaf* (1971), about a cunning man trying to marry a bumbling heiress, was hilarious and possibly self-referential. We laughed our heads off.

Naomi had allowed me to pick her up at her apartment, thus introducing me to her roommates, a pair of ugly and badly behaved pugs who had the same effect on me as my first-date marriage proposition had on her. She was deeply attached to them, having been introduced to pugdom by Shelley Marks, the perfumer who, with his pair of even uglier pugs, inhabited a hobbit-sized store on Madison Avenue where Naomi spent an inordinate amount of time mixing fragrances and potpourri.

Art and Fashion, Going Steady

After the second date we were off and running. I let myself be absorbed into her high-fashion life. The designers whose clothes she modeled and wore including Giorgio di Sant' Angelo, Stephen Burrows, Scott Barrie, Fernando Sanchez, and the man whose muse she was, Halston, the darling of all lunching ladies. Born Halston Frowick in Des Moines, Iowa, he found fame designing Jackie Kennedy's pillbox hat and pioneered the use of synthetic Ultrasuede in haute couture. To ingratiate myself I spent a small fortune on one of his men's blazers which proved surprisingly durable. Unlike Naomi's other friends, he never quite warmed to me, although as a token straight man I was accorded guest privileges at the ongoing Grand Guignol of his largely public life. In time, business reversals obliged him to ask me to sell his Andy Warhol portrait of Jackie wearing, yes, *his* pillbox hat.

Inseparable from Elsa Peretti, whose amazing jewelry was *de rigueur* for anyone wearing his clothes, Halston was often flanked by his showroom manager and former boyfriend, Ed Austin, and his current boyfriend, the outrageous former escort Victor Hugo, whose look surely inspired more than one of the Village People. Joining Naomi as muses-in-residence was house model Karen Bjornson and two Pats—the very lean Pat Cleveland, a gorgeous runway model, and the very rotund Pat Ast, a bumptious and brassy five-foot-three court jester. Halston's in-house illustrator was Joe Eula, and in the mix were walk-ons like the flamboyant and catty window designer Joel Schumacher.

Warhol began his career as a fashion illustrator and kept the business going until 1964, by which time he was well established as a fine artist but until then not convinced that a career as an art-

ist could replace the financial stability of working for fashion magazine editors and advertising agencies. In the mid-1950s he dressed windows for Bonwit Teller under the direction of master window designer Gene Moore, who at that time also hired Jasper Johns and Robert Rauschenberg (as "Matson Jones"), who sometimes incorporated their paintings into the displays. This was not a new idea; Salvador Dalí made a public scene when Bonwit Teller altered windows he dressed in 1939, but for the rising generation of 1960s artists, with the exception of Warhol, it was more out of financial necessity than choice. Johns and Rauschenberg made a clean break once they became solvent from selling their paintings.

Historically the women and men who modeled professionally for artists were not fashion models. That changed in the late twentieth century when super models like Kate Moss sat for artists like Chuck Close. Naomi was possibly the first well-known fashion model to have a presence in the art world, but when she appeared in the work of artists Ray Johnson, Billy Sullivan, and Peter Beard, it was as much because they were friends as it had to do with her celebrity.

Naomi was comfortable in the company of artists; to many, she represented a new kind of Black beauty. Some recognized that hers was an act of self-creation. Previously, there had been no dark-skinned Black fashion models in America. Every aspect of her appearance, from her hair and makeup to the color of the clothes she wore, was her own creative effort, as there were no hairdressers and makeup artists capable of dealing with her hair texture or darkness of skin. Her appearance at gallery and museum openings usually caused a stir.

One of the first art world parties we attended together was in celebration of the marriage of Chilean artist Enrique Castro-Cid and Christophe de Menil, the eldest of John and Dominique de Me-

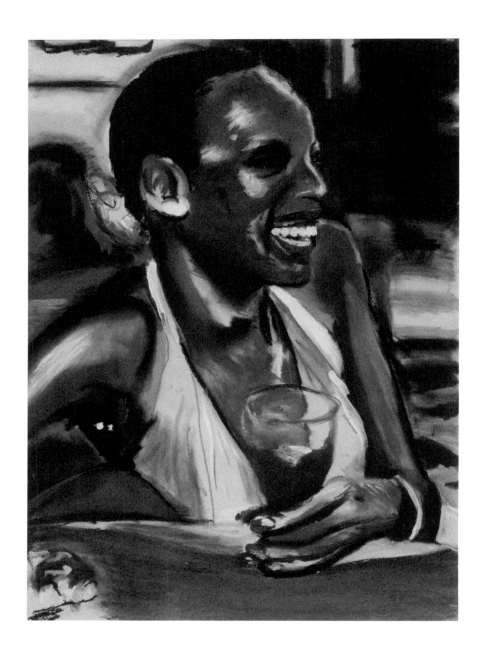

Billy Sullivan, *Naomi Sims*, 1971
Pastel and acrylic on paper. 35 × 46 in. (88.9 × 116.8 cm). Private Collection

nil's five children. Christophe was wealthy, Enrique considerably less so, albeit handsome and charismatic. He was recently divorced from Sylvia, who married performance and installation artist Robert Whitman, a key player in *9 Evenings: Theatre and Engineering*. Christophe built a big modern house in Amagansett on Long Island with a large studio for Enrique. He claimed to have designed the house on a cocktail napkin. Before long cocktails claimed more of his attention than art.

Naomi dancing with the very debonair Willem de Kooning was the star turn at the party, which became more raucous as the night wore on. At midnight the bride retired upstairs to bed alone. Weeks later the house burned to the ground and drinks were served on the lawn as the houseguests watched the firefighters gamely trying to quench the flames. Christophe and Enrique's marriage did not survive much longer.

Lofty People

"It's the crème de la crème of the '70's scene if you ask me,"
volunteered filmmaker Joe Wemple, a veteran of the Beni
Montessori Cathy McAuley set. "You've got some pretty
heavy social people here, plus a lot of artists, film people
and Wall Street heads. These are the people who are going
to be involved in the next moment."

Quoted by *Women's Wear Daily*'s intrepid society reporter, Rosemary Kent, these lines accompanied a spread of photographs documenting the party Naomi and I gave David Hockney for his thirty-fifth birthday. Not only did the art world collide with the fash-

From the left: John Nagel, Marina Schiano and Berry Berenson, Candy Darling and Richard Bernstein.

the lofty people

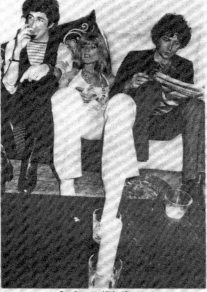

Berry Berenson and Richard Bernstein.

From the left: Pat Cleveland, Bill Smith and Naomi Sims.

From the left: Frenchie Castiner, Anthony Olivers, Ray Johnston and Michael Findlay, Joe Wemple and Sacile Ryan.

From the left: Alfred and Lansing Moran, David Hockney and Robert Indiana.

Rosemary Kent, "The Lofty People," *Women's Wear Daily*, May 18, 1972

ion world, but the overground Upper East Side social world collided with the underground backroom at Max's Kansas City.

The bash occupied all three floors of 141 Greene Street. Naomi hired a cook from Small's Paradise in Harlem, who served up fried chicken from 7 p.m. until 3 a.m. Our pot-smoking guests were ravenous. Writhing on the dance floor or on scattered cushions were fashion mavens China Machado, Pat Cleveland, and Florinda Bolkan; artists Bob Indiana and Ray Johnson; socialites Ahmet and Mica Ertegun, Saville Ryan, and Alfred and Lansing Moran. In orange sequins and a silver Afro, the most popular guest was palm reader Lorrita, the best-dressed man was Naomi's Harlem hairdresser Frenchie Casimir. After Naomi, in a long, white crepe dress by Stephen Burrows, the most glamorous woman was platinum blonde Cyrinda Foxe, followed closely by Candy Darling in silver lamé, who grabbed me aside after dancing with a peer of the realm.

"He's invited me to his estate in Ireland," she said breathlessly. "Do you think he knows?"

"He went to Eton, Candy. I don't think it matters."

Naomi's favorite designers, Bill Smith and Scott Barrie, mingled with Andre Oliver and Marina Cicogna; Berry Berenson huddled with Marina Schiano. By 3 a.m. a shirtless Taylor Mead was tangoing with Elsa Peretti. The most notable absentee was Andy Warhol who was at the Cannes Film Festival, but he sent his Factory movie star and *Interview* magazine publicist, Susan Blond, who glided around with Andy's tape recorder asking our guests impertinently intimate questions. We fielded many post-party, thank you telephone calls, but blue blood will out and the only handwritten thank you was from Mrs. Cass Canfield Jr., who generously wrote, "I always thought I gave the best parties in New York—now I know better!"

Flying Solo

By now I was on my own as an art dealer. I wrote Dick Feigen a letter and made him read it in front of me in order to make him understand I really intended to leave. It was providential for both of us. His move to Seventy-Ninth Street was costly, not all our contemporary artists had sold-out exhibitions and he had lost one of his stars, Bridget Riley. My leaving gave him the excuse to stop representing living artists and concentrate on using his impressive new premises for exhibitions and private sales of profitable nineteenth- and twentieth-century masters. At the same time, he developed a strong interest in Old Master paintings which I found surprising. I had often heard him refer to what he called "Il Vecchio Maestros" with more humor than serious interest.

It was not easy to manage the termination of contracts with the artists since many were now close friends; I was also left with the housekeeping. While Dick kept some works by Ray Johnson and Richard Smith and maintained a personal relationship with each, he cut his losses with others. The gallery had purchased works from Hinman and Laing as part of their contracts. Dick put these works into auction even though neither artist had an established secondary market. They sold for bargain prices and Chuck and Gerald were justifiably upset to have their careers knocked sideways.

Dick did not try to find a replacement for me, he preferred to close Feigen downtown. We cut a deal whereby I rented the building for a year so that I could continue to live there and start my business while looking for a permanent space. There were already a few galleries in town bearing the name Findlay, different branches of the same family (not mine by about a couple of centuries, a source of confusion that exists to this day). I chose to honor my maternal grandfather and three uncles by creating J. H. Duffy & Sons, Ltd.

I planned to operate as a private dealer with the option to have modest exhibitions from time to time. I had no capital with which to give artists stipends and, anticipating at the most one full-time employee, I needed to concentrate on building up a secondary market business with anything I could lay my hands on, from Impressionist paintings to Pop. If I got some traction with that perhaps I would be able to organize one-person and group exhibitions.

I had been spoiled running Feigen downtown. No rent and my salary paid from uptown. All I had to cover from sales profits were staff salaries and day-to-day operating expenses. When it came to actually running an art business, I had zero experience. My capital consisted of my contacts. Two collectors were instrumental in getting me off my feet. One was Keith Barish, my age, who had started a real estate fund when he was twenty and was now a multi-millionaire. He would later found Planet Hollywood and produce award-winning movies.

I met him in the backroom of Madison Avenue gallery–owner Stephen Hahn who specialized in selling paintings and drawings by artists from Cézanne to Picasso. Hahn had no interest in contemporary art, but he knew I was a fan of Warhol's work. A client of his wanted to sell a Warhol painting and, as a favor to both of us, Stephen suggested I meet him. Keith looked up at me as he relaxed on the sofa in Hahn's well-appointed backroom.

"Do you like Nancy?" he said to me smiling.

"Excuse me?" I was at a complete loss.

"Andy's *Nancy*, I bought it from Karp."

"You own *Nancy*?"

"Yes, can you sell it for me?"

Could I! I loved *Nancy*, a drippy 1961 canvas showing Ernie Bushmiller's cartoon character Nancy shivering with a speech bubble: "Brr my snowsuit isn't warm enough—I'll put on a sweater too." In the fall of 1961 Warhol walked into the Leo Castelli Gallery and saw

Andy Warhol, *Nancy*, 1961
Casein on canvas. 37 ¼ × 43 ⅛ in. (94.6 × 109.5 cm). Private Collection

Roy Lichtenstein's *Girl with a Ball* and mentioned to Ivan Karp that he was doing cartoon paintings like Lichtenstein. Karp visited him soon after that and admired *Nancy*, which Warhol had delivered to him at the gallery "wrapped in white paper and tied with a bow." Soon after that Warhol ceded the comic-strip territory to Lichtenstein before embarking on painting cans of Campbell's soup and dollar bills. Karp sold *Nancy* to Barish and I sold it to Kimiko and John Powers. My commission was getting to know Keith.

For a wealthy, self-made young man, Keith was extremely easygoing. When I told him I was going out on my own he asked me how I was going to finance my venture. A good question to which I had no adequate answer.

"How about I give you a loan to get going? Just a loan, I don't want a part of your business. How much?"

I had budgeted $1,000 a month to cover an assistant and rent.

"Could you manage $4,000? I'll pay you back as soon as I can. With interest."

"That's all? Are you sure? Pay me back when you can and no interest."

Thank you, Keith!

Screwed on My First Deal

The other client who offered to help me was Jane Engelhard. She had two good paintings by Josef Albers she gave me to sell. Albers's hard-edge squares-within-squares sold by the inch and by the color. Best was a 40 × 40 inches in various shades of yellow, next best were those with red and green. Mrs. Engelhard gave me one of each to sell, prices agreed, my commission ten per cent, and she was not in a hurry. Foolishly I told her I expected to have them sold in a cou-

ple of months, not unreasonable at a time when such works were highly sought after.

I had a few other potential deals in the works but Barish's $4,000 and the expected commissions from the sale of the Albers were what I counted on to get me traction. At that point I made a classic error, one that from experience I should never have made. I told another dealer about my Albers paintings before offering them to my own clients. Not only that but the dealer was my former employer, Dick Feigen.

I stopped by to visit with him when I was uptown one day and he asked me casually what I had going on, as dealers will do. Instead of saying, "Nothing, can you give me something to sell?" I boasted about my two Albers.

"In your hands?"

"They are being picked up on Thursday."

"Michael, I can sell them immediately. What are the prices?"

I told him what I had agreed to give Mrs. Engelhard, less my commission.

"No problem, we'll split the commission. I'll ship them to my clients in Chicago on Friday and they'll pay no later than Tuesday. These two paintings are exactly what they are looking for and they'll pay immediately."

It was brainless of me to agree. I had just spent seven years working for Dick and more than once heard him say the same thing to other people. He was assuring me he had a solid sale with immediate payment for two paintings he had not seen to a client he had not yet contacted. To my credit I did not agree immediately but he barraged me with phone calls and by Thursday I had agreed to let him ship the paintings to Chicago. I even sent him an invoice in anticipation of the "immediate" sale. Then:

Monday: "The paintings arrived. They love them. All good."

Tuesday: "Everything OK. The wife loves them."

Wednesday: "Slight hitch. Husband has to make a business trip. We'll get paid next week."

The following week: "Bad news. The husband had a stroke. He's in the hospital. I can't ask about payment right now."

The following month: "Things are looking better. I think we'll get paid by September."

September: "Just another week or two."

November: "Great news, I'm sending you a check. We got paid!"

My client was happy I sold her paintings. I was relieved that I made a little money. A steep learning curve but I should have known better.

Enter a Villain

Before I knew it my time on Greene Street was dwindling. I began a serious search for new premises. The SoHo real estate scene was in its infancy. The best information about sales and rentals of both lofts and whole buildings could be obtained by spending an hour or two at the bar in Fanelli Cafe. I heard a rumor that taxes had not been paid on 157 Spring Street, a six-story building on the northeast corner of Spring and West Broadway. Looking into this I found out that the accumulated back taxes totaled $40,000 and that the city was about to foreclose.

Peter Kagel was the first but not the last rogue that I've found intriguing. This despite the fact that he made no bones about behaving with reckless abandon in his personal and business life. A decade older than me, tall, and almost presentable in his expensive

but rumpled gray suits. Kagel appeared to have no day job but talked vaguely about his investments, the principal one seeming to be his wealthy wife, Suzy. They lived in style at 1020 Fifth Avenue. Kagel took his marriage vows lightly and was often on the town with Juan del Garcia, a cherubic forty-something Spaniard with a haughty lisp and an unused desk at a small brokerage house. Del Garcia's father had been minister of foreign affairs for the Second Spanish Republic. Juan's job was to provide social access for the Kagels as a couple and to aid and abet John's private affairs in the fullest sense of the word. At the time the three were absorbed by *Inner City* (1971), a musical by Tom O'Horgan of *Hair* (1967) fame. With Harvey Milk, the Kagels produced *Inner City*, billed as "a street cantata." If the show has any claim on the memory of veteran musical lovers, it was as the debut performance on Broadway of the great blues singer Linda Hopkins. Naomi and I were not, by any stretch, Broadway show fans, but got excited by the energy and enthusiasm of Suzy and John and became part of the opening night fanfare and subsequent attempts to keep it going by giving away tickets to our friends.

From the get-go it was hard to believe even half of what Kagel admitted to, out of the side of his mouth, usually while rolling a joint. Once he alluded to having a wild time at an all-male party for Mick Jagger on Roy Cohn's yacht. He blurted this nonsense out as if challenging his listener. He boasted to me about owning contemporary art, so I treated him as I did any prospective client, with a willing suspension of the disbelief that grew when he got vague about exactly what he had "out on loan." His current obsession was with David Hockney, whose retrospective he and Suzy had seen at the Whitechapel Gallery in London the previous year. He asked me if I knew the artist. This was the year before Hockney's lofty birthday event.

"Yes," I told Kagel, "I know David Hockney."

"I want him to paint a big double portrait of me and Suzy."

I had met Hockney the summer I spent in Aspen five years earlier. I was visiting with Gerald Laing in his studio over a grocery store, watching with some amusement as he tried to teach Max Kozloff how to stretch canvas. The feared modernist critic was unafraid to embarrass himself with a foray into landscape painting. Two Englishmen turned up at the door, both wearing boys' school blazers with white piping, a style later adopted by Angus Young of AC/DC. They were fellow Brit Pop painters David Hockney and Joe Tilson. Later I visited Hockney in his studio at Powis Terrace in Bayswater. At the time comparisons were made between him and Andy Warhol, not only because they were both gay and artificially blond, one from a bottle the other with a wig, but both had a sly sense of humor, even about their own work. I had been subjected to a version of this when Warhol offered me his Abstract Expressionist portraits of Dennis Hopper. Hockney did much the same when he showed me what he was working on, a canvas about four feet in width of two perfectly round concentric rings on top of a hard-edge horizontal line. "I've gone minimal," he deadpanned in his flat Yorkshire accent. "What do you think people will say?" Used to making polite noises in artist's studios, I was flatteringly noncommittal with my reply. When I did see the finished work, aptly titled *Rubber Ring Floating in a Swimming Pool*, it reinforced my long-standing opinion that for artists, words like "abstract" and "figurative" are just words.

At the time of Kagel's request, Hockney had made only three double portraits, two of them of men who liked each other, *Christopher Isherwood and Don Bachardy* (1968) and *Henry Geldzahler and Christopher Scott* (1969), and one of a man and woman: *American*

David Hockney, *Rubber Ring Floating in a Swimming Pool*, 1971
Acrylic on canvas. 36 × 48 in. (91.4 × 121.9 cm). Private Collection

Collectors (Fred and Marcia Weisman) (1968), which shows a man and a woman facing different directions, separated by works of art. None of these had been commissioned by the subjects and I doubted if the artist would even consider a commission, but I needed the money and wanted to please my new client, so I wrote to Hockney. His reply was polite, prompt, and somewhat contradictory, starting with ". . . as I am naturally loathe to undertake portrait commissions I must decline your offer . . . ," but ending with "You could suggest they call me up in London and perhaps come for tea, and then visually they might register on my eye . . ."

In fact, they duly visited, and were received royally by the artist, but they failed to register visually and a commission failed to materialize. It is entirely possible that the purpose of the exercise was to provide substance to yet another tall tale that Kagel could spread around about himself.

While appearing to enjoy his wife's affection and definitely her funds, Kagel made no secret to me of the fact that he was enjoying a high-risk, cocaine-fueled, off-the-books relationship with a brunette neighbor on Park Avenue. I had met Denise when she was with her previous husband, a well-known couturier from her days in the late 1950s as, yes, a Ford model. Now she was married to an Armenian shipping magnate. One late morning, coked to the gills, Kagel dragged me around to meet her in her apartment when her husband was not, they both hoped, coming home for lunch. In her former marriage she had struck me as warm and vivacious, both qualities still at her beck and call even if she was as high as a kite. The pair could not stop giggling and for some bizarre reason insisted on showing me a bedroom safe stacked full of hundred-dollar bills. It had not taken long for the spirit of Woodstock to find its way to Park and Seventy-Second Street.

A Space of My Own

It occurred to me that I might be able to get Kagel interested in buying 157 Spring Street as an investment. The price was right; he leaped at it. "I need a place downtown for Denise and me to hang out," Kagel told me, adding, "and after her I can have chicks live there from time to time and be available." A man with a plan.

It happened very quickly. Kagel paid the back taxes and bought the building. The street-level store was occupied by a physician and there was a rarely seen tenant on the second floor who proved impossible to remove, otherwise the building was empty. Floor space was a little under 2,000 square feet, perfect for a gallery. There was a rear entrance with stairs at 409 West Broadway and a rickety freight elevator at the front entrance on Spring Street.

Kagel bagged the top floor as his pied-á-terre and I took the fifth floor, which had the best light. The doctor moved out and a young art book merchant from the Netherlands with a full Royal Dutch Airforce mustache set up shop with popular and rare books about art and architecture. Jaap Rietman's soon became not just a bookstore but a meeting place for artists, filmmakers, and architects. He was the perfect anchor for a gallery building and I soon found two gallery tenants. Young Max Protetch had a successful gallery in Washington, DC, and took the third floor as his New York outpost, in time showing the work of Marcel Broodthaers, Sol LeWitt, Robert Mangold, Lawrence Wiener, and others. I had established ties with most of the German dealers of contemporary art and the floor below mine was taken by Berlin dealer René Block.

The Victorian-era freight elevator, ramshackle and open-sided, was operated by the building's major domo, Alex John, a jazz musician and devotee of spiritual master Meher Baba. Erudite and conversational, he took an avid interest in what our galleries were

showing and by the time clients arrived at my floor they had been primed by Alex.

With a location for my gallery secured, I had to find the money for renovations, rent, and, if I was lucky, an assistant. If Peter Kagel would turn out to be the dark angel of my destiny in these years, Keith Barish was most certainly my white angel. Impressed with my prompt sale of *Nancy*, or perhaps to help me earn enough to pay back his loan, he asked me to sell his striking 1964 painting by Ellsworth Kelly, *Orange Blue I*.

I had recently met an unassuming collecting couple who lived in Great Neck, Long Island, Paul and Ellen Hirschland. Paul was an investment banker and Ellen taught art history in the Great Neck public schools. As the grandniece of Claribel and Etta Cone, she had also lived art history. Her great aunts, who were from Baltimore, had followed the example of their friend and neighbor Gertrude Stein in building a collection of paintings by Cézanne, Manet, Gauguin, and Picasso. They became principal supporters and close friends of Henri Matisse to whom they introduced their seventeen-year-old grandniece in 1936.

After dining with Paul, Ellen, and their son Edward, I scribbled some notes about what I had seen on their walls, including good drawings by Pissarro, Degas, and van Gogh. They had made a foray into contemporary art with less success and told me they were hoping I might help them sell a reclining chrome figure of a man by Ernest Trova and a block of squeezed black paint tubes in Plexiglas by Arman. I was more interested in selling *to* them than *from* them, so I asked what they were looking for.

"Well, a painting by Mondrian," said Ellen, while Paul nodded, a man of fewer words than his wife.

"I don't know of any for sale," I replied, "but I have a wonderful work by Kelly."

Alex John outside 157 Spring Street, 1971

A few days later they came to see Barish's Kelly and loved it. Paul spotted a tiny hairline crack and asked me to find out from the artist if he thought it needed attention. Kelly did not. The Hirschlands paid $18,000, of which Barish received $17,500. I was solvent for another month. If less than 3% was a modest commission, I had my eyes on a more lucrative project with Barish. We were in discussions with Fred Hughes at the Factory to set up a partnership for the distribution of all existing and future Andy Warhol movies. This project afforded us great opportunities for dining and wining, but like many such endeavors, nothing happened. Undeterred, Keith went on to produce *Sophie's Choice* (1982), *Ironweed* (1987), and many other successful films.

Uptown Gallery Closes, Downtown Gallery Opens

The September 11, 1972, issue of *New York* magazine carried an architecture-oriented story that broke the news that "Dick Feigen may decide to give up his uptown ghost" because of rising taxes. This despite the awards received for his Hollein-designed "spectacular gallery." The writer was obviously ignorant of the fact that the ghost of Feigen downtown had been given up a year earlier. The spectacular gallery was sold to high-end Japanese couturier Hanae Mori, who pledged to keep it architecturally "as is." Feigen moved to a more modest space one block east and turned more toward buying and selling Old Masters.

On October 1st, J. H. Duffy & Sons went into business on Spring and West Broadway. A mailer went out to my modest mailing list

boasting a diverse roster of artists whose "major paintings" I had recently sold: Beuys, Hockney, Monet, Picasso, Stella, and Warhol. The dealer's definition of a "major" work of art is anything they have sold or want to sell. I announced that in the coming year I would be showing the work of Stephen Mueller, Billy Sullivan, and Robin Bruch.

In an attempt to appear exclusive, and because I didn't have the funds, I told my clients-to-be that "we do not advertise in the press nor invest in frequent mailings." One sentence, perhaps too ponderous, that I will still stand by: *We believe that patient and discreet consultation between the collector and the dealer is the key to successful art buying.*

My wickedly sarcastic friend David Bourdon had just left *Life* magazine to write for the *Smithsonian*, and he punctured my youthful pomposity as follows:

October 14, 1972

Dear Michael,

Oh, you poor little lamb! Your sorrowful announcement has distressed me no end. How can you possibly survive with such meager stock? I was especially sad to learn you can't afford advertising or mailings—although, if you're going to show Stephen Mueller, this may be a blessing in disguise.

Please accept my contribution of one dollar to help defray the cost of a display ad in Women's Wear Daily.

Love,
David

This took snide to a new level, but I had to laugh. The reference to *Women's Wear Daily* took deliberate aim at my occupation as boy-friend-of-top-model.

A Cross Between

I deserved an "F" in marketing because after announcing that I would be showing Bruch, Mueller, and Sullivan, three young Americans, my first solo exhibition at J. H. Duffy & Sons was recent work by British artist Keith Milow, a young Royal College of Art graduate. I was beginning to visit studios of artists working in non-traditional materials like epoxy resin and felt, but I was not prepared for what greeted me on my first visit to Milow with his London dealer Nigel Greenwood in 1969. His works collapsed distinctions between abstraction and figuration as well as between painting and sculpture in a uniquely fastidious manner. He was adept with the vocabulary of American artists like Bruce Nauman and Robert Morris, but the works had a lyricism and grace which seemed to me very European. I bought two works and included him in a group exhibition at Feigen downtown. Keith himself was refreshingly self-assured and laconic.

I returned to Keith's studio with Nigel on subsequent visits to London and when he started to make crosses, I had to have an exhibition. I am cross-obsessed, thanks to my Catholic upbringing. Milow's first exhibition in New York consisted of sculptures on the theme of "a cross between painting and sculpture," punning "cross" because they were crosses of copper and bronze pigment on wood oxidizing to hues of green. Accompanying the sculptures were crosses on paper in various mediums, including pen and ink and pencil and gold leaf, as well as an arcane arrangement of coded numbering systems on

graph paper that I was instructed to hang so high as to make deciphering them next to impossible.

Buddha Needs to Pee

With Feigen out of the contemporary art business, Ray Johnson was a free agent. When I set up my own gallery, he gave me a dozen new collages to sell, which I had framed to his stringent specifications by Bernard Walsh, the only framer he allowed to touch his work. While Ray encouraged the New York Correspondance School to function by pure chance and outside all the given structures of the art business, he was obsessively exacting about the framing, hanging, and pricing of what he referred to as his "gallery" works.

Two were portraits of artists Joe Brainard and Jim Rosenquist, two were devoted to Buddha's bladder, *Buddha Urinating on Frank Owen* and *Buddha Urinating on Candy*. The small, abstract, brick-like cardboard units he called "moticos," a staple of his earlier works, were now integrated into pen-and-ink drawings and collaged photographs.

Ray and Toby were frequent unannounced visitors at 157 Spring Street, materializing in an invisible cloud of larkiness, Toby twinkle-eyed and Ray with his sea-blue, deadpan gaze.

RAY: (handing me a rusty, steel, street-found shelf bracket) "Give this to Charles Fahlen. We just saw May Wilson, she found Jesus."

TOBY: "In a photo booth. She left him there. And we just saw Albert Fine on Prince Street."

RAY: "I asked him when he was going to have another show."

TOBY: "He said he was just fine."

Albert M. Fine, who had bandied words across the auditorium

with Ruth Kligman at Ray's Anna May Wong meeting, was often to be found standing on SoHo street corners. In his early forties, with thick blond, uncombed hair, his standard garb was a baggy, soiled jean jacket and pants to match. Long before punk fashion, he decorated his clothes with large safety pins kept handy because he used them in his work. Albert had the bemused affect of a simpleton or seer and to some degree was both. He had distinguished himself as an avant-garde composer with a degree from Juilliard in orchestral conducting. He rarely stopped smiling and was always ready to fish out of his pocket a much-thumbed clipping from the *New York Times* review of his one exhibition in 1966 at Grand Central Moderns Gallery. It is an exhibition I remember clearly, which, like the artist himself, was perplexing but impossible to ignore. Fine had accumulated cheap, store-bought frames of various small sizes, different in design but made from narrow wood or plastic with glass or Plexiglas. He left the price stickers on, and the cardboard backing was visible in most because he put small objects such as safety pins, paper clips, and flat, wooden ice cream spoons into the frames. They were hung in a mass on the wall, not in straight lines and not all level. Fine was inordinately proud of his review by the fearsome John Canaday, possibly the worst any artist has received in New York's newspaper of record:

> . . . *this is the stalest, dreariest little show of the year. The only interesting thing about it is as to how a sensible dealer could ever rationalize a reason for hanging it, and why a critic who to the best of his knowledge is still in his right mind finds himself bothering to review it . . .*

My No Program Program

Many if not most galleries, in SoHo or uptown, were identifiable by their adherence to a specific category. Reese Palley's eggs were all in the Pattern and Decoration basket, which was also championed by Holly Solomon when she opened in SoHo in 1975. Paula Cooper had the early fast track with Minimal and Conceptual art by showing Carl Andre, Donald Judd, Dan Flavin, Robert Ryman, and Sol LeWitt. Louis Meisel had a lock on photorealism with Richard Estes, Ralph Goings, Robert Bechtle, and John Salt. Likewise, many of the artists whose studios I was visiting fell into one currently fashionable camp or another, whether it was hard-edge abstraction, lyrical abstraction, Photo-Realism, Minimalism, or catch-all Conceptual art. I was looking for interesting work that was not necessarily fashionable or even categorizable. Artists like Hannah Wilke, John Baldessarri, and John Van Saun did not fit into any of the currently available boxes, perhaps one reason I liked them. This was an instinctual bias of mine toward what jolted my feelings and curiosity. I was looking for the same kind of hit I got from Dalí's Christ when I was seven.

I didn't care if the roots were showing so long as the artist found a good new use for an existing language. Mueller was clearly indebted to Abstract Expressionist and color field painters, but to me his semi-structured, gorgeously colored abstract paintings were fresh and exciting. Billy Sullivan's personal diary of skilled and lyrically candid portraits of his friends made me think of Degas, and there was nobody doing anything like it (and predating the work of Elizabeth Peyton and Nan Goldin by a decade). The word postmodern was not yet used in art criticism so I had no jargon for Charles Fahlen's solemn, uncommon sculptures made of common materials.

While admiring the skill of the photorealists, the cult of flat, smooth-surfaced figuration failed to interest me until a client of mine needed to have a painting by Morris Louis restored. My subsequent research led me to a talented young German conservator, Brigitta Weyer, who worked at the Guggenheim Museum. After doing an excellent job for my client, she asked me to visit her studio and look at her own work. This I did to exchange the favor but with no expectations.

I was seriously impressed. She was making realist paintings of vintage aircraft in vast cloudless skies. The tenet of most photo-realistic work was exacting detail of streets or cars or piles of candy in the here and now. Weyer's work had an otherworldly sensibility; while not imitative, her sense of space and composition reminded me of the work of Yves Tanguy. I knew I could sell the work and I did. The problem was her excruciatingly slow pace of production. I was never able to accumulate enough works for a solo exhibition.

Another realist who fascinated me was Richard Joseph. He had been in the landmark *22 Realists Exhibition* at the Whitney Museum in 1970, but like Weyer, his work invoked a Surrealist sense of strangeness and displacement but on a larger scale. He was also a very slow worker, but I managed to buy two of his larger works. I sold one fairly quickly and I still have the other, happily so.

My trade in realists got a boost when I met the maverick *jefe* of Spanish art dealers, Fernando Guereta. A well-tailored bon vivant with thick, black hair and a striking profile, he was based in Madrid and devoted his considerable energy promoting the collecting of contemporary art in Spain. Guereta had a New York office and two *banderilleros*. Rolando Blain, tubby and jovial who lived at Alwyn Court on Seventh and Fifty-Eighth and taught flamenco guitar, and Paco Rebés, as skinny as Don Quixote, a true art lover and scholar.

There was rarely more than two degrees of separation between me and anyone I met in the then small art world. Paco knew Xavier Corberó and through him had met and become very fond of both Naomi and Elsa Peretti. Fernando had clients in Spain with an inexhaustible appetite for realist works representing the skimpily clad female form. With no shame, but also without hanging the works in my gallery, I sold them as many paintings as I could find by Hilo Chen, who specialized in topless beach beauties, every bead of sweat lovingly rendered, and John Kacere, who focused on ample female keisters clad in scanty panties. It paid the rent.

I visited artist studios every week. What was I looking for? To use today's terminology, I had no program. In any given week one or two artists would drop off a box of 35mm slides of their work at my gallery, and I probably visited the studios of one out of five, not a hardship since most studios were walking distance from my gallery, everyone in low-rent SoHo. I often found it necessary to make more than one visit. Why a second visit? Couldn't I tell right away if I liked the work of not? Sometimes no. Some artists are very good at presenting themselves and their work, others simply terrible. I had to separate the environment and personality of the artist from the work. More important, at that time artists were experimenting at the extremes of what had been accepted as art. In order to decide about the quality of something unlike anything I had seen before required more than one visit. Pathetically naïve compared to the mechanics of today's art "market," I never decided to exhibit an artist based on whether or not I thought collectors would buy their work. Along with many of my SoHo pioneer peers, my belief was that if I made a commitment to an artist, it was my job to convey my enthusiasm to others, hopefully resulting in interest from critics and curators which might lead to sales. As for the lure of investment, it

was nonexistent as far as I was concerned. I was focused on exhibiting what was new and exciting to me *now*.

Occasionally I came across work that was so raw and new I couldn't decide if it was wonderful or rubbish. One young artist I returned to twice nailed together uneven horizontal wooden slats, each crudely painted a primary color. Badly made and badly painted but they had a strong presence. Eventually I decided they were rubbish. I can still remember the visits, but just as well for both our sakes, I don't remember his name.

Holy Romans

Two years after my blurted first-date proposal, Naomi and I sealed the deal. Both raised Catholic, we decided we wanted the nuptial blessings of the church of our childhood. Despite this, Naomi often referred to Alex as "your *real* wife, Michael" in jest—I think. Since I had been excommunicated by marrying Alex in an Episcopalian ceremony, I had to get back into the good graces of the Holy Romans. This was managed with speed and efficiency by one of the great proselytizers of the twentieth century. Father Martin D'Arcy, Jesuit, ordained in 1907, was a frequent guest at Jane and Charlie Engelhard's dinner table. Now in his eighties, wizened and birdlike, he had been a spiritual mentor to more than one generation of English writers and intellectuals, including Evelyn Waugh, who converted to Catholicism shortly after writing *Vile Bodies* (1930), in which D'Arcy appears as "Father Rothschild." Charlie Engelhard had been one of D'Arcy's converts when he married Jane, already a Catholic.

Jane Engelhard was a hostess who enjoyed encouraging the narrative, and I found myself seated next to the good Father more than

once. Learning that I was a lapsed Catholic with a Jesuit education who wanted to re-marry in the church, he went to work. He was delighted to introduce me to the top man at the Jesuit's Manhattan lair next door to the Church of Jesuit founder Saint Ignatius Loyola on Park Avenue and Eight-Fourth Street. I arrived at my appointment with Father Robert Mitchell in a state of trepidation. D'Arcy assured me I would be received back into the Holy Roman Catholic Church swiftly and easily, but as a schoolboy my experience with the Jesuits was a combination of biting sarcasm and corporal punishment, a euphemism for clerically sanctioned assault. What bothered me the most was the prospect of remembering, let alone confessing, well over a decade of what I had been once told were mortal sins.

Father Mitchell received me warmly in a cozy study and we chatted easily in deep armchairs. He had been prepped by D'Arcy, so we spoke less than an hour when he got up and said, "Well Michael, that just about does it. We are happy you will be coming to Mass regularly."

"Isn't there something else, Father?"

"What do you mean?"

"Shouldn't you hear my confession? It's been over ten years . . ."

A pained look came over his face. "We still do that, of course, but since your day we've had Vatican II and a lot of reforms. I think we can skip the details. Is that all right with you?"

You bet.

I still had to get my earlier marriage scrubbed, which meant a formal application to the archdiocese of New York. This involved considerable paperwork and the hand delivery of an envelope containing eighteen hundred dollars in cash to the archdiocese offices behind St. Patrick's Cathedral. No receipt was provided.

Civil Wrongs on Central Park West

With that accomplished we booked a midsummer date with the Church of the Blessed Sacrament on West Seventy-First Street. Miniskirts were over and my bride was on the Best-Dressed List, so no worries in that department. But we still had to find an apartment. Naomi wanted to stay on the Upper West Side where she lived and where both of us felt comfortable. Before we looked in earnest, we went to a party given by poet and filmmaker Charles Henri Ford at the Dakota on Central Park West and Seventy-Second Street. Charles lived in one of the small turret-like apartments at the top of the building. It was thick with charm but so thin on amenities that dishes were washed in the bathtub. Ford had been the lover of painter Pavel Tchelitchew in the 1950s and introduced fellow poet Gerard Malanga to Andy Warhol. At that party we met Ford's sister, Ruth Ford, who also lived at the Dakota in a much more spacious apartment. She was an actress, the widow of actor Zachary Scott, and at the time involved with a young writer, Dotson Rader. Ruth took a shine to us and called me a week later.

"Are you and Naomi still looking for a place to live?"

"Yes, frankly we are getting a bit desperate."

"Well, I'm on the board here at the Dakota and there is an apartment that is going to be coming up for sale, six rooms. I could put you first on the list."

The Dakota. Six rooms. How much does heaven cost?

"Ruth, that's fantastic. How much do you think it would be?"

"Around $100,000, the maintenance is $1,000 a month."

I know, I know. We might have just managed the maintenance but definitely not the mortgage as well. We passed up the golden opportunity and started to scour rental agents for a prewar as big

and as close to Central Park as we could afford. We lucked out at a busy, small real estate agency on Broadway. A young female agent pitched us a sublease that had just been listed for a three bedroom on the corner of Eighty-Fourth Street and Central Park West. It had a large living room and separate dining room and two maid's rooms. The principal tenant was the filmmaker Stanley Kubrick then living in Ireland. Perfect. The rent was a steep $750 a month, but Naomi was booked months ahead and I had some deals in the works. Once we saw it we, signed the lease on the spot.

Before the listing was removed, the apartment was shown an hour or so later by another agent in the same office to the distinguished young lawyer, Gordon Davis, who was later to be New York Mayor Ed Koch's parks commissioner. Gordon is a light-skinned African American. He liked the apartment and asked if it could be held for him until he could get his wife Peggy to see it later in the day.

"Of course, we can," was the reply. Then, with a chuckle, "Unless, of course, your wife is Black." As indeed she is.

This agent had seen us in the office earlier and assumed his colleague had enforced the firm's Keep-Central-Park-West-White policy and turned us down. We met Gordon and fellow lawyer (and eventual judge) Peggy Davis after they had moved into a very nice apartment in the building on Central Park West next to ours. Being good neighbors, we had a son when they had a daughter.

Rockettes or Cockettes?

We had a date for the wedding, an apartment, now all we needed was an all-hell-break-loose engagement party. We turned to our good friend Luis Martinez who lived in what used to be Fanny Brice's vast duplex at 1 West Sixty-Seventh Street, the same building as the Café

des Artistes with its seductive murals by Howard Chandler Christy. Just thirty-three, Luis had been the Panamanian cultural ambassador to the United States until his boss, President Arnulfo Arias, was ousted. Luis had the means to enjoy a comfortable exile in Manhattan rather than return to a less welcoming regime in Panama.

He went all out on our behalf with "one of the prettiest parties of the year," according to *Women's Wear Daily*. Their intrepid reporter noted that Naomi wore a white Halston dress with two white orchids at her wrist, and Halston himself hogged a red sofa with MoMA trustee Lily Auchincloss, who put us all in our place when asked where her husband, Douglas, was: "He doesn't know any of these people."

What a shame! He missed dancing to the energetic bar mitzvah trio up on the balcony overlooking the long living room. Louise Nevelson held court in one corner, slowly blinking her long mink eyelashes. *Jeunesse dorée* were represented by Babe Paley's daughter, Kate, and Betsy Theodoracopoulos, née Kasper, née Pickering. Talking head Geraldo Rivera's young wife, Margot, "looking very sexy," was there with her boss, Giorgio di Sant'angelo. Geraldo came later but *WWD* noted that "he wasn't looking so sexy." True to his disliked nickname "Drella" (Dracula and Cinderella), Andy Warhol arrived at midnight with two fine young men wearing little more than glitter. "They are the original Cockettes," Andy whispered to Claude Picasso. "From Radio City Music Hall?" asked Claude.

One Funeral and a Wedding

A few weeks before our wedding, the sad news came that Naomi's birth mother Elizabeth, only fifty-six, was dying of cancer. Born in Oxford, Mississippi, Naomi was raised in foster care in Pittsburgh

by a Mr. and Mrs. Talbott, a straightlaced couple who treated her as if she was the maid for their light-skinned adopted daughter Jamesina. Naomi was placed with the Talbotts by social services. Her father Johnny Sims had left his wife with three daughters. Naomi, the youngest, was more than Elizabeth could care for. Growing up with the Talbotts, Naomi lived only streets away from her mother and older sisters, Doris and Betty, but they had very little contact.

Despite that I witnessed an affecting reunion between daughter and mother in a Pittsburgh hospital the day before Elizabeth passed away. A week later we attended the funeral which took place in a former Catholic church that had been repurposed for an Evangelical sect—no saints but an alarming thunderbolt behind the altar. It was packed. I was the only white mourner.

Naomi's surrogate parents for our wedding were Kenneth and Mamie Clark, the psychologists whose work had been a vital component of the Supreme Court Brown v. Board of Education ruling, which in 1954 declared racial segregation unconstitutional. Both Naomi and I were on the board of the Northside Center for Child Development, a Harlem-based nonprofit founded for early child development. We helped with fundraising, and I published a print by Jacob Lawrence to benefit the organization. We became close friends with the Clarks and had celebrated the previous Christmas with them and their children. Naomi asked Kenneth to escort her down the aisle.

The day dawned and the weather was gorgeous. Naomi spent the night before with her sisters at their hotel so that I would not see her until the ceremony, but she had not allowed for the extra amount of time it took her bridesmaid sisters, Doris and Betty, to get dressed and made-up. My best man, Kynaston McShine, and I were waiting a good twenty minutes at the altar until we heard a very loud car horn to the tune of "Here Comes the Bride," which had

Ali and Steve

A sudden Jamaican rain didn't trouble the serenity of Ali MacGraw, 34, and Steve McQueen, 43, during the filming of his $13 million epic of the best seller "Papillon." The pair have finally legalized their love affair by marrying in a Cheyenne, Wyo. public park.

STEVE SCHAPIRO

NANCY MORAN

Naomi and Michael

Naomi Sims was the first black model to reach the pinnacle of international fashion stardom, and Michael Alistair Findlay owns a New York art gallery. Both are trend-setters. So what mod mode did they choose for their wedding? A Roman Catholic church; educator Kenneth Clark to give away the bride; a white lace gown; just 12 guests at the ceremony; and a reception for 40. Understated elegance.

not been requested but for which the enthusiastic limousine driver did not charge us extra. Then we were married in the eyes of God, the Holy Roman Catholic Church, the well-dressed from the worlds of art and fashion, and, of course, in the eyes of the press, waiting outside. I was for belting down the stone steps to our limousine, but Naomi gently held my arm.

"Let's take a minute here," she whispered, ever the professional.

White petals were thrown, and we let the photographers shoot. The moment made it into the first issue of *People* magazine, sandwiched between photos of two other pairs of newlyweds: "Ali and Steve" (Ali MacGraw and Steve McQueen) and "Cybill and Peter" (Cybill Shepherd and Peter Bogdanovich).

Alfred and Lansing Moran threw us a wedding feast at 812 Park Avenue, yet another opportunity for the worlds of art and fashion to do more than eye one another. My mother flew in from London, her second brief visit to New York since a three-day stop on the *Empress of Britain*'s world voyage in 1934. Naomi and I had holidayed with her and her second husband, Sam, in Scotland, and I was delighted at how swiftly and sincerely my mother took to Naomi. Birds of a feather? Sisters under the skin? Still competing with her long-since-divorced husband, my father, she was disappointed that he, too, was enthusiastic about our marriage. My guess is that for him her fame trumped her color.

Race and the Fifth Estate

What was it like for a Black woman marrying a white man in 1973? Naomi's popularity and to a lesser degree my being British insulated us from facing direct prejudice. I was treated warmly by Naomi's sisters, and Naomi and I spent one thoroughly enjoyable day

in Pittsburgh with her congenial but profligate father, Johnny Sims, and his wife, Dorothy. I never met her foster parents. In Oxford, Naomi's grandmother, Priscilla, prudently placed our wedding photo in her bedroom. My two brothers were sincerely congratulatory.

So, who did have a problem with us? "Naomi Sims Marries Wealthy Englishman" was the headline in the *Amsterdam News*, New York's Black newspaper. Let's see, I was not "wealthy" and not "English," but such details were hardly important since the message to the community was *Naomi Sims Marries a White Man*. Despite being darker skinned than any other Black fashion model, Naomi was not Black enough for the Black establishment in Harlem. Arriving on the front page of the *Fashions of the Times* at the age of eighteen and then making her way to the top with no help from the *Amsterdam News* was considered a slap in the face. Black models were supposed to be discovered and groomed by Ebony Fashion Fair, an in-house operation for Johnson publications. John H. Johnson ran the publications, and his wife, Eunice, ran the Ebony Fashion Fair. Naomi was too dark for them but not Black enough. She was, however, championed by Susan Taylor at Ed Lewis's fledgling *Essence* magazine on whose cover she appeared many times.

One Honeymoon, Two Calamities

We honeymooned in Mexico, first to Mexico City, where, as good Catholics, we stayed at a hotel called El Convento, a former nunnery. Adventurous, we visited Teotihuacan, the ancient city of pyramids, many of which are stepped so it is possible to walk to the top. Being young and sporty we chose one of the tallest; a half an hour later we found ourselves enjoying a stunning view. Then trouble. Beanpole tall, Naomi had feet to match. Feet that were considerably

longer than steps made for the ancient, somewhat shorter Toltecs. Going up seemed not to be an issue but a fear of vertigo made her freeze as soon as we approached the edge to walk down. We finally made it, sideways, in two hours. At our next stop in Puerta Vallarta I went parasailing, alone.

A brief stop in London followed Mexico. I had gone all out with a suite at the Dorchester Hotel, then and now one of the finest. We arrived late at night and Naomi was famished.

"Can we call room service and order hamburgers? Will they have hamburgers?"

"Of course, this hotel caters to Americans, I'll get two medium rare."

"With ketchup and mayonnaise."

"Of course."

The Dorchester Hotel in London, at 11:30 p.m. on August 15, 1973, was out of mayonnaise. This was the only time I saw Naomi Sims play Medea. Over mayonnaise. But in the end, of course, she got it.

Switching Gears

When we became engaged, Naomi told me her plan was to wind down her modeling work once we were married. She had the germ of an idea to design beauty products for Black women. Her first ambition though, was to write a book for children. A friend put her in touch with Lisa Drew at Doubleday. Lisa told Naomi she thought there would be a market for a book of beauty tips for Black women by the leading Black model. Taking this more than seriously, Naomi proposed an encyclopedic *All About Health and Beauty for the Black Woman* (1976). Doubleday gave her an advance and an author was born. She knew hair and makeup from scratch, having to take care

of her own since there were no stylists in the fashion industry who could tackle the hair and complexions of Black models. She also reached out to her fellow Black models and Black hairdressers. For health, she interviewed professionals ranging from a professor of physiology at Howard University to a detective in the New York Police Department sex crimes unit.

As she was writing what would be her first of four successful books, she was approached by major beauty product companies who wanted her to help them reach the ill-served and potentially lucrative African American market. Johnson's Fashion Fair brand had just launched a substandard cosmetics line. Even worse were the cheap mail-order products advertised in the back pages of *Jet* and *Ebony* magazines manufactured in Chicago by a mom-and-pop business run by Mort and Rose Neumann, who were successful enough to build one of the country's most impressive collections of modern and contemporary art. It seemed that everyone from Hoffman-La Roche to the Neumanns wanted Naomi's name for branding but were not willing to let her design the products.

Although Afros were becoming popular with the young, most Black women straightened their hair, an arduous and dangerous process involving curling irons, or else they wore wigs. The wigs on the market for Black women had exactly the same texture as caucasian hair and looked patently false. Naomi wore her hair straight, flat back across her skull, and had never found a convincing wig or hairpiece. A small wig manufacturing company in New Jersey sent her a box of samples and she was so incensed she called the president and said he should be ashamed to sell such awful products to Black women. He listened.

"What's so bad about them?"

"Everything, the styles are out of date and the texture is silky. We don't have hair like that!"

"Think you can do better?"

"What do you mean?"

"Help us come up with something new."

We ate out for weeks in a row because our oven was baking artificial fibers. Naomi took this company's products and, inspired by how Estée Lauder got started, used her stove to burn and bake dozens of wigs. Eventually she found that by rolling them in setting lotion and baking 15 minutes at 175 degrees, she produced the consistency of straightened Black hair. Six months later, Korean chemists were reproducing this fiber and Naomi was designing her first collection of wigs named after African queens. Huge success. They were carried everywhere from neighborhood hair salons and wig shops to big urban departments stores.

After making one television commercial as a favor to Halston, Naomi stopped modeling, but she had a larger public presence than ever. She was featured in "Dewar's Profiles," a full-page advertisement describing her as "Writer, businesswoman, one of America's most original and successful wig designers;" her career as a model went unmentioned. One day she had an excited call from Berry: "I just passed Doubleday on Fifth Avenue. Your book is in the window!"

We rushed down and there it was, a big display of her first book. It became a best seller and deservedly so. With a foreword by Dr. Norma Goodwin, head of New York City Health and Hospitals Corporation, it was much more than "how to apply lipstick." There were chapters on *every* part of the body, as well as "Mental Health," "Beauty and Behavior," and "Fashion: Myth and Reality." Also an extensive appendix covering health insurance, state and national health agencies, and Black physicians.

I came home one day to find our sofa festooned with Kleenex tissues.

"What on earth is going on?"

"I'm working on a fragrance. I had help from Shelley Marks and I have an appointment at International Flavors and Fragrances. They tell me they can duplicate anything I can mix. I want your opinion. Just sniff each one and tell me which you like the best." Unsurprisingly, her "Naomi" fragrance soon hit the market.

Doing the Hustle

In order to match Naomi's contribution to the household kitty, I kept busy on Spring Street. Along with my niche in erotic realists, I was open to any transaction involving modern and contemporary art: selling a Chagall print to help Dorothy Dean pay her rent; taking a small *Lavender Marilyn* Warhol painting on consignment from fellow dealer Vivian Horan; telling Ray Johnson I had a client for his collage portrait, *Robert Rauschenberg*; buying a big red, blue, and yellow Albers from Feigen for a client and paying him in five days; selling a Dan Christensen painting called *Ghost Dancer* to Susan Engelhard's sister, Charlene; a large abstract painting by David Diao to Lansing and Alfred Moran; and *Landscape Relating to Music* by East Hampton–based Ian Hornak to Berry and Tony Perkins. By now "Saturday in SoHo" was the thing to do for adventurers from both the Upper East and Upper West Sides.

Sotheby's Earthquake

When the then British firm Sotheby's bought the American auction house Parke-Bernet in 1964, they sent a gaggle of Brits to New York to run it. Some brighter and more energetic than others, but none had any concept of what became known as "client development." The

basis for this is straight talk and a firm handshake, but those were not on the syllabus at Eton and Harrow.

They did have the good sense to hire Francine LeFrak, the effervescent, golden-tressed scion of a leading New York real estate family and recent graduate of Finch College, where she had been mentored by the extraordinary Elayne Varian, the director of the Finch College Museum of Art, who had previously worked for the distinguished Duveen Gallery. I met Francine when Elayne invited me to give a talk to Finch students. Francine's parents, Sam and Ethel LeFrak, were prominent collectors as was her older brother, Richard. Francine was known for her charm, good looks, and chutzpah. She joined Sotheby's at a very tender age to look after major clients, sellers, and buyers who might need to have the Queen's English translated into American.

Located on the second floor of 980 Madison Avenue at Seventy-Sixth Street, Sotheby's offices and saleroom were entered through a spacious lobby dominated by a donut-shaped, red velvet sofa, with arm rests, very comfortable. Whenever I visited uptown galleries, I was always sure to make my way to that sofa and find Francine for the latest gossip.

In December 1972, Managua, the capital of Nicaragua, suffered a major earthquake destroying much of the city center and displacing a million people. Generous Americans sent winter clothes and frozen TV dinners to this tropical capital. The US government sent money, most of which ended up in President Samoza's bank account. In the settling dust, a flame-haired stockbroker named Catalina Kitty Meyer entered the art world like a whirlwind, and Francine and I found ourselves the leading lights of the Nicaraguan Earthquake Art Relief Manguan Homeless Settlement Committee, soliciting contributions of artworks for a charity auction that Francine had persuaded Sotheby's to host. Between Kitty and ourselves, we arm-

twisted Alexander Calder, Andy Warhol, Larry Rivers, Frank Stella, Red Grooms, Robert Rauschenberg, Saul Steinberg, and even Peter Max to donate prints and works on paper. Salvador Dalí produced a custom-painted *Homage to Nicaragua*. Lending their boldfaced names to the charity were the usual suspects, including Charlotte Ford Forstmann, Bianca Jagger, and Bob and Ethel Scull.

Thanks to Kitty's connection, we previewed the art in the United Nations Delegates Dining Room with a cocktail party preceding the auction, which was presided over by G. Bradford Morse, the under-secretary-general for political affairs. The auction itself was extremely successful and very lively thanks to theatrical interruptions by Argentinian performance artist Marta Minujín and cohorts, in what she billed as an anti-dictatorship *Nicappening*. Boisterous yells of "Do you know what's happening?" punctuated but did not deter the bidding. Over $150,000 was raised and the Pan American Foundation saw that it all went to build as many modest $500 homes as possible.

The Virgin and the Bell

The second auction I had a hand in organizing was even more exuberantly off-the-wall. It was in Santa Fe, New Mexico, which had become a second home for my Texan friends. Compared to the social proprieties of Fort Worth and Dallas, the high, dry desert air was perfect for relaxing with a pitcher of margarita after a stroll through the market looking at Navajo rugs and turquoise jewelry. In a state where elected officials were not afraid to be seen inhaling, the adage "live and let live" had real meaning. I was a frequent visitor, staying at La Fonda on the Plaza, a 1920s-style adobe palace redolent of the Old West.

Janie Beggs found herself an adobe house high on a hillside in Tesuque. In the early evening friends would drop in to enjoy margaritas, the sweet smell of a mesquite fire, and a stunning 360-degree view of scrub desert, forested mesas, and the snowcaps of the distant Sangre de Cristo Mountains. Artists like Georgia O'Keefe and Agnes Martin had long enjoyed New Mexico's quiet spiritual energy, and in the 1960s California artists Ken Price and Larry Bell had gravitated to Taos.

A distinctive feature of downtown Santa Fe is the Santuario de Guadalupe built in 1795 to honor the dark-skinned Virgin of Guadalupe, possibly the oldest shrine in the United States. This distinctive chapel was almost destroyed by fire in 1922, restored but fell into disrepair, and was closed as a church in 1961, after which it was used only occasionally for community functions. A dynamic parish priest, Father Leo Lucero, and an activist historian, Dr. Gabrielle Palmer, formed a foundation to raise money to restore it to its original architectural glory. Father Lucero enlisted the indefatigable Jim Meeker to get the art crowd involved. I was roped into two hare-brained schemes, one of which turned out very well.

Mentioned in an 1883 guidebook for the Santuario is a 1779 painting on copper of *Our Lady of Guadalupe Virgin* by Mexican painter Sebastian Salcedo, which by the 1970s had found its way into the permanent collection of the Denver Art Museum. Meeker's plan was for me to persuade the museum to swap the late eighteenth-century Salcedo for a mid-twentieth-century sculpture by Larry Bell that he owned, a large glass work that Bell would install in the museum. Thomas Maytham, the director of the museum, was politely not receptive, although today the idea does not seem as outlandish as it did then. From a box office perspective, the Larry Bell would be considered the bigger draw. Maytham did, however, lend the Salcedo for the re-opening of the restored Santuario.

The scheme that turned out well was the auction that we organized in the Santuario itself to raise money for its restoration. Meeker went all out arm-twisting his Los Angeles cronies, Larry Bell, Ken Price, Ed Ruscha, and Malibu surfer-artist Jim Ganzer, to contribute works. I managed to scrape together a few from artists in New York like Stephen Mueller.

It was a rollicking event catered with excellent Mexican food courtesy of the ladies of the parish as well as liberal libations. The star of the show was Jimmy Buffet, who had agreed to be the honorary auctioneer. He described the lots as they came up to be sold, but the actual bid calling was done by a white-suited, cowboy-hatted, cattle-rattler with more than a gift for the very swift gab. Wearing airy white dresses, not too long, Janie Beggs and a friend acted as "spotters" patrolling the aisles and exhorting their pals to bid.

Bidders came from far and wide, meaning Los Angeles and Dallas-Fort Worth, as much for the party as for the auction. Larry Bell and Ken Price and their wives attended and after the event those of us sober enough to drive made for a big, open-air barbecue and beer joint. There was a small stage with a live band, more Ramones than Beach Boys, but when they spotted Jimmy Buffet at our table, they hauled him onto the stage and backed him singing his new hit "Margaritaville," a fitting ode to the proceedings.

We All Like America

Apart from Ray Johnson and Toby Spiselman's spontaneous performative visits, I only used my gallery space for exhibiting objects, not actions. I envied Sonnabend, across the street, who could afford to entertain the public with *Singing Sculpture*—artists Gilbert & George, in bronze makeup, moving slowly and singing on a plinth

in the middle of the gallery. I did, however, provide vital assistance to an art action in my building that became legendary.

On May 2, 1974, I received a telegram from Berlin addressed to "Findlay Galery—Dufy" which read: "OPENING AT THE 21. MAY NEED THE COYOTE MONDAY MAY 20. TILL 25. RENE BLOCK." I was on excellent terms with my downstairs neighbor, the Berlin dealer René Block, and delighted when he told me that Joseph Beuys would be visiting New York for the first time in January as part of his lecture tour *Energy Plan for the Western Man*. When Beuys came upstairs to my gallery, he was affable and amusing, far from the forbidding personality I had imagined. Delighted that I had sold his *Sled* to the Museum of Modern Art, he and René confided in me that this was a scouting trip for an action planned for Rene's gallery in May, involving an ambulance, a cage, and a coyote. Beuys envisaged a visit to America during which he would only interact with a coyote, his companion in a caged portion of the René Block gallery. I was fascinated and told them to let me know if there was anything I could do to help.

Indeed there was. Block's New York gallery staff managed to find a vintage ambulance to transport Beuys to and from Kennedy airport as he requested, as well as a grill with which to fence off two thirds of the gallery. The daily copies of the *Wall Street Journal* were also easy to obtain. What they could not find was a coyote. Hence the telegram.

I Like America and America Likes Me (1974) is a major work by Beuys and has been described, analyzed, and theorized about for almost fifty years, so it would be churlish of me to suggest I had anything to add except that for the record the coyote did not come from Texas or "the desert," as has been variously proposed in scholarly literature, nor was it wild. It was rented by me for a fully reimbursed $300 ($100 dollars per day) from Dan Gruber, who had a New York City Plaza telephone exchange number. The coyote came from and

Film still from Joseph Beuys, *I Like America And America Likes Me*, 1974.
The coyote is looking out the rear window of the René Block Gallery
with a view of 420 West Broadway, Castelli Gallery, and others

was returned to a New Jersey farm. Its name was not "Little John," as had been suggested by art historians.

I spent a good hour in René Block's gallery every morning for the three days of the performance. There was a narrow space in the front for spectators to gather. I had watched out of my window to see Beuys arrive in the 1950s-style ambulance. He did not communicate with any human the entire time he was on American soil, including his dealer and the gallery staff. At the end of three days, he returned to the airport as he had arrived, silent, in an ambulance.

Initially there was some tension between the artist and the coyote, possibly more projected by us onlookers than actually existed. Since the coyote was used to human contact there was little danger involved, although I may have been one of the few people who knew that. Beuys had his props, including his trademark hook-handled walking stick and a large felt blanket. By day two he had established a routine where he covered his body and head with the blanket, the top of the stick poking out over his head as he rolled about on the floor. I watched in amazement as the coyote rolled with him. Despite the availability of factual information, video evidence, and first-person recollections, the way this action has become paraphrased for art history's sake is that Beuys "locked himself in a room with a wild coyote" as if it were a circus act. Witnessing the dialogue evolve over three days, I felt that Beuys was creating an elementary relationship with America. Every work of art, regardless of the medium, deserves to be seen slowly, over time.

The Good Neighbor

An important lesson I had learned from Feigen was that friendships in business make good business. Some art dealers are by nature

competitive, secretive, and untrusting, but part of Feigen's success was in being popular and collaborative with his peers. This might mean borrowing works from Leo Castelli's artists for a group exhibition or buying a Matisse together with Stephen Hahn and hoping one of them could sell it. I tried to emulate that as I made my way in the business.

The SoHo dealer I felt the most affinity for and who became a close friend was Betty Cuningham. Her gallery was sometimes as precariously on the brink of insolvency as mine. It was in the not entirely level loft space immediately above Fanelli Cafe; Mike Fanelli was her accommodating landlord. On slow days I was more likely to be found in her gallery than mine. She was passionate about the talented young artists she showed. I shared her enthusiasm for their work and some, like John Walker, became good friends. Apart from Walker, she showed Alan Cote, Jake Berthot, David Diao, and Christopher Wilmarth, all of whom owed their first solo exhibitions to her, as did a young man who also helped out in the gallery, Ross Bleckner.

Betty and I hustled together, supporting each other's artists, sharing clients, and trying to pull off secondary market sales of paintings by Rothko, Edvard Munch, and even a Rembrandt Peale. Betty and I trusted each other and believed that the rising tide raised all ships, so that the more people we could encourage to buy each other's works the better for us both, whether the profit was large or small or a simple thank you. All very "Happy Days" with Fanelli as our Arnolds.

What Can I Find to Sell?

Gerald Laing, married to Galina and with two bonny sons, was now living and working in Scotland in Kinkell Castle near Inverness. He bought the property for a song when it was close to becoming

a ruin and single-handedly restored it to new glory as a home and studio. Taking a break from making his monumental sixteen-piece steel sculpture *Callanish* (1971) for the University of Strathclyde in Glasgow, he came back to New York for a visit, bringing me three recently cast bronzes from Scotland. These were a striking departure from the flat floor and wall sculptures he had previously shown in New York. Semi-figurative, two were busts of Galina and one a reclining figure. They were quite original, but if I had to assign parents, they would be Raymond Duchamp-Villon and Henry Moore.

Naomi and I invited Gerald and Galina to dinner to celebrate their visit to New York. Gerald told me that he had become friendly with Douglas Hall, keeper of the Scottish Gallery of Modern Art, and that the museum wanted to acquire major twentieth-century sculpture as well as an early "astronaut" painting by Laing himself. My good fortune, or so I hoped, was that I could supply both. The sculpture I offered them was a bronze cast of *Head of a Woman (Fernande)* (1909) by Picasso, owned by a private collector who told me he would sell if I could get $500,000. Unfortunately, this price was deemed "far beyond our present, or likely future, resources." At the same time I had suggested they buy *Astronaut IV*, a classic 1963 shaped canvas that I owned myself, for a mere $2,200. Every art dealer is familiar with the client who asks you for something very specific and when you make the effort to find exactly what they have described, they tell you that, actually, they want something completely different. In this case "a later work by Laing," which of course they could get from the artist himself and good luck to both.

My spirits soon lifted when my dermatologist, Dr. Alvin Friedman-Kien, told me he would like to sell a very appealing table-sized standing Calder mobile from 1952. Alvin was a passionate collector and physician to the worlds of art and theater and would become one of the first doctors to identify Kaposi's sarcoma as related to HIV and

to warn and treat the gay community. His Calder had once been owned by an artist named Erik Bruhn, who had committed suicide in his early twenties and willed it to Ray Johnson, who had sold it to Alvin. Because, or perhaps despite this history, I sold the work quickly for $8,500 and was happy with my 10%.

Among the most sought-after works by Joseph Cornell, then and now, are his boxes of perched parrots. Kynaston McShine owned one I long coveted and eventually he entrusted the sale of it to me. *Grand Hyacinth Parrot* (1954) is one of the artist's very best, and I was hoping to sell it for at least $20,000. Richard Feigen got wind of this and again implored me to give him a chance to make the sale. Because he was one of the few dealers Cornell himself used to sell his work, and despite my past experience of long-delayed payment, I let him show it to *one client only* from noon on April 2 until 11 a.m. on April 3, 1975. His client was interested but took too long to decide. Operating on the "first come, first served" principle, I sold it shortly after that to a private collector and made both Kynaston and me happy with the result.

"SoHo Sucks"

The writing was literally on the walls of SoHo for small gallery owners like me. Bold stickers had appeared in the streets, red letters on white: SOHO SUCKS BRING BACK THE TRUCKS. These were the work of artists protesting the influx of well-heeled, non-artist residents, expensive dress stores, and restaurants with tablecloths. Across West Broadway from me was a five-story paper warehouse approximately 4,000 square feet per floor. Until late 1971, trucks stretching halfway into the street were backed up to its loading dock. Then the building became the epicenter of SoHo when it sold

for $275,000 to dealers Leo Castelli and André Emmerich and Hague Art Deliveries, a shipping and storage company. They each took a floor and rented the remaining two to Ileana Sonnabend, Castelli's ex-wife, and dealer John Weber. For me it felt like Bloomingdale's had moved into the village High Street. This behemoth increased visibility and traffic for everyone but upped the ante for what artists expected from their SoHo gallery in terms of advertising, sales, and promotion.

SoHo was only zoned for commercial use, so nothing stopped galleries, big or small, from taking any space available. Artists had a hard-won pass with the A.I.R. (Artist-in-Residence) designation which at first was strictly enforced, then became increasingly easy to obtain if you were in an associated business like, for instance, architecture. In the November 24, 1974, issue of the *New York Times*, Norma Skurka reported a visit to my client, architect Hanford Yang, who had just moved into the SoHo building he bought and turned into a co-op using the ground floor for his offices. He designed "an enormous expanse of 35 by 80 feet of living space" into a "living room and gallery." The word "gallery" referred to a residential space to accommodate his private collection, which included paintings by Morris Louis and Frank Stella, sculptures by Louise Nevelson, Alexander Calder, and Richard Stankiewicz. There was also a Frank Lloyd Wright window he had bought in 1969 from me at Feigen downtown. Poetic justice?

Naomi Gets Big, I Get Sick

SoHo was not the only thing in my life that was about to expand. One evening Naomi served our favorite dish, honey-baked ham with cloves.

"What's the special occasion?" I asked.

"We're having a baby."

And as if a baby on the way wasn't enough, Billy and Amy Sullivan told us there was a litter of Lhasa Apsos available to pick from. They had already chosen "Andy," honoring Warhol, so we chose "Mildred," honoring Joan Crawford in *Mildred Pierce* (1945). Mildred moved effortlessly into our lives, almost as effortlessly as Ms. Sims approached being pregnant.

Naomi hurled herself into the promotion of her wigs just as her stomach was expanding. She made personal appearances in department stores from Boston to Los Angeles, on her feet for hours, training salespeople, giving demonstrations, and talking to her customers. The more pregnant she became the more she glowed and thrived and the sicker I got. It's called couvade syndrome. The partner shares the symptoms of pregnancy including nausea, only in our case Naomi didn't have any symptoms except a heartier appetite. I took it all on, including weight loss. I was a two-pack-a-day Benson & Hedges 100's man, and I was so nauseous I stopped smoking. For good. I was also an at-least-one-perhaps-two-bottles-of-Pinot-Grigio-a-meal man, and I stopped drinking. For a while.

I was in the room at Beth Israel Hospital when Bob entered the world in the early hours of January 2, 1975. My elation was equaled twenty-six years later when my now and forever wife Victoria and I held our daughter, Beatrice, in our arms.

Bob's arrival occasioned yet another party, this time in our home following a christening ceremony at the Church of the Blessed Sacrament where we had been married. Godparents were a very nervous Kynaston McShine and a very confident and happy Berry Berenson Perkins, whose own first child, Oz, was just one year old.

White was the theme of the baptismal celebrations. Naomi's signature gardenias abounded and lots of champagne and caviar was

consumed. I am not ashamed to reveal the record player's playlist included Donna Summer, ABBA, and Joe Cocker, as well as my staple for ceremonies, Bach's Brandenburg Concertos. Artists came, Stephen Mueller and Billy Sullivan with his wife Amy, who now lived nearby in a townhouse on West Eighty-Seventh Street. Halston and his entourage, Elsa Peretti, Marina Schiano, and Pat Cleveland Sullivan; and of course our Park Avenue chums, Lansing and Alfred Moran. Naomi's sister, Betty, was dating her future husband, Alex Erwiah, a mercurial entrepreneur from Cote d'Ivoire who arrived with a flamboyant young boxing promoter, Butch Lewis, a protégé of Don King, so we could add "sports figures" to our mélange of art and fashion world friends. Later Erwiah and Lewis would match Naomi with Muhammad Ali in a charity fashion show for which they both wore floor-length mink coats.

Me and Sara Lee

With a full-time cook-housekeeper and a live-in nanny, we were living beyond our means, so I had to put the pedal to the metal. Sara Lee came to my rescue.

Nathan "Nate" Cummings, a self-made, Canadian-born, Chicago-based entrepreneur, built the giant Sara Lee Corporation known for food products as well as Kiwi Shoe Polish and Bali Bras. With money in his pocket in postwar Paris, he saw a painting by Camille Pissarro in the window of a gallery and bought it because he liked it. This was followed by decades of astutely collecting Impressionist and Modern paintings both for his own residences and for a Sara Lee corporate collection.

The apple of his eye was his daughter, nicknamed "Buddy," who developed a keen interest in contemporary art. She married Robert

B. Mayer, a director of her father's company. They were in New York every month and among the first collectors to buy Rauschenberg, Warhol, and Lichtenstein, as well as British artists Gerald Laing and Allen Jones, and young Chicago artists Roger Brown and Ed Paschke. Their neighbors thought they were crazy as they added galleries onto their Winnetka home to accommodate their acquisitions.

I am fascinated by the collecting dynamics in marriages, since it is not always apparent which spouse is making the final decisions. Robert Scull was clearly making the choices while Ethel enjoyed the attention that ownership conferred. Alternatively, Emily Tremaine was the lead collector in her marriage while Burton deferred to her taste, shrewdly using the collection to promote his lighting company.

I first met Buddy and Bob in 1965 when they visited the Feigen Gallery. Bob was a big man with horn-rimmed glasses, a deep voice, and a strong Chicago accent. While Bob barked Buddy looked—and looked carefully. In the end it was she who made the final choices. Buddy had the taste, and the money, but was totally without affectations. She dressed simply and spoke plainly. She had firm principals which she put into action, in the Red Cross during World War II and by going to Mississippi in 1964 and 1965 to participate in Civil rights protests with her friend Dorothy L. Height of the National Council of Negro Women.

Bob Mayer died at 63 in 1974, and I helped Buddy with the necessary appraisals, including the works purchased from me. The next year she asked me if I thought I might be able to sell one or two and I leaped at the chance, starting with two 1963 paintings by Allen Jones, a 1964 black-and-white work by Bridget Riley, and a classic nails painting by Günther Uecker from the same year.

I used this consignment as the basis for an exhibition that opened just after Bob's first birthday called *Early Works*, even though most had been done only a little over a decade earlier. In the 1960s and

Allen Jones, *Black Hat*, c. 1964.
Oil on canvas. 84 × 46 in. (213.4 × 116.8 cm). Sheffield Museum.
Used as the announcement for *Early Works*

1970s movements evolved swiftly. Good artists kept moving forward in their work, more interested in taking risks than establishing brands, as many do now. Collectors had to keep up with them. By the mid-seventies some works of the early sixties had already achieved classic status, even though the artists that made them were still experimenting.

I complemented Buddy's works with paintings by Americans Al Held, Theodoros Stamos, and Charles Hinman, also a rare 1952 collage by Ray Johnson, the earliest work in the show. UK artists were represented not only by Riley and Jones, but also by a 1962 painting Richard Smith had shown at the Greene Gallery, one of Gerald Laing's first chrome and enamel hinged wall and floor sculptures, and a vibrant wheel of color by Peter Sedgley. The gallery never looked better. I sold half the exhibition, which for me was a big success. Just as good for me was that it had tempted John Russell, then reviewing for the *New York Times* to visit me and describe the exhibition as "an intelligent and inventive choice of paintings," finally putting me on the map.

Rising Young Stars

I was now getting decent foot traffic and launched a schedule of solo exhibitions, starting with Stephen Mueller. Now showing with collegial Tibor de Nagy and my former colleague Fredericka Hunter's pioneering Texas Gallery in Houston, Stephen had new paintings that Tibor was willing to let me show downtown. He and I had partnered to buy two Muellers that had come to auction, so we both had a stake in Stephen's career. Mueller opened at Duffy & Sons in March 1976 with seven paintings that were sold within the month.

This was followed by Billy Sullivan's exhibition of exceptional

portraits of his circle of friends, capturing them unposed and very expressively in paintings and large works on paper; these included images of Jane Forth, Taylor Mead, another star of Warhol's films, as well as the gifted and outrageous poet Rene Ricard and the beguiling designer Delia Doherty.

At this time in my life there were few seams between my work and my friendships. Naomi and I spent a lot of time at Billy and Amy's house and often found Stephen and Robin there with Delia. At party time it might as well have been the Factory uptown with Warhol stars like model Carol La Brie, her boyfriend, Gilles Raysse, Andy's boyfriend, Jed Johnson, and his twin brother, Jay, as well as Warhol assistant Ronnie Cutrone, whose own work I had showed at Feigen downtown. One very late night found a topless Brigid Berlin in Billy's studio jumping and pressing as she endeavored to make breast prints high on the wall. Billy designed the sets for Warhol's only theater production, *Pork* (1971), which was based on taped conversations between Brigid and her socially prominent mother, "Honey" Berlin.

The third solo exhibition on my schedule was sculptor Charles Fahlen, whose strange floor and wall works made from roof cement, Homasote, felt, fiberglass, and galvanized wire had intrigued me since 1968, when I had first been introduced to him by Dianne Vanderlip. He showed with Marian Locks in his hometown of Philadelphia and had a strong following there. I had included him in group shows at Feigen both downtown and uptown between 1969 and 1971, and he now had a sufficient body of new work for me to present as forcefully as I could with a glossy catalog, including essays by Locks, myself, and the brilliant Gregory Battcock, who managed to combine an acting career as the star of the Andy Warhol movies *Batman Dracula* (1964) and *Eating Too Fast* (1966), with serious writing: *Minimal Art: A Critical Anthology* (1968).

Fahlen's work was quite unlike anybody else's. His wall and floor pieces were structured and built, at a time when sculptors were dropping and flopping and flinging. His light industrial materials give them unusual delicacy and grace. His opening was crowded and included his cronies from Philadelphia mentioned earlier, George Herbert, Joe Rishel, and his wife, Anne d'Harnoncourt. I was delighted when John Russell returned and told his readers that Charles Fahlen "is one of the best young sculptors around," describing the work much better and with fewer long words than I had managed to do in my catalog essay.

How to Write about Art

I had known John Russell since 1969 when he and his girlfriend, Suzi Gablik, curated *Pop Art Redefined*, the definitive survey of a movement still in motion, at the Hayward Gallery. He had been in naval intelligence during the Second World War and rose to prominence as both a curator and art critic for London's *Sunday Times*. With Whitechapel Gallery Director Bryan Robertson, he wrote the lavishly illustrated *Private View* (1965), profiling the postwar art world in London and introducing the new generation of young artists. Lured to New York by the *New York Times*, he met and married another art star, perhaps more age-appropriate than Suzy, the lecturer Rosamond Bernier. "Peggy," as she was known to some, had known and been known by many celebrated artists of the twentieth century, thanks to her second marriage to the founder of *L'Oeil* magazine, Georges Bernier. Later in her life she dramatized these acquaintanceships with lectures more performed than delivered, her memory of events and conversations becoming more specific as her old pals passed away, rather like I am doing in this book. For all his

accomplishments, John Russell's enduring legacy was his humble summation of his life's work: *I wanted to persuade people to go and see things I myself liked.*

Why make it more complicated than that? It may sound philistine, but the few times I have tried to plough through the work of esteemed art critics like Rosalind Krauss, I find myself getting tired of reaching for the dictionary. Hilton Kramer visited galleries with the enthusiasm of a hypochondriac in a leper colony and usually left with an angry scowl. Max Kozloff was easy to talk to but hard to read. Donald Judd declared, "Criticism is pretty much after the fact" and he knew because he had been a critic himself. The writers I admired were those who inhabited the same world as the artist they wrote about and were just as offbeat as the artists: mad Gene Swenson, David Bourdon, Gregory Battcock, and the poet Rene Ricard. Like very good sports commentators, they called the action and critiqued in real time, taking the same risk as the artists. Other plainspoken, intelligent reviewers were Nicolas Calas and Peter Schjeldahl.

Circus by Day and Circus by Night

Once we became a family, Naomi and I curbed our night life, slightly. By now Berry and Tony Perkins had their son, Oz, a year older than Bob, and their son, Elvis, a year younger. We were often to be found at their brownstone in Chelsea on playdates. It took me a while to get used to being on familiar terms with Perkins. I had seen him in *Friendly Persuasion* (1956) and, of course, *Psycho* (1960), the film that defined him for most people. The first time we were to meet him, I was expecting a sinister boy-man with a murderous glint. He was, of course, an actor, and Norman Bates a character. In his own

home he was a relaxed and affable husband and father, comfortable with himself and easy to be around.

The first time we met he was rehearsing to replace Anthony Hopkins on Broadway in the British play *Equus* (1973). His character, Dr. Martin Dysart, is a child psychiatrist, and Tony was diffident about replacing Hopkins, who had a very distinctive voice and delivery. He asked me for feedback on the British accent he was working on for the part.

One of our memorable outings together was organized by a young collector friend, Maria Celis. When the Barnum & Bailey Circus came to Madison Square Garden in April, she had behind-the-scenes connections and offered to host a VIP visit if Naomi and I put an interesting group together. This ended up including ourselves and two-year-old Bob, Berry and Tony Perkins with their three-year-old Oz and year-old Elvis. The clowns were unusually creepy that year, but to my knowledge the children suffered no lasting damage, particularly since we were invited backstage after the performance, thanks to Maria and because some of the circus folk wanted Mr. Perkins's autograph.

We had not entirely retired our dancing shoes however, and eight days later the four of us, minus our children, were at the opening of another circus, a dive club on the far west side called Studio 54, the brainchild of Ian Schrager and Steve Rubell, who had failed with a chain of steakhouses as well as a club in Queens called the Enchanted Garden. Why would we go to the opening of a club way off the map owned by two losers? The answers is Carmen D'Alessio, a feverishly successful fashion industry publicist with a celebrity-packed rolodex that included my wife. And Halston. And Andy Warhol. And Bianca Jagger. And Liza Minelli.

Yes, in its brief three-year run, Studio 54 was an adult play-

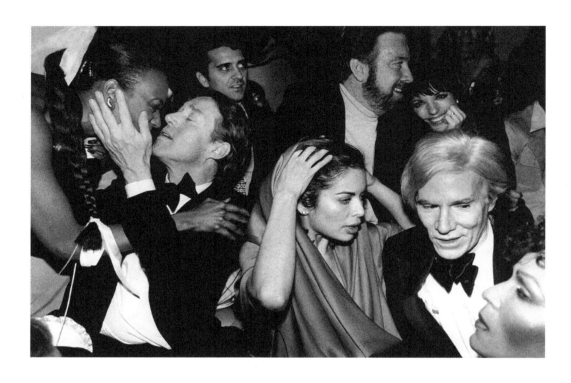

Robin Platzer, *Studio 54, New Year's Eve*, 1977.
From left: Naomi Sims, Halston, Bianca Jagger, Jack Haley,
Liza Minelli, and Andy Warhol

ground for boldfaced names who drank and danced while, it was rumored—sorry, I was not invited—much more happened in the basement downstairs. Schrager and Rubell managed to maintain a mystique of exclusivity with eagle-eyed doormen Marc Benecke and Chris Sullivan letting in the colorful high-lifers and lowlifes while keeping the bridge-and-tunnel crowd out. Inside it was much like any other club, although the image over the stage of the man in the moon snorting from a spoon left little to the imagination. The music was very loud, favoring Donna Summer and Gloria Gaynor, and the bartenders were very pretty boys in very tight silver shorts. Naomi liked to dance.

My Landlord Tops Himself

In SoHo, however, the changes afoot were not to my advantage. My erstwhile friend and landlord Peter Kagel had been AWOL for months when, along with his other tenants at 157 Spring Street, I received a notice from a court-appointed referee that ownership of the building had been transferred to an entity called Broad-Spring Associates, Inc. Henceforth our rent checks were to go to them. I called Kagel's wife, Suzy, who informed me she was no longer his wife, and she had no idea where he was. He eventually surfaced, with a needle in his arm and rigor mortis, in a New Jersey trailer park. Not so chic. Having bought our building for $40,000 in 1971, Kagel's estate sold it for not much more five years later.

I had a good run paying affordable rent, but with no illusions things would stay as they were. This was bad timing because I had just found an artist I really wanted to show. Providentially, I ran into my old friend David Gibbs who told me he was working at Pace

Gallery but looking for fresher fields where he would have more autonomy. This led to a lunch where I confessed to him that I needed help hanging on to J. H. Duffy & Sons. David had handled Jackson Pollock's estate in London before he moved to New York, and, perhaps through knowing Lee Krasner, had become a strong advocate for woman artists. Two whose work he wanted me to see were Andra Samelson and Susan Elias. I told him I would be happy to consider them if we could work out a partnership agreement. And I mentioned a young Irish painter new to New York who had been showing with David's friend, Alex Gregory-Hood, at the Rowan Gallery in London.

The Dublin Linesman

I followed up my lunch with David with a letter, as one used to do:

> *I want to tell you about Sean Scully who has been working here on a scholarship and is in New York. He has had very successful shows with Alex at the Rowan but has not made any assault on NY galleries. His credits are already very good, European museums, etc., and the few people who have been to the studio (John Russell for instance) are very impressed with the new work. . . . He does not want to get caught up in SoHo and is not hungering for a show right away. It does him a great injustice to compare the work to early Stella or Agnes Martin but it is along those lines (awful pun). If you could visit the studio I think it would be mutually edifying. His own instincts and my advice have led him to pursue a very low profile so far and he has not had dealers trekking in and out.*

David accepted my invitation. I took him to Scully's studio, then a barely furnished loft on West Eighteenth Street between Sixth and Seventh Avenues. A mattress on the floor with black sheets, although I may be making that up. At first glance the paintings also looked black and the pugnacious Scully himself appeared to be in a dark mood. In fact, seen slowly, his paintings were composed of evenly spaced, hard-edge horizontal stripes, perhaps an inch high, of two alternating hues. They were not startlingly original but powerful and challenging and rewarded lengthy scrutiny.

I was afraid that David might find the gloomy atmosphere in Scully's studio, the art, and the man, off-putting. But he was as enthusiastic about the work as me. We quickly formulated a plan to consolidate as Duffy/Gibbs Gallery and give Scully an exhibition at 157 Spring Street early in the New Year.

"Abstractions in dark grids that approach the monochrome, but keep a dancing variety" was *New York* magazine's description of Scully's first exhibition in the US, which turned out to be the full extent of published opinion. David and I worked hard to drum up interest but with little luck. The work appealed more to artists than to collectors. The longer I looked at them on the gallery walls the more exciting I found them. I bought two for myself.

Three in a Row

It was to be the only exhibition season for Duffy/Gibbs Gallery. In addition to Andra Samelson and Susan Elias, both David and I were very impressed with the paintings of Catherine Lee, at the time Sean Scully's girlfriend, later his wife. I ended my career as a gallery owner with three consecutive solo exhibitions by young women.

For David this was a consequence of his deliberate interest in good artists who were women. I cannot claim that there was a gender agenda for me, I just thought they were good artists.

I had shown Carol Browne, Pamela Jenrette, Gladys Nilsson, Gloria Ross, Brigitta Weyer, Hannah Wilke, and Claire Zeisler, a not unimpressive list of women artists, though nothing approaching the number of male artists I had shown, yet proportionate to the number of women artists who asked me to see their work. In my own collection were paintings, drawings, and collages by Dotty Attie, Susan Childress, Agnes Denes, Daria Dorosh, Nancy Kitchell, Howardena Pindell, and Betye Saar—many purchased from the neighboring all-women A.I.R. Gallery where I was a frequent visitor.

R.I.P. SoHo

The Broad-Spring Associates that had bought 157 Spring Street was in fact a Mrs. Judith Halevi, who had promptly moved into the late John Kagel's sixth floor space and was anxious to move me out of the fifth so she could enjoy a duplex. She forced out the rest of the tenants and turned the building into cooperative residences for yuppie refugees from uptown. David and I were willing to buy my floor for the market price of $30,000, but she wanted $50,000. She then threatened to sue me on the grounds that my partner was an illegal subtenant. All normal for a New York City real estate negotiation, but her sole goal was to get rid of me and it worked. Before my legal bills got out of hand, I accepted five thousand dollars to move out.

I closed the gallery in October of 1977. That previous May, *theArtgallery* magazine published a "Special New York Feature" headlined "SUCCESS SPOILS SOHO." On the cover was the same photograph of Cooper, Hutchinson, Karp, Radich, Whitney, and myself

that had appeared on their December 1969 issue, which they claimed to be "the first art publication to recognize and report on the SoHo phenomen." Now they served up SoHo's obituary: "Widespread Impact Foreseen as LoCal, Tribeca, SoCan Encroach Upon SoHo."

The article describes soaring real estate values, "the sparkly new bistros, bars and boutiques," weekend "street fair atmosphere," and the exodus of artists to less expensive digs. Proud of having been early to tag SoHo, the publication named SoCan (south of Canal Street) as the next venue for emerging artists and progressive galleries. Artists who owned their lofts stayed in SoHo. Those who could not afford the rising rents dispersed to the Lower East Side and Brooklyn.

I rented storage space west of SoHo on Hudson Street in Tribeca and set up an office east of SoHo in the East River Savings Bank Building on Lafayette Street, a landmark designed in 1927 by Cass Gilbert. The real estate industry baptized this area "NoLita" (North of Little Italy) in the late 1990s, but back then it had NoName.

Out With a Bang

Naomi and I joined Halston's crew to celebrate New Year's Eve at Studio 54. The sensational Grace Jones was promised on stage at midnight, but we knew her reputation for milking her audience's anticipation to the breaking point, so we ate late at Elaine's. Marc, the blond Cerberus who guarded the impossible-to-get-into club, swept us through the red velvet rope at half past eleven. The place was jam packed with the cream of the cream as well as the many layers found below the cream. The bar boys were already stoned, virtually naked, and dancing as they poured; Rollerena, the in-house, unconvincing drag queen roller skater, sped in and out of the dance floor

throng throbbing to "Le Freak" by Chic. Wading through the crowd we helloed Andy Warhol in black-tie and blue jeans, with his frequent date, the elegant Barbara Allen, whose A-list conquests were legendary. Halston was nowhere to be seen, but we found Pat Cleveland and Joe Eula and squeezed into their booth. By one o'clock the crowd was singing along to the Village People's "YMCA" but still no Miss Jones.

Eventually Halston and his mustachioed boyfriend, Victor Hugo, emerged from the lower depths much the worse for wear but well fueled with white powder. Communication was possible only by shouting across the table or whispering loudly into an ear. Naomi and I were high, but only on champagne. We danced our butts off, stopping to chat with people we knew.

Finally, at 3 a.m. Grace Jones hit the stage close to naked with white satin ribbon tight across the naughty bits, striped hair, and a huge feather boa. She hit "Slave to the Rhythm" and the room went wild. An hour later she closed with "La Vie En Rose." The music stopped. The doors opened. We walked out into the early dawn light of West Fifty-Fourth Street and Eighth Avenue. My Sixties were over.

★

Ray Johnson, *Robert Rauschenberg*, 1972

Mixed media collage on board. 20.38 x 15.38 in. (51.8 x 39.1 cm). Private Collection, Paris

Acknowledgements

The remembered events in this book were enhanced by notes made sporadically at the time, as well as archival research, and in some cases remastered by the recollections of friends kind enough to engage with their younger selves. I owe a debt of gratitude to the following:

Galina Bartholomew	Maria Ilario
Frances Beatty	Estate of Gerald Laing
Julia May Boddewyn	Maeve Lawler
Diana Bowers	Ellen Levy
Kristen Clevenson	Chris Lyon
Beatrice Findlay	Kilolo Luckett
John Findlay	Sean Mooney
Ian Glennie	Bridget Riley
Rachel Graham	Billy Sullivan
Marsia Holzer	Michael von Uchtrop
Martin Hartung	Dianne Vanderlip
Fredericka Hunter	Irene Zola

Michael Steger, my talented agent at Janklow & Nesbit, was a thoughtful guide ever at my side, and I could not have had a better team at Prestel than Katharina Haderer, Andrew Hansen, John Son, and, above all, my excellent editor, Rochelle Roberts. A very special thanks to designer Mark Melnick who perfectly conjured the zeitgeist of the times, and finally to my photographer Kent Pell.